KV-003-596

Making New Media

Colin Lankshear, Michele Knobel,
and Michael Peters
General Editors

Vol. 32

PETER LANG
New York • Washington, D.C./Baltimore • Bern
Frankfurt am Main • Berlin • Brussels • Vienna • Oxford

THE CENTRAL SCHOOL OF
SPEECH AND DRAMA
UNIVERSITY OF LONDON

1 9 OCT 2011

1 8 MAR 2013

Please return or renew this item by the last date shown.

The Library, Central School of Speech and Drama,
Embassy Theatre, Eton Avenue, London, NW3 3HY
http://heritage.cssd.ac.uk
library@cssd.ac.uk
Direct line: 0207 559 3942

30692113

Andrew Burn

Making New Media

Creative Production
and Digital Literacies

PETER LANG
New York • Washington, D.C./Baltimore • Bern
Frankfurt am Main • Berlin • Brussels • Vienna • Oxford

Library of Congress Cataloging-in-Publication Data

Burn, Andrew.
Making new media: creative production and digital literacies / Andrew Burn.
p. cm. — (New literacies and digital epistemologies; v. 32)
Includes bibliographical references and index.
1. Media literacy. 2. Mass media—Technological innovations.
3. Semiotics. 4. Mass media and culture. I. Title.
P96.M4B87 302.23—dc22 2008040438
ISBN 978-1-4331-0086-4 (hardcover)
ISBN 978-1-4331-0085-7 (paperback)
ISSN 1523-9543

Bibliographic information published by **Die Deutsche Bibliothek**.
Die Deutsche Bibliothek lists this publication in the "Deutsche
Nationalbibliografie"; detailed bibliographic data is available
on the Internet at http://dnb.ddb.de/.

Cover design by Joni Holst

The paper in this book meets the guidelines for permanence and durability
of the Committee on Production Guidelines for Book Longevity
of the Council of Library Resources.

© 2009 Peter Lang Publishing, Inc., New York
29 Broadway, 18th floor, New York, NY 10006
www.peterlang.com

All rights reserved.
Reprint or reproduction, even partially, in all forms such as microfilm,
xerography, microfiche, microcard, and offset strictly prohibited.

Printed in the United States of America

Contents

Acknowledgements

I am grateful to the publishers and editors of the journals in which a number of chapters of this book were originally published.

Chapter 2 appeared in *Convergence*, 3:4, Winter 1999.

Chapter 3 appeared in *Education, Communication & Information*, Vol. 1, No. 2, 2001., pp. 155–179,

Chapter 4 appeared in *English in Education*, 33:3, Autumn 1999, pp. 5–20, and is re-published here by permission of the National Association for the Teaching of English.

Chapter 5 appeared in *English in Education*, Vol. 37, No. 3, Autumn 2003, pp. 41–50, 20, and is re-published here by permission of the National Association for the Teaching of English.

Chapter 6 appeared in *Papers: Explorations into Children's Literature*. Vol. 14, No. 2, 2004., pp. 5–17

Chapter 7 appeared in *L1 – Educational Studies in Language and Literature*, Vol. 7, Issue 4, October 2007.

Much of the work represented here was collaborative in nature. I am grateful to David Parker and Kate Reed, who were co-authors of, respectively, the original versions of chapters 2 and 3. I am grateful to colleagues at the Institute of Education, in the Centre for the Study of Children, Youth and Media and the London Knowledge Lab, with whom I have worked on various funded research

projects on which the book draws, especially David Buckingham, Diane Carr, Martin Oliver, Caroline Pelletier, Shakuntala Banaji, Rebekah Willett; and Mark Reid of the BFI. I owe no less of a debt to colleagues in schools and other educational settings who have contributed to the projects described in some of the chapters, especially James Durran, Louise Spraggon, Trish Sheil, Donna Burton-Willcock and Britta Pollmuller. Also to the students and staff of Parkside Community College, Cambridge, where much of the practical work described in this book took place. I also acknowledge with gratitude the encouragement and editorial skill of journal editors whose close reading helped to shape some of these chapters: Julian Sefton-Green, Mark Reid, Jenny Leach, Helen Nixon, Wendy Morgan and Colin Lankshear.

I also realise how much of a debt I owe to those who introduced me to the histories of cultural studies, social semiotics and media education which underpin this book: Ken Jones, Gunther Kress and David Buckingham.

I acknowledge with thanks the support of the funders of the various research projects on which several chapters draw: the Arts and Humanities Research Council ('Textuality in Videogames'); the Economic and Social Research Council and Department for Trade and Industry ('Making Games', RES-328–25-0001); Creative Partnerships ('Rhetorics of Creativity'); the Cambridge Film Consortium, Screen East and the British Film Institute (the Primary Animation Project); BECTa (the Digital Video Pilot); and the Eduserv Foundation ('Learning in Virtual Worlds; Teaching in Second Life'). I am also grateful to Peter Twining and the Open University's Schome project, on which Chapter 8 draws.

Making New Media: Culture, Semiotics, Digital Lit/Oracy

And hath he skill to make so excellent?

—EDMUND SPENSER, *THE SHEPHERD'S CALENDAR*

This book is about two things: Making and New Media. To 'make', in Middle English and Middle Scots, was a synonym for writing poetry, itself a derivation of the Greek verb *poieo*, 'to make'. This etymology is significant for the collection of essays in this book. For one thing, it suggests the making of expressive or artistic pieces of work; and all of the practice described here is about learners and teachers making media which can be loosely described in this way. It is about the relationship between media production and the arts in education, as well as about kinds of literacy. It is also about creativity, and what we might mean by that word, as teachers and researchers. For another thing, it suggests expressivity as practical, material construction, which will also be a theme of this book.

Making is primarily about *representation*: the combination of ideas that represent the world in some way and the material substances—of language, image, music, dramatic gesture—which make it possible. For Aristotle, who used the word mimesis, or imitation, this was cultural both in the sense that it was an imitation of nature made by human art, and in the sense that it took place within the 'cultural' space of poetry. But it was also cultural in a material sense, in its use of the physical instruments of language and music to create specific aesthetic effects. However, to see representation only as imitation is to depoliticise it.

Aristotle's conception of how language might intervene in, indeed perform, the work of politics belongs not to his *Poetics*, but to his *Rhetoric*. For modern theorists of literacy, representation and rhetoric belong together. Bill Green argued as long ago as 1995 that English teachers needed to seek a critical-postmodernist pedagogy 'within which notions of popular culture, textuality, rhetoric and the politics and pleasures of representation become the primary focus of attention in both "creative" and "critical" terms.' (Green, 1995: 400).

Re-reading these words now, I am struck by their ambitious synthesis of ideas. As well as the notion of rhetoric, which runs more strongly through the Australian history of literacy studies than the British one, this vision of a future pedagogy includes elements of current models of media literacy, the critical and the creative, to which I will return. It also embraces the idea of textuality, which implies both objects of study in the media and English curricula, and the textual structures which we have become used to thinking of in terms of different modes and media (Kress & van Leeuwen, 2000), and in relation to multiple forms of literacy (Cope & Kalantzis, 2000; Lankshear & Knobel, 2003). It also situates these practices firmly in a political context; but at the same time invokes the elusive idea of pleasure, to which, again, I will return.

Green's yoking together of the concepts of rhetoric, textuality and popular culture is reminiscent of a proposal made by Kress and van Leeuwen (1992) in a paper critiquing the work of the later Barthes. In it, they make the claim that social semiotics is 'the theoretical, analytical and descriptive branch of cultural studies'.

For those who, like me, are schooled in the tradition of British Cultural Studies, this claim indicates a desire to operate with the theories of culture emanating originally from the work of pioneers such as Raymond Williams (1961), the subsequent work of the Birmingham Centre for Contemporary Cultural Studies, and the more recent developments in this tradition which seek to interpret the phenomena of popular culture, and especially diverse, fragmented, fluid patterns of youth culture. Kress and van Leeuwen's proposal relates this tradition to a theory of signification rooted in the cultural and social function of the text, derived from sociolinguistics, and Halliday in particular (1985). As a necessary corollary of this, it connects texts with the social interests of their related signmakers: those who make them, and those who use, read, view or play them. In the context of education, it offers a theory of signification ready for synthesis with the work of scholars of children's media cultures, such as Buckingham, who provides influential research in how children engage with media texts (e.g., 1996), as well as proposals for how the pedagogies of media education might be influenced by Cultural Studies (2003).

CULTURAL STUDIES: BACK TO BROADER
DEFINITIONS OF CULTURE

This has always seemed to me a potentially valuable connection to make. Cultural Studies has been an immensely invigorating development in media research, radically shifting the emphasis from textual structures to lived cultures, from ideal spectators to real audiences, from abstract textual politics to situated cultural politics. However, in developing its methodological apparatus from forms of ethnographic investigation, discourse analysis, and social theory, it gradually became apparent that it never really developed a new way to think about signification and text. When the scholars of Cultural Studies reached for techniques of textual analysis, they reached back in time, or borrowed, as Hebdige and Fiske did from French semiotics in their respective analyses of punk and Madonna (Hebdige, 1979; Fiske, 1989).

So the combination with a new semiotics proposed by Kress and van Leeuwen, which offered to recover some of the clarity of structuralist semiotics, while sustaining the benefits of a post-structuralist emphasis on the fluidity and contingency of meaning, looked appealing, to say the least.

However, to date there has been little in the way of worked-through practical realisations of this promising combination of theoretical and methodological approaches. Green's argument is the best, most inclusive, most imaginative one I know for why the connection urgently needs to be made. His reference to popular culture, and to the pleasures and politics of representation, strongly suggests Cultural Studies scholarship which has productively informed both the sociology of education, extending our understanding of youth subculture (Willis, 1977; 1990); and the development of models of media education in the UK which attended more positively and specifically to the popular cultural experience students bring into school (Buckingham & Sefton-Green, 1994; Marsh & Millard, 2000).

Popular culture is a recurrent theme of the essays in this book, written for journals over the last decade, and charting practices, theories and methodologies in my work as a school teacher and then as an academic researcher in the general field of literacy, and the more specific field of media education. Popular culture is frequently referred to, and the media educator's mantra that media studies and media education are one of the few areas of the curriculum that take popular culture seriously is often acknowledged. One of the probable benefits of postmodernist theory, however, is the hypothesis of a collapse of the formerly well-policed boundary between popular and élite cultures, suggesting that those media texts which exist in borderline spaces may be the most productive ones to use with

young people, to unsettle and explore questions of taste and cultural value. Chapter 2 provides an example, discussing 13-year-olds' work on Neil Jordan's film *The Company of Wolves*, in one sense a self-consciously art-house fantasy, in another a skilled deployer of the visual tropes of popular werewolf movies. Similarly, Chapter 3 explores teenage reverse-engineering of *Psycho*: low-budget popular horror, later elevated to auteurist masterpiece. Other chapters explore how children's animations infuse traditional folktales with the imagery of popular TV cartoons (chapter 4); how children's computer game designs can make popular sci-fi texts but also remediate epic classical narratives (chapter 7); how machinima can locate itself in different aesthetic traditions, from First Person Shooters to European arthouse animation (chapter 8).

The postmodernist explanation is perhaps too glib, however. Another way to think about different kinds of culture, more closely related to the history of Cultural Studies, and to the interdisciplinary landscape of media and literacy teachers, is to return to one of the founding texts of British Cultural Studies, Raymond Williams' *The Long Revolution* (1961). For Cultural Studies at its inception, this was perhaps the most influential manifesto of the importance and value of popular culture, rooted in Williams' level of 'lived culture', corresponding to his 'social definition' of culture, 'in which culture is a description of a particular way of life, which expresses certain meanings and values not only in art and learning but also in institutions and ordinary behaviour.' (1961: 41).

Media educators influenced by Cultural Studies have been at pains to point out the dangers of homogenising this 'common culture', the need to recognise the proliferation of tastes displayed by young people; while the sociology of youth culture has increasingly recognised the fragmentation of young people's and children's cultural affiliations into myriad forms and lifestyles, shaping and shaped by forces both global and local (e.g., Bennett, 2000; McRobbie, 1991; Willett, 2006).

However, what the field of Cultural Studies has always been reluctant to do is to return to Williams' triple definition of culture, and the three corresponding levels of culture he identified. Along with the social definition, he identified an 'ideal' definition; and a 'documentary' definition. These correspond to the levels of culture he described as 'the selective tradition', and the 'documentary record'.

These—understandably overlooked by Cultural Studies in its traditional concerns with the contemporary moment and the emancipatory politics of class-based accounts of culture—seem to me to be worth returning to.

The value of Williams' idea of the selective tradition may now be threefold. Firstly, it offers a way out of the binary opposition of élite-popular by proposing a historical process of cultural distinction. To be sure, this process may still reaffirm

the dominant tastes and values of an élite class, but if the postmodernist hypothesis has any value, something more diverse, if not an actual inversion of the old hierarchies, may be the consequence. Secondly, the selective tradition provides for the possibility of today's item of popular culture becoming tomorrow's item of undisputed cultural value. This kind of pattern is common in the history of popular media—yesterday's comic-strip culture becomes the stuff of today's collectors' fairs; the computer games of thirty years ago become curated in élite cultural institutions[1]; 50s 'B' movies are affectionately and reverently showcased by the British Film Institute. Thirdly, the selective tradition itself as a process suggests the contestation and negotiation of cultural value, which is surely exactly the kind of process we want students to uncover, critically observe, and learn how to participate in.

As for Williams' idea of culture as a documentary record, this again offers a historicised view of culture which is of value to our students of literature and media. One argument here is to do with critical distance. All media teachers know the difficulties of making music videos with students—how absorbed they become in the delighted affirmation of their own musical tastes, how blind to the possible merits of other people's. One way out of this is to somehow negotiate a truce, a listening space for the discussion of different genres and styles. Another, proposed by the influential English media teacher Pete Fraser and his colleague, Barney Oram (2003), is to give students old singles from the 60s and 70s, creating instant critical distance. A further move would be the study of the cultural moment represented by this 'old' music: a study, in other words, of its documentary cultural significance. Although Williams' notion of the cultural record was illustrated by vast historical distance (the documentary evidence of classical civilisation), we may consider much shorter time frames. Popular cultural forms mutate dramatically over a few decades—but the lifestyles and tastes they record still live in the memories of the parents and grandparents whom our students can profitably interview.

The return to Williams' tripartite model, then, seems to offer several clear benefits for teachers of literacy and media. Chiefly, it offers a historical perspective which gives us much-needed relief in several tricky areas. Rather than simply relativising cultural value, or reducing it purely to contemporary tastes, it offers a way to consider how cultural value accretes over time, making visible the operations of social power at work in this process. Rather than endlessly celebrating or bemoaning the present moment, the historical view, whether long or short, gives us and our students critical purchase and inter-generational understanding. Rather than lampooning élite culture at one moment, and lurching into a postmodern clinch with it the next, we can see how the élite and popular ends of the spectrum develop together, feed from each other, caricature each other, morph into each

other. Most importantly, we can actually address the question of cultural value, a problematic issue for media educators. In so doing, we can rethink the aesthetic dimension of media texts, to which I will return below.

MULTIMODALITY AND CULTURAL STUDIES: COMPLEMENTARY FRAMEWORKS?

The value of a social semiotic, and more specifically multimodal, approach to literacy is well known. This approach has underpinned a good deal of work in the Anglophone world over the last decade and more, exploring how communicative and representational work by children and young people needs to be conceived of in relation to the social motivations of such work, and across the range of semiotic modes in which it might be expressed.

However, if Cultural Studies has lacked a theory of signification, it might be said that social semiotics has never managed to reach out to Cultural Studies as its ideal disciplinary partner in the way Kress and van Leeuwen proposed in 1992. The emphasis on common culture, on the social determinants of cultural taste proposed by Bourdieu, on the politics of popular culture, on the subcultural affiliations within which identity is forged and subjectivity constructed—these have not been strong themes in recent work on multimodality. Simply put, the emphasis in social semiotics and multimodality theory has remained textual: its account of meaning-making, while properly attentive to the motivation of the sign-maker, seeks its evidence exclusively in the texts made by such social agents. By contrast, Cultural Studies has famously ignored text: from its early reactions against the textual fixation of Screen theory to its more recent sociologically-framed attention to taste, lifestyle, community and identity, it has sought its evidence in interview, ethnographic study and situated observation.

These are not simply arcane methodological points. The methodology and the theory are intertwined. One approach constructs the world as text, albeit shaped by the motivations of social agents; the other as (what used to be known as) audience, while the texts they engage with are backgrounded and reified. Two important examples illustrate, for me, why these two approaches need each other.

From Cultural Studies, comes the well-known model of the 'Circuit of Culture'. This model, deriving from a proposal by Stuart Hall in an effort to break out of the sterile opposition of structure and agency, and further developed in a study of the Sony Walkman (du Gay et al., 1997), proposes that representation and communication move round cyclically between different nodes in the life of a media artifact: *representation, identity, production, consumption* and *regulation*.

These nodes foreground, on the one hand, the political economy of the media and its regimes of industrial production and policy-governed regulation; and on the other, the social contexts of audiences, caught between interpretation and consumption, between receiving media texts made for them and producing their own meanings. Questions of textuality are relatively weakly represented: representation is shown in its political rather than textual sense; textual making is represented as production, emphasising the political economy of the media rather than its semiotic function; audiences are termed consumers, again underlining economic rather than interpretive function.

My example from multimodality theory is the influential schema of semiotic strata proposed by Kress and van Leeuwen (2000). The strata are:

Discourse (defined as knowledge of some aspect of reality)
Design (defined as choice of semiotic mode)
Production (defined as choice of medium)
Distribution (in which modes and media are further modified by what may be new media of distribution—for instance, a music video modified by the broadcasting apparatus of television)

Though Kress and van Leeuwen do not propose it, it seems reasonable to me to add the further layer of **interpretation**, the subject of an ensuing chapter in their book (and of chapter 6 in this book). Since for them interpretation is also a form of semiotic production, it seems to follow logically from distribution.

Given this, it can be argued that Kress and van Leeuwen's strata closely match du Gay et al.'s circuit of culture. Both propose a kind of movement, not exactly chronological (Kress and van Leeuwen resist this idea), but at least incorporating sequences of design and production, distribution and reception, a cyclical exchange of meanings between those who make texts and those who read them. The differences are that the multimodal model is closely related to a semiotic theory which tracks into the detail of textual structure at the most minute level of sign production (but is not structurally associated with a theory of culture), while the Cultural Studies model is closely related to a theory of the cultural politics of production and consumption (but not structurally related to any theory of signification).

This is a simplification of both positions, of course—but I simplify in order to argue that both models are incomplete, and the media and literacy educator would best be served by a combination of the two.

The remainder of this chapter will reflect on the ideas of literacy most relevant to the studies represented in this book and to contemporary literacy and media educators. The key words in the discussion are all, again, derived from Bill Green's vision of a future pedagogy.

CRITICALITY AND RHETORIC

As well as the reference to rhetoric, Green's condensed manifesto included the word 'critical', which signals an element in the tripartite model of literacy he and others have espoused: *operational, cultural and critical* (e.g., Bigum et al., 1998; Lankshear, Snyder, & Green, 2000). The term also signals more broadly the well-developed notion of critical literacy (e.g., Morgan, 1997).

The notion of criticality has its own more specific history in the context of media education. Both in the UK, and more broadly internationally, there is a good consensus around a general conceptual framework (Buckingham & Domaille, 2003), which, although it displays local variations across countries, exam sylla-buses, media education theorists and advocates, always includes conceptions of production (or media institutions), text, and audience. Media teachers always have their own grounded understanding of the opportunities of this framework: it develops a critical understanding of the political economy of how the media is produced, of the 'languages' of media texts, and of the regime of reception and interpretation, and its attendant tastes and pleasures. They also have a grounded understanding of its problems: it is notoriously difficult to get at the industry; textual analysis can be abstract and demotivating for students; and 'real' audiences are as hard to identify and reach as the industry.

I want to make two points about this conceptual framework. The first is to emphasise how this conceptual framework is, of course, another version of the Cultural Studies 'circuit of culture'. This relationship is obvious, well known, and the result of these two models developing together over time, over the history of Cultural Studies and its wrestle with problems of structure and agency on the one hand, and the history of media education and its attempts to shift the emphasis from text to context on the other.

In this sense, then, what we mean by 'critical' in media education is irreducibly cultural. However, if my analogy between the circuit of culture and Kress and van Leeuwen's semiotic strata holds good, then the conceptual framework is, by the same token, irreducibly semiotic. What consequences might this hold? Its implications for the future would be a broader idea of the semiotic. Traditionally, semiotics is only explored in media education in relation to the middle bit of the tripartite model—text, and the 'languages' of the media. This tradition of textual analysis is problematic. It can be seen as remote and abstract, as rooted in scraps of 70s semiotic and narratological theory,[2] as divorced from practical production work. Kress and van Leeuwen's model would suggest something more sustained, flexible and pervasive. A social semiotic perspective here would require attention to the discursive context and origins of the media text or phenomenon: who made it? What was their motive? What hierarchies of power shaped its generic and stylistic

characteristics? And to its design: what modes are employed and to what end? How can we, for instance, move beyond the grammar of filming and editing to look at the meanings of dramatic movement, speech, music, set design? And to its production: how is meaning changed by the use of digital editing technologies; or game engines; or hypertext? And to its distribution—how is meaning changed by the frame of a TV schedule? By the projection technology of a multiplex cinema? By the online persistence of an immersive virtual world? And to its interpretation: how are the semiotic resources provided by media texts understood, employed in the service of identity and social action, and reshaped into new texts by players, readers, spectators?

If what we mean by 'critical' in media education is, then, a desire for students to learn both about the cultural and the semiotic properties of the media, it is worth remarking that the conceptual framework also recalls another of Bill Green's terms, noted earlier: the idea of rhetoric. For Aristotle, who was as fond of tripartite structures as contemporary media theorists, this meant three things: *ethos, logos* and *pathos*. The first term refers to the ethical aspect of the message, the emphasis being on the credibility of the speaker. The second refers to the logical consistency of the message, the emphasis being on the text. The third refers to the emotional appeal to the listeners, the emphasis being on the audience. Clearly, the triumvirate of institution, text, audience is not an invention of today's media curriculum. The important thing about Aristotle's theory, however, and the modern rhetorical studies which are descended from it, is their emphasis on politics and argument. This model of communication seeks to explain how texts persuade, are never neutral, always have an angle (Andrews, 1994). However, the emphasis here is not a narrow, suspicious attitude to the media. Indeed, this route would simply lead us back to a Leavisian distrust of the commercial motives of the media (Leavis & Thompson, 1933), or the renowned pessimism of Theodor Adorno about the ideological function of popular culture (Adorno, 1941). Such forms of mistrust are enshrined in successive versions of media in the English curriculum in the UK. While these have softened and become more positive in recent years, the general tendency has been for media texts to be treated as factual and untruthful, requiring a reading mode of suspicion, as distinct from literary texts which are treated as fictional and truthful, requiring a reading mode of appreciation.

The rhetorical approach is more even-handed. It allows us to recognise duplicity, exploitation, and misrepresentation, to be sure (both in media and literary texts) but also the stylistic properties of a text or an oral performance: how an idea is conveyed with passion and conviction, how an audience believes in a representation with its head and its heart. In respect of the credibility of the text and the judgment made of this by the audience, this is the process known in social semiotic theory as modality: how a text makes a truth claim, and what a reader makes

of this. The rhetorical model also invokes the immediacy, performance and context of speech, and a theme of this book (most explicit in chapters 7 and 8) is that orality and oracy may often be better metaphors for the communicative processes of new media than literacy, with its associations of the fixity, abstraction and temporal deferral of print.

If the rhetorical model is also semiotic in this respect, it is in others, too, which should prevent it from being reduced to a notion of 'critical' which is about context but not about how meaning is made in these contexts. It may be about how Harry Potter has become a commercial brand, a trademarked possession of Time-Warner; or about how extreme Potter fans attend costumed conventions or make fan websites: an exploration of these phenomena is certainly part of what it might mean for children to become critical. But the rhetorical model requires attention to how these meanings are made: the semiotic work of the trademark sign in Harry PotterTM; or of the design and production of a Hogwarts gown worn by a fan, and purchased from an online merchandise company.

CRITICALITY, AESTHETICS AND PLEASURE

If criticality is about rhetoric, it is also about the aesthetic dimension of literacy. Attention to the material details of Potter fandom—to the cold shock of the Warner trademark logo or to the warm colours and woollen texture of a Hogwarts scarf—is a consideration of the aesthetic properties of these items as much as their rhetorical claims; indeed, the two cannot be separated. Aesthetics has a problematic history in media education, either reduced to a simple attention to style divorced from meaning (e.g., the visual style of Ridley Scott); or neglected altogether as a category belonging to élite art forms and their study. A productive way to approach its future may be to consider what it means from the viewpoint of Bourdieu's critique of Kant (1984). As is well known, Bourdieu argues that Kant's version of aesthetic judgment, while claiming to be absolute, is in fact a class-based judgment, designed to repudiate the immediacy of popular aesthetic values, to instantiate instead a mode of aesthetic appreciation characterised by chilly distance, and to exclude those who belong to subordinate social classes from this set of rarefied tastes. Bourdieu seeks to invert Kant's aesthetic values, championing the visceral intimacy of popular cultural taste, demonising the bourgeois remoteness of Kant's 'pure gaze'.

Bourdieu's critique has been profoundly influential in Cultural Studies: its influence can be seen in the extreme partisan rejection of the élite cultures of concert-hall and theatre in Willis's *Common Culture*, and his corresponding promotion of the 'grounded aesthetic' of young people's engagement with the forms

of popular media (1990). This defence of the popular media arts can be followed, in the field of media education, into Buckingham and Sefton-Green's *Cultural Studies Goes to School* (1994), where to be critical means neither the haughty contempt of the Leavisian media critique, nor the ascetic denial of popular pleasures produced by the Marxist ideology critique. It means instead a difficult balance between critical distance and cultural affiliation.

I call this a difficult balance for good reasons. In popular terms, it means a balance between objective and subjective critical engagement. In this book, the need for such a balance is indicated in chapter 6, which explores how a group of 13-year-olds engage with the book, film and computer game of *Harry Potter and the Chamber of Secrets*. On the one hand, the students are seeking objective conceptualisations of these texts: how they represent particular values ('Harry has to be brave'), or particular textual structures ('end of level bosses'; 'cut scenes'). On the other hand, they express engagements which are intimately related to their own developing sense of self, as in the example of the boy who dismisses Harry as a teacher's pet, indicating here and elsewhere that Harry represents a kind of boyhood from which he increasingly wants to dissociate himself.

This kind of territory, where objective structures (here introduced by media texts and by educational experiences) meet, merge, collide with subjective, embodied experience, aspiration, desire, is the territory indicated by Bourdieu in his notion of habitus. Habitus in Bourdieu's scheme is the system of dispositions in which objective structures meet subjective thoughts, actions and perceptions. It is his version of the longstanding effort in sociology and philosophy to reconcile structure and agency, an opposition considered in relation to children and the media by Buckingham and Sefton-Green in an article on Pokémon (2003). Their argument is that a mediating force in an otherwise endless speculation about the determining effects of structure or agency is pedagogy, conceived broadly here as an intervention to promote critical understanding.

If, then, we re-conceive of aesthetic engagement in Bourdieu's terms as a wholesale endorsement of the values of popular culture, we must also imagine the meeting of objective structures and subjective action which his habitus indicates, and which Buckingham and Sefton-Green seek to reconcile. In this spirit, Leander and Frank argue that a version of the aesthetic which unites it with the cognitive on the one hand, and with the sensual on the other, will serve as a corrective to multimodal approaches which have tended to 'place much more emphasis on meaning-making than on affective or aesthetic attachment' (2006: 186). This kind of approach is of considerable value, not only in thinking about how students engage with the aesthetic properties of traditional media, but how they become subjectively immersed in new, online worlds. Leander and Frank's insistence that encounters with the media should be understood as identity work explored 'through

affective relations, desire, and sensory immersion' (2006: 186) is directly applicable to the kind of media-making of student avatars explored in chapter 8 of this book. It can also serve to bring closer, in the way I have proposed in the first part of this chapter, the territories of social semiotics and Cultural Studies, with the latter's emphasis on the concrete nature of lived experience, often ethnographically imagined.

What, however, of pleasure, another powerful term included in Green's argument for a future model of literacy? Pleasure is an elusive idea: although we might be forgiven for thinking it is a self-evident end of the function of the arts in society, it is a term almost wholly absent from mandatory curricula the world over. In recent debates about digital literacy, and in particular about the potential lessons computer games might hold for education, pleasure (in popular terms, fun) is often opposed to the notion of work embodied in traditional schooling. In James Paul Gee's book about videogames, literacy and learning, the pleasurable work of play is contrasted to the dreary, unpleasurable work of traditional education. Playful learning is seen as immediate, collaborative, practical, goal-oriented; traditional school work is seen as remote, divorced from meaningful purpose, fragmented, individual (Gee, 2003).

In relation to the arts, pleasure is profoundly ambiguous. Steve Connor traces two histories: one of hedonic affirmation of cultural pleasures, from Bakhtin's carnival to Barthes' jouissance; the other of ascetic denial of pleasure in the search for cultural value, from F.R. Leavis' refusal of the 'easy' pleasures of popular culture to Laura Mulvey's refusal of the visual pleasures of Hollywood narrative cinema. Connor concludes that there is no simple reconciliation of these opposites, no way out but for us to 'inhabit the paradox' (Connor, 1992).

This may seem like a theoretical cop-out—but I mention it because it is another effort to square the circle, like Bourdieu's habitus; and again, the tension here is between an aesthetic of detachment on the one hand and sensual proximity on the other. Furthermore, something like Connor's paradoxical solution seems to be necessary if we return to my earlier argument about the levels of culture sketched by Raymond Williams. We make some progress with Bourdieu's habitus, and Buckingham and Sefton-Green's pedagogic answer to the structure-agency problem. But if we are to attend to all Williams' levels of culture—to the selective tradition and the documentary record as well as to lived, popular culture—then we need to imagine what will happen if students encounter aesthetic experiences outside their comfort zone. An example in this book can be found in chapter 3, where the teacher has asked her class to remake Hitchcock's *Psycho* for a millennium audience. This is a familiar experience for media and film teachers, noisy with student objections to boring old black-and-white movies. It is an encounter between a habitus accustomed to a particular aesthetic of popular cinema, in this

case the more recent descendants of the slasher sub-genre such as Wes Craven's *Scream* franchise, and a text displaying a more remote aesthetic. Whether the remoteness is to do with the stylistic expression of Hitchcock as auteur, or the unfamiliar stylistic conventions of a distant historical period, or both, the teacher has to find a way through the disconnection.

In this case, the teacher breaks through by asking students to make a trailer using original footage from the film. The process of unstitching the fabric of the original movie, and re-editing it for a contemporary audience, provokes the necessary connections between this old film and their own filmic culture; between their historical moment and the earlier ones of their parents and grandparents to whom the film would have meant something different; and between the analogue era of film culture and the digital era, whose compositional procedures they employ and explicitly reflect on.

Here, arguably, habitus means the accommodation of external structures of text, history, education with the internal structures of perception, embodied creative work and subjective experience. At the same time, the cultural aspect of media education here means a recognition of the grounded aesthetic of popular culture, and specifically, the interest for teenage girls of slasher movies. But it also means the importance of the documentary record (how is this film a material residue of an earlier cultural moment), and the selective tradition (how did it come to have the status it possesses?). And finally, pleasure here means some kind of accommodation, oscillation, between the uncomfortable remoteness of an old, tedious-looking text and the gradual recognition that it is related to the visceral pleasures of more recent slasher films and, indeed, can be subjected to an aesthetic transformation in the process of digital remaking, its visual and aural aesthetic supplemented by blood-red titles and re-edited music tracks.

CREATIVITY

The models of criticality rehearsed above may appear to favour the 'reading' aspect of media literacy. Yet the thrust of research and practice in the fields of digital literacy, media literacy, and multiliteracies has been much more about the production of texts by young people than about their critical interpretation of them. This can be seen as a pendulum swing, in which the related school subjects of English and Media education, traditionally about the analysis and interpretation of a textual canon, discover the benefits of students making their own texts. At the same time, it can be seen as the move from a fixation with text in the media theories of the seventies to an interest in the cultural work of media audiences in the eighties and nineties.

Of course, it has never been as simple as this. English has always also been about creative writing (though more for younger students); while media education has always attempted forms of production, even in the face of a complete absence of authoring technology. Nevertheless, the last decade or so has seen a marked shift from critique to production, enabled by the advent of widely-distributed and affordable digital authoring tools. The implications of this will be explored further in the next section. The central point, often reiterated in recent work on media education (cf. Buckingham, 2003), is that critical understanding and creative production belong together and are best developed in tandem.

In current debates about the nature of the creative act in relation to education, creativity is often a vague and confused term, variously appearing as post-Romantic conceptions of artistic genius (Scruton, 1987), psychological accounts of the cognitive mechanisms of creative thought (Boden, 1990), cultural notions of 'grounded aesthetic work' (Willis, 1990), policy notions of the collaborative problem-solving skills necessary for new kinds of workforce (Leadbeater, 2000). My preferred approach draws on the work of the Russian psychologist, Lev Vygotsky, for whom the creativity of children was closely related to play (Vygotsky, 1931/1998). In playful activity, children learn the meaning of symbolic substitution through the manipulation of physical objects: so a broomstick becomes a horse, to use Vygotsky's example. These symbolic understandings become internalised and develop into the mental processes which generate creative work. In these processes, importantly, imaginative play becomes full creativity, for Vygotsky, only when allied with rational thought, thinking in concepts. Although this formulation is not explicitly made in many of the chapters of this book, they are all concerned, in one way or another, with the way in which creative work draws on children's cultural resources and depends on social forms of learning; and how creativity is linked to intellectual development, rather than being something mysteriously separate from it.

In this way, then, creativity is not something distinct from critical work, but something inseparable from it, as others have pointed out (Buckingham et al., 1995; Buckingham, 2003). It does not imply some kind of easy surrender to a practical alternative to 'theory'. Media teachers—drama teachers too—know the perils of sending students off to make something up on their own with no intervention. The pedagogy of media education consists of constructive interventions of many kinds—inserting pauses for critical reflection; making time for students to present work in draft to peers; playing with constraints to raise the technical or intellectual challenge of the task (Sharples, 1999); negotiating social roles of students working in groups (Buckingham et al., 1995).

These kinds of creativity, in the familiar context of the media classroom, seem at odds with the visions of new media literacy proposed in recent years. Henry

Jenkins' *Convergence Culture* (2006), for example, exemplifies the autonomy of young people at ease with online tools, protocols and communities, like Heather who produces her Harry Potter fansite, managing an entire online community and a panoply of media-literate practices in defiance of the oppressive moves against her by Warner corporate interests.

However, it seems to me that the real function of Jenkins' illuminating examples is not to suggest, in an excess of cyberoptimism, that schools are redundant and kids can do it all on their own. Indeed, in his 'white paper' on new media literacy (2007), he proposes three challenges which suggest the opposite—that many young people do not have access, in many ways, to new media; that they may not be able to see through the opacity of new media messages in many cases; and that they may need help in negotiating the ethical dilemmas of online experience. Rather, then, examples such as Heather and her Harry Potter site are intended to serve as wakeup calls for educators and policymakers, reminders that some young people, while they may be the exception rather than the rule, can use new media in ways which are more imaginative, ambitious, sophisticated, and more rooted in authentic social, cultural or political purpose than much of what they might encounter in formal education. At the same time, Jenkins' three challenges represent another version of the arguments rehearsed above for pedagogic intervention to develop critical understandings of the media, as well as a level playing field for all children to experience its creative possibilities.

NEW MEDIA

This book is about the culture and semiotics of making media, then; but it is also about *new* media. As Neil Selwyn argued recently (2008), disavowals of technological determinism have become routine for researchers in ICT, new media and education. Like others (Buckingham, 2007; Jenkins, 2007), he argues the case for the prioritising of cultural and social uses of the media over the nature of the technology, for close attention to how social uses shape the development of the technology, and for an understanding of the affordances and constraints of new technologies on they way they are used. Needless to say, the following discussion will adopt this approach.

New media is an expression that requires some preliminary definition. Contemporary debates about how media education and media studies might respond to the challenges and opportunities of new media are currently dominated by the forms of social networking and participatory internet culture for which Tim O'Reilly coined the expression Web 2.0. We need to address these concerns—but also identify other quite distinct developments of digital media, in

particular, the sets of authoring technologies which have permitted this generation of media students to become producers of their own media texts. By far the largest impact of the digital age on media teachers, for instance, is the advent of digital video editing softwares, allowing students and teachers to become creative forces in what remains the most popular medium for study in media studies classrooms in England and Wales (Grahame & Simons, 2004). Yet the use of this medium is dramatically under-researched: a systematic review of literature on its use in media and English classrooms revealed only twelve studies internationally (Burn & Leach, 2004).

In fact, even this wave of authoring technologies is not the first arrival in the digital pantheon, but rather the breakthrough into screen media authoring. It was preceded by something we now simply take for granted: the digital authoring of print media. My own first encounter with digital production in media education was with the arrival in my school of new Acorn Archimedes machines in 1988, with their excellent desktop publisher, *Ovation!,* their answer to Adobe's *Pagemaker.* With this, my Year 9 class made newspapers with real local reportage in Cambridge, desktop-published at a time when the local paper, the *Cambridge Evening News,* was still pasting up strips of paper. My point here is that three features still much discussed in the context of the latest developments of Web 2.0 were already apparent: a shift from consumption to production, a heady sense of being ahead of a lumbering traditional industry, and a new sense of the compositional fluidity of digital authoring.

Moreover, it seems to me, looking back at this moment, twenty years ago, that it contained the seeds of a new kind of language, most memorably described by Lev Manovich in *The Language of New Media* (1998). I will return below to his account of the new ways in which information is organised and cultural objects created through the algorithmic manipulation of media objects and databases.

Among digital authoring technologies, the use of digital video editing software in particular has grown, and most schools in the UK with substantial media education programmes have invested in editing suites, using either professional or semi-professional editing software. In practical terms, this has meant a significant increase in creative production work in schools. This seems obvious—yet its effects are profound. The blossoming of such work shifts the balance away from the analytical practices which dominated media education for so long, under the model of academic media studies and sociology and also under the influence of approaches to media education based in ideology theory. The shift can also be seen as a move away from the metaphor of literacy and towards the Arts area of the curriculum, where making creative products in Art or Music has tended to be less encumbered with 'theory'. There is also a shift away from the traditional dominance of secondary education, with researched accounts of creative work with

digital video in primary schools, such as John Potter's study of 10-year-olds' auto-biographical digital video work, emphasising themes of identity and popular media culture (Potter, 2005).

Needless to say, however, a balance needs to be maintained in the shift towards a more Arts-based model: the critical approach media education brings is an essential element and part of the rationale for production work is that critical understanding is better achieved when students have some grasp of how media texts are produced as I have argued above. Chapter 8 also explores how creative media work can represent a meeting-point of Art and Media education at a time when the former is seeking a more critical approach, the latter a more creative one.

There is considerably less evidence of the authoring of other kinds of new media, however. Radio continues to be easy to produce but restricted to a relatively small number of enthusiasts while the authoring of computer games has been almost impossible until recently because of the lack of appropriate software. My own research centre has recently spent three years developing such a product, *Missionmaker*, with Immersive Education Ltd, which has seen successful results in media education classrooms (Buckingham & Burn, 2007). Its early use with twelve-year-old students is described in chapter 7.

The digital revolution, then, is rather older than we are sometimes inclined to think, and while the current interest in social softwares and participatory web cultures offers new possibilities and challenges, many of them continue from, grow out of, and even incorporate, older digital media. It seems important not to lose sight of these 'older' media in the heady excitement about Web 2.0. Broadly speaking, they tend to be questions about what digital tools can make possible, and how we distinguish these from what was possible with the tools of the pre-digital era: how we identify what is distinctly new about digital media, a central question raised by Manovich (1998). Reid et al. (2002), addressing this question in a study of digital video in schools, posed a series of affordances of digital video, derived from Moseley et al. (1999), and further developed by Burn and Durran (2007) as:

- *Iteration* (the ability to endlessly revise)
- *feedback* (the realtime display of the developing work)
- *convergence* (the integration of different authoring modes, such as video and audio, in the same software)
- *exhibition* (the ability to display work in different formats, on different platforms, to different audiences).

However, such affordances are only the first step. More profoundly, Manovich asks what it means for our traditional media texts, such as photographs and film,

to have become computable. This is something the community of media educators both in the UK and internationally has barely begun to address.[3] Manovich distinguishes between what he calls 'the cultural layer' and 'the computer layer'. The cultural layer consists of all the forms in which, over the years, we as media teachers—along with teachers of language and literature—have become expert. The computer layer is the set of concepts about how the world can be represented through the numerical organisation of information: a language we are still uncomfortable with. What we used to call *representation*—say of a landscape, in Photoshop—is now constructed with numerical scales and filter (determining colour, or transparency, say); what we like to think of as a character may be, in a computer game, what programmers might call an *entity module*: a bundle of media objects articulated and animated by algorithms.

The humanist sensibility in media and literary studies instinctively reacts against the idea that texts might be made from numbers or formulae. This kind of belief can be seen as the residue of an ideology of representation dominant in the modern era, and typical of, for instance, the European novel. This ideology demands a simplistic kind of naturalistic realism, a claim to psychological veracity (in character development, for instance), and a rejection of fantasy and formulaic forms of narrative. This ideology, driven in effect by one strand of the Enlightenment project (not the scientific strand, of course), seeking in fictional form an affirmation of the rational and the ideal, unitary self, propelled inexorably along the road of *Bildung*, displaces more ancient forms of storytelling. English teachers, and by the same token media teachers, inherit the residue of this ideology, and a set of beliefs that representations of the world proceed organically from their referents. What, then, are they to make of computer games which represent the world by mathematically constructed puzzles clothed in 3-D graphics? Or of characters who are programmed to behave according to fixed formulae?

Chapter 7 ends with an example of a 12-year-old boy who proposes a computer game based on Homer's *Odyssey*. He conceives of it in terms of the rules and economies he has learned about in a media course on game design. This example recalls the productive remarks made about game characters by Janet Murray: that they resemble the heroes of oral narrative and to compare them to the psychologically developed characters of modern literature or drama is to miss the point (Murray, 1998).

Her comparison implies, for me, a profound idea about historical continuity in the practices of new media. While the cultures, narratives, communities of the new media age are qualitatively different in many respects from their immediate predecessors, these differences are evolutions from older forms. To see the formulae of game-narrative as analogous to the formulae of ancient oral narrative is to make this point exactly. By extension, to see meaning-making in new media as improvisatory, communal, performative, fluid, is to make bold contrasts with the

stuffy, fixed, slow, dreary world of traditional education and a curriculum dominated by the fixities of print and the values of a rigidly hierarchical society; but at the same time, it is to recall the immediacy and responsiveness of oral narrative, its persistent renewal in communal performance, and its obedience to structures of social solidarity rather than the divisions of social hierarchy.

To say all this is to echo an idea about the persistence of the values of oral societies in the age of new media: Walter Ong's 'secondary orality', which other scholars of new media have invoked:

> Electronic text will…serve as the vehicle for displaying all of Western literature in a new light. Since much of this literature is oral in origin and nature, and self-consciously rhetorical, and since electronic text is both oral and rhetorical to a degree, 'repurposing' can reveal to us aspects of our greatest works of art—literary, artistic, and musical—that we have never noticed before. (Lanham, 1993: 131)

The metaphor of secondary orality has many implications for the model of new media literacy which this chapter is seeking, and which successive chapters in this book explore, but never fully resolve. In general terms, of course, it challenges the metaphor of literacy altogether. If the semiotic and multimodal approaches explored above imply text-like objects and writing-like processes, the image of orality loosens these up, emphasising performance, ephemerality, improvisation. These characteristics describe much better than the literacy metaphor what kind of work happens when students use digital camcorders, or when they meet as avatars in an online roleplaying game, or when they act a part in a digital film. These acts of representation and composition are much more like drama and oral narrative than they are like reading and writing. For this reason, I tentatively propose, in the title of this chapter, that the spelling of literacy as 'Lit/oracy' might serve as a useful reminder.

To proclaim the virtues of computer games and online communities, then, is certainly to draw attention to new, rapid and responsive forms of learning, making and communicating. But it is also to recall that ancient forms of narrative, and the communities which sustained them, are legitimate antecedents of these social processes. The reasons for drawing attention to these kinds of historical continuity are threefold. Firstly, to challenge arts and literature educators to rediscover ancient, powerful narrative forms through an engagement with the new media cultures familiar to their students. Second, to help us understand that representations of the world made from numerical structures, quantified resources and formulaic patterns are not aesthetically suspect or debased but related to an older aesthetic whose formulae were creative resources for a culture of performance and improvisation. Thirdly, to challenge once again the technological determinism rife in popular, even academic, discourses of the place of new technologies in education

(see Buckingham, 2007; Selwyn, 2008). Representational technologies in the digital era possess distinctive characteristics, as Manovich clarifies. But they do not represent such a rupture as we may think. Some features often claimed for digital media were also true of 'old' media, as Manovich also demonstrates. And even those that are truly distinctive, such as their numerical basis, have their analogies in older representational forms. The metre of poetry, for instance, is effectively numerical, as is its sister, musical measure. These metrical representations of basic human activities—walking, marching, dancing, breathing, time-keeping—underlie centuries of evolving cultural form. They are the informational units of cultural representation.

Moreover, in a general sense, digital media are another technology which succeeds older technologies of representation and information. Manovich tells the story of how the multimedia computer inherits the two explosions of invention in the 1830s represented by Babbage's Analytical Engine on the one hand, and Daguerre's prototype camera on the other. Today's schools have inherited these two traditions, the one of visual culture, the other of information-processing, and our teachers of media and ICT are still working out the implications of this convergence. Meanwhile, as many have pointed out, the digital revolution has many similarities to the Gutenberg revolution, as did pre-digital mass communications media (McLuhan, 1962), and we continue to deal with the interplay between opportunity and constraint, with rhetorics of wild optimism and moral panic that echo those which greeted the invention of the printing press.

COLLECTIVE INTELLIGENCE

Nevertheless, the general shift of interest from the affordances of digital technologies to the kinds of community, communication and production made possible by the participatory internet has produced new arguments: about what we might mean by media education (or more narrowly, media studies) and what we might mean by media literacy in this context.

In his article calling for a Media Studies 2.0, David Gauntlett argues for a move away from the fetishisation of specialist interpretive practices by the academy (Gauntlett, 2007). While he is referring here mainly to Media Studies in Higher Education, this argument does have some resonance in school media education also. For me, this debate relates to the arguments I have made above about the semiotic aspect, and more generally the critical aspect, of media literacy. The consequence of a move away from specialist interpretative practices is that some other way of approaching texts 'critically' needs to be found, and it is by no

means clear what this might be. The research and practice represented in this book has borrowed heavily from social semiotic and multimodality theory, which for me has the advantages of recovering some of the clarity of structuralist semiotics, while being based in a sociolinguistic tradition which incorporates a theory of social contingency.

As I have suggested above, the best model of this I can find is a blend of social semiotics and Cultural Studies. The former has a strong idea of textual structures and social meanings; the latter pays close attention to contexts, cultures, lifestyles. However, in relation to media education, the big question here is, what would a school-level version of such an approach look like; and how might any kind of sufficiently large consensus be built for it to catch on? In relation to the first point, I have, with colleagues, tried some kinds of interpretive work based on this approach with secondary pupils (see Burn & Durran, 2007). However, the whole future of how we interpret and theorise media texts with students, what level of abstraction is needed, seems to me an open question. Gauntlett disputes the need for 'difficulty'; and if by this he means the more obscure depths of post-structuralist or postmodernist theory, then I would agree. But if we abandon close and critical reading in favour of, say, an entirely production-based approach, and do away with all the 'difficult' business of working out what texts mean, and how these meanings are in certain ways political, then I believe we lose something distinctive about Media Education which differentiates it from Art education on the one hand, and literature teaching on the other.

One of the more illuminating thinkers about media literacy and media education in the new media age has been Henry Jenkins, whose 'White Paper' on media education and new media—'Confronting the Challenges of Participatory Culture: Media Education for the 21st Century' (Jenkins, 2007)—frames the issue in terms of three challenges. These are his answers to why we don't just leave kids to get on with their media cultures and uses and abandon media education as old-fashioned adult interference:

> There are three core flaws with the laissez faire approach. The first is that it does not address the fundamental inequalities in young people's access to new media technologies and the opportunities for participation they represent (what we call the *participation gap*). The second is that it assumes that children are actively reflecting on their media experiences and can thus articulate what they learn from their participation (what we call the *transparency problem*). The third problem with the laissez faire approach is that it assumes children, on their own, can develop the ethical norms needed to cope with a complex and diverse social environment online (the *ethics challenge*). Any attempt to provide meaningful media education in the age of participatory culture must begin by addressing these three core concerns.

The implications of this, then, are that media education can even out children's and young people's access to media texts, technologies and cultures. It can develop an ability to reflect on ethical issues, on meaning, on power (what I have discussed in this chapter as the critical and rhetorical aspects of media education); while the semiotic emphasis I have argued for in this chapter, though not an explicit theme of Jenkins' proposals, can be aligned with the transparency gap he identifies, perhaps.

More explicit is Jenkins' account of how online communities function. His use of Pierre Levy's notion of collective intelligence (Jenkins, 2002) is used in chapter 8 of this book, which explores creative media work in machinima made by students working in the immersive online world Second Life. Jenkins is quite specific about what collective intelligence will mean: how it will bring a deterritorialisation of knowledge, a horizontal network of participants held in relations of temporary affiliation, a creative process more geared towards the production of a dynamic environment than the production and regulation of texts. For the students making machinima in Second Life, much of this is already true: if they are producing short films in a conventional sense, they are also producing themselves as avatars, and the environments in which their films are made, exhibited, and reviewed. Nevertheless, while this may seem a utopian vision of a particularly futuristic version of media studies, the historical continuities again deserve attention: how student voices compete as well as collaborate; and how even the newest of new media—machinima—demands a return to the traditional craft of moving image composition.

CONCLUSION

A persistent theme of the chapters in this book, then, is an image of Janus, the Roman god of doors and the new year, looking backward with one face and forward with the other. Taking my cue from Raymond Williams' scrupulously historical approach to the theory and practice of culture, I hope that the various excursions in the following chapters into how school students engage with, remake and make anew images, narratives, compositions of the age of new media will locate their analyses in interrogation of contemporary practices, identification of historical precedents, and informed speculation about future possibilities.

For teachers, this ten-year history of work with digital media, though it contains inevitable uncertainties and red herrings, may hold some lessons for the future, or at least some hints about what we can do with such tools if we retain a clear sense of our cultural purpose.

For researchers, the essays represent a series of methodological debates and experiments. These are not always clear; but this introductory chapter has attempted to spell out, albeit with the benefit of hindsight, how the dominant debate is the attempt to find an accommodation between Cultural Studies and its roots in the cultural theory of Williams, and the framework provided for the analysis of signs across different modes and media represented by multimodality theory and social semiotics. There is much more to do here, but perhaps this can at least be a beginning. Like Henry Jenkins' description of Pierre Levy, I want to characterise myself, and the work in this book, in terms of critical utopianism. I have found in my own work in schools that the experiences of teachers and students continue to improve, and the experience of creative work with digital media has been no exception. The properly sceptical attitude represented by David Buckingham (2007) provides the kind of cautionary notes we all need as we consider the value of new tools, new learning spaces, new communities. But the experience of teaching and research narrated in the following chapters tells, on the whole, an optimistic story of the last ten years, and suggests an optimistic future for media education, broadly conceived across literacy, literature and arts curricula. To maintain a critical utopianism means, for me, the chance to avoid the extremes of cyber-optimism and Luddite denial, as well as the possibility of a world of technological determinism in which media education and media literacy become subordinate to ICT education, while the reverse should be the case. Teachers of English and Media should resist this. At the International Federation for the Teaching of English conference in Melbourne in 2001, Allan Luke challenged delegates to consider what they professed. We should profess our expertise in culture, representation, creativity and meaning-making.

Grabbing THE Werewolf: Digital Freezeframes, THE Cinematic Still AND Technologies OF THE Social

TECHNOLOGIES OF THE IMAGE—AN 'EPOCHAL CHANGE'?

Audiovisual technologies have made dramatic leaps forward in the last ten years, bringing the creative possibilities of professional sound, video and multimedia studios within reach both of schools and homes for the first time. School students are becoming the first generation of media audiences able to operate the powerful technologies of the moving image used in the production of film, television, audio CD, multimedia and hypertext. That such technologies can only be understood as operating within social processes is a point central to this chapter. It was emphasised in the early 80's by Raymond Williams, who envisaged an 'epochal change' (1981) from a period of wide accessibility to the mass media, but characterised by a relation of a few producers to many consumers, to a period in which the means of production themselves become widely distributed, leading to:

> the provision of equitable access to the means and resources of directly determined communication, serving immediate and social needs ... the full mobility of a range of communications processes which in all their aspects—amplifying and connecting, storing and reminding, alternative and extending—would be the means and resources of a qualitatively different social life. (Williams, 1981: 191)

Williams makes another point of direct relevance to this chapter: that the new technologies of communication in this century (he specifies radio, telephone,

cinema and the camera) have been far less determined by formal regimes of instruction and training than print literacy, requiring only a set of relatively simple skills, informally acquired, to allow mass access. A development of this point pertinent to my argument is that these technologies have been until recently largely ignored by the pedagogies of formal education, which have, instead, stuck persistently to the technologies (and ideologies) of print literacy and literature. Now that schools are beginning to grapple with new media, they face the twin problems of coping with the need for new skills (for teachers and students), and accommodating an accompanying cultural sphere often at odds with the traditional official culture of the school.

A final introductory point is that growing competence in these technologies among young people, both in and beyond school, has become part of a long sequence of debates about literacy, debates which still oscillate between narrowly-defined models of print literacy and more widely-conceived models of plural, multimodal literacies, recognising the determining importance of social contexts (see Street, 1997; Raney, 1998). Apart from the debate about the appropriateness of the language analogy to visual and other media, important questions are raised here about what new skills might be needed, how and when they can be acquired, what kinds of metalinguistic competence might be needed by young people, and what new social and cultural contexts will frame and determine aspects of these literacies.

This chapter will examine the impact of the 'turn to the visual' and the increasing availability of digital technology, in some very specific instances of work in the secondary school classroom; also some of the social practices determining, and determined by, these events; and the cultural histories that lie behind such practices. In much of the chapter, I will concentrate on the practice of abstracting single frames from film or video. The use of the cinematic still has always appeared natural and simple—a visual quote, anchoring the point made in a review, proposing a distilled version of the film in a press kit, or enticing us into the cinema in a poster. In fact, of course, it is a complex historical process of selection, representation, and certain forms of discursive empowerment. It offers important clues about the way in which we read, transform, and re-present the images of a film: how we anticipate them, respond to them at the moment of viewing, and later recall them. It is also a form of image engaged in particular ways with the technological: from the photographs of unit stills photographers and studio portrait photographers on film sets, or the early use of 35mm frame enlargements; to recent forms of digital imaging derived from film—a historical progression of cultural uses marked by a shift from the professional-industrial sphere to the domestic, between which spheres education often finds itself positioned.

The technical apparatuses of the cinema have often been used as metaphors for the act of spectating, most extensively in the psychoanalytic screen theory of the late seventies. A valuable corrective to conceptions of an ideal, transhistorical viewer which arose from this was issued by Stephen Heath, who emphasised, like Williams, that the technological and the social are mutually determining:

> Cinema does not exist in the technological and then become this or that practice in the social; its history is a history of the technological and social together…, in which the ideological is there from the start. (Heath, 1980: 6)

Part of my argument in this chapter will be that the processes of production of the cinematic still can also be seen, like the technologies of filming and projection, as a kind of metaphor for, as well as a material enactment of, certain aspects of understanding film.

Traditional techniques of the cinematic still, then, interacted with their ideological purpose. Both production stills and studio 8" x 10" portraits in Hollywood constructed versions of the film texts which emphasised the star system and certain aspects of genre and narrative. By contrast, the Stenberg brothers,[1] who produced movie posters in Soviet Russia in the twenties, including posters of several of Eisenstein's films, used a projector of their own invention to enlarge frames of the film to construct representations of the film's key ideas using techniques deliberately modelled on Eisenstein's montage theory and working in the Constructivist tradition of pre-Stalinist revolutionary art.

Kress and van Leeuwen (1996: ch. 7) describe the making of texts as 'inscription', identifying three historically successive classes of inscription technology: technologies of the hand (paint, pen, print); recording technologies (of the eye and ear); and synthesising technologies, which depend on digitally manipulated developments of text. Their main point is that these successive classes allow for different kinds of textual ideologies, which move from ideologies of reference, in which the text appears simply to represent the world by reference, to ideologies of 'representation-as-design', which allow for the endless recombination of texts, and for a dissolution of the distinction between reading and writing.

The Stenbergs might seem to have anticipated this last phase, their innovative combination of frames from film and traditional technologies of inscription operating as a re-reading of film through a process of spectatorial montage made material on the surface of their huge, arresting poster designs. In other ways, however, though their approach to film perhaps opened possibilities for more democratic spectatorial engagement, they were still working within the artistic and professional sphere of movie production and distribution; and their project was, in larger ways, aligned with the period of modernism in which the artist

belonged to an élite group. They belong in the stage of Raymond Williams' scheme characterised, as we have seen, by the relation of a few producers to a mass audience.

School students equipped with digital imaging software, by contrast, belong to a period which is beginning to see a considerable shift in productive power from author to audience in ways which may be material amplifications of responses to film that have always happened in audience's minds, but which now offer the possibility of visual inscription, of making images rather than only viewing and imagining them: Kress and van Leeuwen's 'dissolution' of the reading/writing distinction. In one of the first accounts of children's work with digital film images, Julian Sefton-Green makes this point:

> ...I would want to make the larger claim that being able to handle the film in 'virtual' form, frame by frame, image by image, may transform the power relations that normally obtain between text and viewer. (1995: 63)

In the school projects I will refer to, students have used video digitiser software to digitise key sections of the films they are studying, and to grab images and drop them into their desktop-published commentaries on the film—in effect, to make their own stills, and use them for the kind of purposes that film commentators and critics have used them for throughout the history of the cinema. What does this act of appropriation mean, what does it make possible? It seems a small moment in the story of the digital revolution; but it allows for certain kinds of amplification of the ways in which we read, interpret and transform the films we watch.

In the mixed comprehensive school where this work took place, this use of digital freezeframes was a central part of a Year 9 media course, based on Neil Jordan's *Company of Wolves* (1984). The course was set up, following the feminist intentions of Angela Carter's story (1981) and screenplay, to teach how the representation of women in horror could be observed as changing, from its earlier moments in the Universal pictures of the thirties and forties, through the AIP[2] and Hammer films of the fifties and sixties, to this film of 1984, very untypical of the popular horror genre in some ways, but in other ways closely allied to it. As the course developed, it also increasingly concentrated on scenes of werewolf transformation, setting these against similar scenes from earlier films in the werewolf sub-genre, and exploring the significance of this event as a characteristic horror metaphor.

This research combined a theoretical inquiry into the semiotic nature of the still and moving image with an empirical study of three mixed-ability Year 9 classes. It took place over a period of three years, working on this Media Studies course on horror films. The study employed a broadly ethnographic approach, employing classroom journal observations, semi-structured interviews with twenty-eight students over the three years, and social semiotic analysis of students'

work with writing, image, and ICT. The context of the work was a small mixed comprehensive school in Cambridge, the first in England to be designated by the UK government as a specialist Media Arts College. While these case studies do not necessarily represent typical patterns, even among students in the UK, they do establish patterns of engagement with film and use of digital technology over a period of time, and the examples selected in this chapter are typical of patterns observed across the case studies, rather than isolated examples.

The chapter looks at four broad areas. My questions were prompted partly by observation of the way young people deal with still images from film, and partly by certain points in the history of the theory of the cinematic image, from Eisenstein's montage theory to contemporary social semiotic theory. A particular point in this history which I will discuss is the remarks made about the cinematic still by Roland Barthes in his well-known essay, 'The Third Meaning' (1978).

The first of the four areas is the question of the single image in a moving sequence, and how this is read by actual audiences (and school students in particular)—the image as a unit of meaning in the visual 'grammar' of the film; and how this meaning changes when the image is abstracted from the sequence.

The second is the question of the still image as a condensation of the film, a significant image that stands metonymically for whole sequences, important themes, sometimes even, as in a film poster, for the whole film.

The third is a particular social use of what Barthes calls 'this major artefact', the cinematic still: the still as quotation. How will this social purpose usually associated with the academy be transformed by the use by young people of freezeframe and digital selection?

The fourth question is about the role played by particular kinds of digital technology in the social communicative practices described here.

THE STILL: FROM MONTAGE THEORY
TO THE SYNCHRONIC SYNTAGM

Barthes' account of the cinematic still builds on Eisenstein's well-known idea of 'vertical montage' (1968). However, where for Eisenstein this meant a vertical articulation of shot and sound-track, Barthes' new move is to suggest a vertical reading of the individual frame, below the level of the shot. This idea is developed further by recent social semiotic theorists (Hodge & Tripp, 1986; Kress & van Leeuwen, 1996), who suggest that powerful images from film operate as synchronic syntagms—moments experienced by the spectator as almost instantaneous, but which have a syntagmatic structure of their own, working at right angles, as it were, to the diachronic syntagm of the film's flow.

This sequence of theories proposes these views of the relation of image to moving sequence as part of a developing set of ideas about the power relations of audience to author. Eisenstein proposed a radical revision of text-viewer relations, in that his montage theory depended upon the spectator operating their own montage, in which the cinematic image is understood by a kind of cinematic counterpart in the mind of the viewer, who makes connections between images on the screen and other images in his/her own experience. In keeping with Eisenstein's political project, however, the (ideal) viewer's construction of meaning is invariably in harmony with the intentions of the director. Barthes is in accord with this emphasis on the power of the spectator, though his ideal viewer, again the ideal of his historical political moment, is characteristically subversive. In specific relation to the cinematic still, Barthes suggests that it offers a subversion of cinematic time: 'by instituting a reading that is at once instantaneous and vertical, [it] scorns logical time…' (page 332).

The synchronic syntagm of social semiotic theory is similarly subversive, offering the potential for viewers to stitch together their own readings of film from powerful images, producing unpredictable meanings of particular ideological potency for the spectator. In this respect it follows the stance of post-structuralist theory generally; though it grounds its claims in an analysis of young spectators' responses derived from specific sociolinguistic theories applied, in this case, to the moving image (Hodge and Tripp, 1986).

Another social semiotic analysis of the syntagmatic structure of the image, though in this case it is not the cinematic image, is offered by Kress and Van Leeuwen (1996), who analyse images in terms of a grammar of visual design, where each element operates as part of the grammar of the image, in analogy to the elements of Halliday's functional grammar (1985). In this system, the objects and people in the picture function as participants, subjects of the action signalled by vectors of movement, and the angles and perspectives of the picture signal meanings such as point-of-view, or the system of person, as it would be in language.

The following analysis explores what evidence there might be of young people using these kinds of structure in their own interpretations of cinematic images. How does one 13 – year-old boy, Ben, use an image he has digitised? How does he read the still; how does he relate it to the moving image; is there any evidence of Barthes' gesture of denial of filmic time, or of a reading of the social semiotic elements of visual grammar?

Ben has chosen an image of a werewolf in the final stages of transformation. It is taken from a brief narrative of a werewolf bridegroom who abandons his wife on the night of their wedding, then returns years later to terrorise her and her children by her new husband. The story belongs to a third layer in the film's narrative structure: the outer layer of the onion, as it were, is an adolescent girl, dreaming the main story; the second layer—derived, via Angela Carter's short

story, from Charles Perrault's 'Red Riding Hood' (1991) and the mediaeval story which is its main antecedent[3]. The third, inner, layer is a series of tales told by the girl's grandmother (within the dream); and then by the girl herself.

Ben's choice itself is significant, then: he chooses an image which bypasses the main narrative structures of the film, an image in which usually stable identities are replaced by disturbing processes of transformation, an image which carries accreted historical meanings from traditions of cinema and folktale. How does he read this image?

Ben clearly recognizes certain properties of the still image, but his reading is everywhere informed by understandings of the moving text. He uses a number of words to describe the creature in the image—he transforms the visual sign and its nominal function into a number of nominal groups of his own. His first sentence is:

> In this image the man is in the final stages of turning into a wolf.

One noun will not suffice for the creature, of course, but two are needed: 'man' and 'wolf', signifying the syntagmatic structure of this brief narrative sequence that covers the werewolf transformation. This brief introduction also serves as a paradigmatic indication of the genre conventions that produce both the man/wolf, the werewolf, and the characteristic sequence of transformation that is a hallmark of the subgenre, from the celebrated transformation of Frederic March from Jekyll to Hyde in Rouben Mamoulian's film of 1931, to the spectacular transformation sequences of John Landis's *American Werewolf in London* (1981), both films from which the class has viewed extracts.

Later, Ben refers to the creature as 'the monster (almost wolf)', a complex nominal group that articulates cultural echoes of the spectacular nature of the creatures of the Gothic tradition with a parenthetic representation of the dynamic process of the transformation, '(almost wolf)'. Later, he calls it 'the thing', perhaps indicative of uncertainty about its ever-transforming nature; perhaps an echo of an older sci-fi horror tradition which did indeed label one of its most celebrated inventions 'The Thing'. Elsewhere he calls it 'the beast'—another choice resonant with apocalyptic horror imagery. A significant point, perhaps, about all these selections is that they relate to the genre, their ruling paradigm, in a way that the everyday word—which Ben never uses—doesn't: the word 'animal'. It's clear that the processes of re-lexicalisation Ben uses to transform the transforming werewolf aren't by any means random, but carry the social history of meanings which the Russian psychologist Lev Vygotsky described in *Thought and Language*:

> The primary word is not a straightforward symbol for a concept but rather an image, a picture, a mental sketch of a concept, a short tale about it, indeed, a small work of

art. In naming an object by means of such a pictorial concept, man ties it into one group with a number of other objects. (1962: 75)

But the werewolf paradigm is defined, of course, not only by what it looks like but what it does—its part in the *action* which this sequence is all about. The still image, Barthes asserted, offers a kind of defiance of narrative time—but here, it seems it can only be read by reinstituting the temporal sense of the narrative syntagm, which is, of course, what Ben does, translating the actions of the wolf into verbs, which give some indication of how he reads these narrative processes. If the major participant, the werewolf, is the dominant *Actor*, then an interesting question, in terms of the transformation, is who functions as what Kress and Van Leeuwen (using the terminology of functional grammar) call the *Goal*—who's on the receiving end? The verbs make it clear that Ben perceives three Goals. One of them is the werewolf himself. That he is simultaneously the actor and the goal, the monster and the victim, is registered in the implied reflexivity of the verbs in the first few sentences: 'the man is in the final stages of turning [himself] into a wolf. He has developed [in himself] his muzzle and teeth and all that remains is for him to get his fur.' Here, as in what's often been noted in the imagery of divided identity in the horror film (Jancovich, 1992; Clover, 1993), the monster is literally divided against himself. That he appears as victim in the affective structures of the sequence is all too plain in Ben's commentary in a sentence which makes an affective articulation of the three victims of the horror—the monster, the woman in the sequence, and the viewer:

> This image is particularly gory because the monster (almost wolf) is obviously in quite a lot of pain and as the lady keeps screaming and the music is becoming quite intense it is quite distressing [to the viewer].

As this sentence indicates, the other Goals of the transformation process are the woman (not in this image, but in other parts of the sequence which Ben is obliged to describe to make sense of the threat of the creature) and the viewer, whose position is of central concern in Ben's piece.

The threat offered to the viewer is clearly crucial to the appeal of horror films, depending for their emotional impact on a masochistic audience-text relation, as Carol Clover argues (1993), in which the viewer is typically identified with victim rather than monster.[4] This image is clearly offering such a threat, snarling from the screen directly at the viewer. Does Ben register this kind of response?

He has chosen an image that addresses the viewer in a particularly direct way. Kress and van Leeuwen describe this kind of image act as a 'demand' which establishes a specific relation between two participants in the semiotic exchange:

the represented participant on the screen and the interactive participant who is the viewer:

> ...the participant's gaze...demands something from the viewer, demands that the viewer enter into some kind of imaginary relation with him or her. (1996: 26)

So we might see this image as demanding a particular service from the viewer, in fact, exercising the dominant imperative of the horror genre, encapsulated in the memorable catchphrase of modern horror in David Cronenberg's remake of *The Fly* (1986), when one potential victim commands another: 'Be afraid. Be very afraid'.[5] Ben has registered this text-audience relation in his commentary. To begin with, he observes the nature of the 'demand' image quite explicitly:

> As the monster is looking almost straight at the viewer it gives the viewer the feeling that the beast is looking at them personally!

Here Ben conceives of the viewer in the third person, as if he is describing the process by which the ideal viewer, the general audience the film is addressing, becomes the actual individual spectator—as indeed it does in the next sentence, where the third person viewer gives way to the first person Ben:

> I really felt that the 'thing' was looking straight at me.

As if to complete the trinity of persons, the next sentence positions the viewer in the second person:

> This image has great significance on the film because you can suddenly believe that it is possible for a man to transform into a wolf in a few seconds.

This shifting of pronouns which represent the viewer goes on through the rest of the piece, suggesting the multiplicity of positions Ben can, and does, take up—as an individual, positioned against his knowledge of this text and others like it; as a member of a class who have shared their responses to some idea; as a pupil, discussing his response with a teacher-reader; as a member of a viewing public who might choose horror films. So we get:

> I didn't know how the makers of the film would cope with the transformation
> scenes
> You can tell that this wolf is out for the kill
> you think of it as being evil
> I think it makes her seem innocent

> When we watched the film I was not aware of thinking this but I am sure that the whole class were unconsciously aware of this.

These lexicogrammatical choices, the nouns and pronouns which represent audience-text relations in Ben's writing, demonstrate the irreducibly social nature of this textual engagement. This aspect of his engagement with the text depends on a social viewing, made up of a diverse group of peers in the classroom, in a context caught between their own cultural affiliations and the educational project of the school. It also recognises, even constructs, a more abstract ideal viewer, who belongs to that aspect of the commentary closer to the abstract levels of critical analysis promoted by the school context.

It looks, then, from this analysis of Ben's work as if the grammar of the still image is everywhere informed by that of the moving sequence; though the text is not read as it presumably is at the moment of viewing. This is a rereading, a transformation; the digital freezing of the image allows for an anatomy of the elements of the frame. There's a sense in which Barthes' disobedient attitude to narrative time fits. Certainly, the 'realtime' of the film is suspended, and the diachronic sequence is undone in the digital unstitching of the film's sequence, and the abstraction of a series of frames, of which this is one. The strict temporality of the viewing is replaced by a different temporality, that of the interpretive performance, recasting the film narrative in the dominant present tense of exegesis, freezing the image for anatomical investigation.

Does he make any comment on the particular power of the synchronic syntagm? The meanings tied up in his choice, the pleasure presumably contained in the scene—these unspoken meanings will be those described by Hodge and Kress (1988) as the aspects of the synchronic syntagm peculiarly resistant to decoding. Ben has clearly opted for the most powerful image of the body-horror paradigm that Jordan borrows from the popular horror tradition, characterized by excess and a refusal of the sublimated aesthetic that Philip Brophy, in a condemnation of the body-horror of Cronenberg and others, describes approvingly as 'the Hitchcock debt' (1986). Ben's recognition of the power of this image is registered in the affective binding of spectator to image act, and in the diversity of his rendering in language of the werewolf paradigm. His lexicogrammatical choices also locate the act of viewing in specific social and cultural circumstances, reflecting the ideal viewer of the quasi-academic textual analysis as well as the actual spectators: the diverse group of peers watching the film with him.

PART FOR WHOLE: SYNCHRONIC SYNTAGMS 2

My second question was about the still image as a condensation of the film, a metonymic substitution for whole sequences, important themes, even the whole film.

We might borrow from Eisenstein's account a view of montage, not only as the compositional process of juxtaposing and superimposing images but also as the process by which a reader makes their own reading of the text by appropriating key images, reordering and restructuring them to produce their own remembered version of the film.

Barthes approaches the problem the other way round, describing the still as '…the fragment of a second text whose existence never exceeds the fragment', suggesting that film and still are in a palimpsest relationship, '…without it being possible to say that one is on top of the other or that one is extracted from the other.' (1978: 332)

He seems to be suggesting that each still, and the process of selecting it, provides the reader in question with one of an infinite number of texts, dependent in some ways on the whole, in other ways independent, always a new text, condensed into the still, able, presumably, to be released into conscious thought by explication.

Gemma and Ellie, two 13-year-old students, have digitised three images. The first shows the heroine, Rosaleen, asleep in her bedroom at the start of the film. She's a contemporary heroine, wrapped like an envelope around Angela Carter's original story, providing a new narrative frame, as it's her dream that contains the story of *The Company of Wolves*.

Their second image is of the werewolf-hunter, as he meets Rosaleen in the wood on the way to her grandmother's.

Their third is of the wolf that once was Rosaleen, after a transformation that she has invited, even controlled, in order to gain access to the world of adult sexuality that the werewolves appear to represent.

In a sense this selection is their own condensation of the entire film, bound up with the consciousness of the character they're interested in. They have chosen images that concentrate on the girl. The first positions her, as it were, in the first person, dreaming the story. The second locates her in the second person, addressed by the hunter, imagined as the reverse of the shot. The third, in the third person, makes her the object of the action, object of the werewolf transformation, object of the attack with a gun from her father who doesn't recognise her, saved by her mother who does, alerted by the cross around her neck.

The reading of the film represented by such a selection highlights the fairytale element, the point-of-view of the contemporary teenage girl, and the deeply

ambiguous role of the girl protagonist in relation to the monster/victim axis of modern horror movies. Several commentators, including Stephen King himself (1982), have noted how, in films from the late seventies onwards (with Brian de Palma's film version of King's *Carrie* (1976) as a landmark, perhaps) female characters have occupied victim roles much more ambiguously, with such roles blurring into traditionally male hero functions, or into the role of the monster, or sometimes (again, Carrie is the classic example), all three.

So their condensed image of the film reads it as a film about a girl growing up, predominantly; the spectacular horror of the werewolf transformation scenes is marginalised. Ben's reading, on the other hand, places the film closer to contemporary body horror, selecting the most replete image of horror, foregrounding the images closest to popular horror, furthest from the art-house style of much of the fantasy.

All of this, it seems to me, is a detailed and explicit reading of those features of the visual text that would be noted first by the reader in a much more condensed way, perhaps unconsciously, or more accurately *preconsciously*, to use Freud's distinction (1915) between the repressed unconscious and that which is waiting to become conscious. So we might envisage this reading of the film which uses a still image supported by a written commentary, as a kind of triple movement: first, the reader recollects the image mentally; then she finds it, and fixes it (though this process, involving the often long and complex business of fast forward, rewind and freezeframe before the digitiser is even brought into play, has its own narrative of textual engagement), thereby condensing an understanding of an aspect of the film into one synchronic syntagm which metonymically represents, in this case, the protagonist/narrator. Thirdly, the condensation effect is reversed, as they unpack the meanings of the image, resituating it in their own version of the narrative syntagm, and elaborating the elements of the image and their significance in both synchronic and diachronic dimensions. All of this, it's important to reiterate, takes place in specifically social contexts. I have described elsewhere (Burn, 1996) how the engagement with the film text can begin with gestures and facial expressions by viewers, oriented on the one hand towards the fictional characters on screen, setting up patterns of proximity and identification; and on the other hand towards other viewers, again establishing proximity and shared experience of the text; or distance and disputed interpretations.

The digital production, then, of still frames and a detailed commentary on them, is not dissimilar from what viewers do informally—retain key images, reorder them mentally, discuss them with friends ('What about the bit where...?'). So the classroom operates as an amplification, a rehearsal, an explication, a bringing into consciousness, of processes that happen in the social context outside the classroom anyway. The 'very easily learned skills' Williams (1981: 189) described

are being adopted and extended, with the advent of digital technologies and their emphasis on newly accessible forms of production, by the institutions of training and education.

SOCIAL USES: STILLS AS TEMPTATION AND QUOTATION

Barthes' notes on the cinematic still begin with some speculations about its fascination, rooted, as so often with Barthes, in his own behaviour. In this quite personal account, he evokes the part that stills play in the small social history that is the individual's experience of a film. All parts of this social history are important, as is recognised by later cultural theory, especially in the Cultural Studies tradition—so the fact that Barthes describes himself looking at stills in the pages of *Cahiers du Cinema*, or outside a cinema, immediately affects the kinds of meanings that might be made from such images as opposed to, say, images of Will Smith, Sigourney Weaver, or John Travolta on the walls of a Blockbuster video store.

The pleasures evoked here are the pleasures of particular individual tastes, socially formed, acceded to, contested or transformed. As Bourdieu describes (1984), they may have their roots in formations of social class, in traditions of elite or popular taste, but they are at least modifiable. In any case, the immediate or gradual recognition that 'this will be a film I'll enjoy' begins here.

So the still image offers a pre-reading of the film, to the viewer who lingers outside the cinema, or browses though a film guide, or reads the previews in the TV magazines. No control over the material production of the still here—it is firmly locked within the institutional practices of the media. But the powerful play of audience pleasures, choices, and generic expertise has started, as spectators make the dialogic connections between these pre-spectatorial images and the after-images in their minds of related texts they have viewed in the past.

Barthes also recognises that the still is a kind of quotation. This use, related to the academy as well as to the marketing and publicity mechanisms of the film industry, marks the movement from spontaneous to scientific understandings of media texts, to use Vygotsky's terms. To this extent, students use the still as a quotation, in what's often a self-consciously expository text in quasi-academic mode. Unlike Barthes, however—indeed, unlike a good deal of academic commentary on film—they have chosen their own exact images, rather than relying on stills libraries, which in turn rely on the processes of selection involved in the work of the stills photographer, producing photographs which may not even be frames from the film, at least in their traditional form.

Gemma and Ellie's commentary, though far from a traditional expository essay, makes the nature of textuality its explicit theme, and thus its partial motive

for the selection of the images. In their piece, there are the vocabularies and structures of quasi-academic discourse:

> ...it is symbolic of her...
> ...panning around her face...
> ...closeup of each of her toys...
> ...it gives the indication that...

But there are other voices in their piece, voices of popular, informal comment and judgement, suggesting other motivations for the selection of the images:

> ...she was new at putting makeup on...
> ...the hunky hunter which has now turned into a wolf.
> ...Her granny told her to stay away from men whose eyebrows join but she didn't pay
> any attention to what she said but is totally blown over by him and his charms.
> ...You can tell from the beginning that he is a slimy prat who just wants to eat her,
> the silly thing is that she totally falls head over heals [sic] about him.

Such a hybrid discourse signals a corresponding mixture of social intentions, what Mikhail Bakhtin calls 'the speech will', determining the 'compositional and stylistic features' (1952–3) of the utterance. They're simultaneously addressing a peer, as in an informal discussion of the film, peppered with indignation and concrete social detail; and a teacher, or academic system, and its expectations of formality. Speakers and writers, especially schoolchildren, are much more likely to have a mixture of motives than some kind of pure or authentic intention, and their speech and writing is bound to polyphonically suggest this. Teachers need to help them clarify their intentions, and find the representational resources to carry them out. If that makes for hybrid and contradictory discourses, we need to live with these, at least provisionally, without becoming censorious, which would only drive the contradictions underground. Bakhtin's view of language expresses just this tolerance of contradiction:

> Such is the fleeting language of a day, of an epoch, a social group, a genre, a school
> and so forth. It is possible to give a concrete and detailed analysis of any utterance,
> once having exposed it as a contradiction-ridden, tension-filled unity of two embat-
> tled tendencies in the life of language. (1981: 271)

Like Barthes, then, Gemma and Ellie's use of the stills is partly rooted in personal pleasures, and partly in a development from these into a more formal process of interpretation and enquiry. For these girls, as for all of the students in this study, both these pleasures and this growing process of interpretation are located in the process of searching and digitising, the older technologies of film editing and

exhibition now converging on the computer screen. An interview with one pair of boys as they search for the images they want shows clearly both how the search grows out of a clear series of 'mental stills' already in Graeme's mind; and also how far the process of interpretation has already come, even before the image is found:

> Graeme: And, um, the images we're looking for right now is one from the third transformation scene where a wolf comes out from the mouth of the werewolf, and, um, sort of symbolising that the wolf is inside the person, and, er, I think we're looking for—right when the wolf's nose is sticking out of his mouth.

Another pair of boys are searching for an image in *Aliens* (Cameron, 1986) of a victim of the creature stuck to a wall, about to be ruptured by the alien inside her, begging to be killed. One of the boys, a student with extensive specific literacy problems, explains that he wants this image, remembered from home viewing of *Aliens*, because the image of the monster erupting from inside the person is 'like the *Company of Wolves*—they all come from inside the person'.

The social spaces in school all play a part in the constructions of meaning and the subjectivities involved in these acts of semiosis. The darkened classroom with the bright screen, a hybrid spectatorial space, with something of the reverential hush of the concert-hall, something of the noise and interactivity of the multiplex, something of the formality of the public sphere, something of the closeness of the domestic. The groups of pupils round computer screens; who gets to operate the mouse; how the decision is reached about which frame to grab. The public nature of the electronic page; the social decision-making about design, information, what looks good. These contexts help determine the contingency of these teenage engagements with film. And they are the ambiguous, borderline spaces in which Gemma and Ellie use the still as visual quotation, poised between the analytical repertoires of formal education and the pleasures of popular fiction and film.

TRAILER-MAKING: TECHNOLOGIES OF THE STILL AND MOVING IMAGE

Gemma and Ellie, with another friend, Alex, go on to make a trailer of *The Company of Wolves*, which takes their use of the still a stage further. Although they use an analogue editing suite, this particular work employs digital effects produced in real time by a vision mixer. The trailer makes extensive use of the digital still function and the dissolve function of the vision mixer—they dissolve very slowly, lingering on superimpositions of one shot on another. Their first sequence consists

of two digital stills, showing two closeups of female characters: Rosaleen's dead sister, and the grandmother.

These have been mixed with, respectively, a scene of wolves running through the forest, and the first werewolf transformation scene. The mix makes the images of the female characters a little more 'solid' than the moving scenes, which, in addition to the fact that they are closeups, makes these images stronger in the whole composition, an example of the salience used by Kress and van Leeuwen (1996) to denote relative weightings of elements of visual composition. This reordering of and selection from the film text not only creates a new montage, then, but a new synchronic syntagm, which depends for its meaning on the articulation of two images related by another kind of 'vertical montage', one which constructs the impression of an image laid on top of another. The selection of the female characters, followed by another still of Rosaleen's face, seems, in the light of the work of these girls, as well as the discussions of the representation of women in the film, to signify their recognition of the importance of these related female roles: victim/sister; narrator/wise woman; strong heroine and dreaming narrator. It makes explicit the narrative envelope of the film, and foregrounds the representation of teenage female identity that, for these viewers, is at the centre of the text and their engagement with it, and now, their literal remaking of it.

CONCLUSION: DIGITAL COTTAGE INDUSTRIES OF THE FUTURE[6]

I have argued that the use of images digitally abstracted from film (at least in this particular educational context) can usefully be seen in relation to the cultural history of the cinematic still. Isolating film frames as a kind of secondary production for purposes of marketing and academic commentary also involves a history of social and cultural practices to do with the preview and review of film, practices with their counterparts in the minds and social exchanges of spectators.

The new ability to digitally undo and reconstruct still and moving image (and audio) enables the students I have described to become writers as well as readers of the visual—indeed, these settled distinctions begin to unravel. The literacies of the visual semiotic they have acquired become extended in the digital manipulation of image and moving image, and in the transcoding of image to word and back again, in group discussion and written commentary. The mental act of spectating becomes concrete in the digital frame and sequence; the plasticity and provisionality of the digital timeline begin to measure up to the ultimate plasticity of the mental image act. The computer screen, the magnetic centre of excited discussion and group production, has replaced the projection apparatus of seventies

Screen theory's metaphors of the spectatorial act—and in this new screen, the acts of unmaking, making and projection of film now converge. The large-scale industrial processes of film shrink to the digital cottage industry in which these students make small, local understandings of film but also connect to global understandings, downloading movie posters, information, film reviews from the internet. The slow, incremental transformation of subjectivity involved in engagement with film finds new pleasures and powers in the anatomisation and reconstitution of image, always gesturing backwards to the cultural histories of film condensation—the still and the trailer—as well as forwards to a future where these forms of production, as Williams predicted, are themselves widely distributed. The tools of digital inscription are becoming, as Sefton-Green has suggested (1999: 29), the new writing, with the possibility of democratised access to complex forms of media production.

How we move forward with this in schools and colleges is still unclear. The skills needed can clearly be taught. We need to recognise, though, that there are still informally-acquired skills of production, and that if anything, these will grow as software designers create increasingly intuitive programs, improving the extent to which visual interfaces provide accurate metaphors for mental processes. At the same time, a cultural theory is needed which describes how communicative practices rooted in popular media will always require complexly-negotiated dialogue between domains of work, home and leisure, and a new language of understanding and analysis, perhaps analogous to grammars of the word. We seem to have arrived at an extended version of Williams' historic moment of 1981, 'when the relations between communications technologies and social institutions are a matter not only for study and analysis, but for a wide set of practical choices.' (Williams, 1981: 192).

Digi-Teens: Media Literacies AND Digital Technologies IN THE Secondary Classroom

The digital revolution evokes a number of questions for those of us concerned with literacy, with communication, with rhetorical repertoires, and with the place of young people in such social processes. Like other technological revolutions in the field of communication, it isn't surprising that this massive and accelerating change should attract comment, initially, on the nature of the technology itself. Stephen Heath wrote at the end of the 1970s about the way in which, 'in the first moments of the history of cinema, it is the technology which provides the immediate interest: what is promoted and sold is the experience of the machine, the apparatus' (1980: 1–2). His warning—applicable as much to the digital revolution as to that other modern upsurge in the visual semiotic, cinema—is that technology does not somehow precede the social, but that the technical and social interact.

So one set of questions we will need to address will be those to do with how digital technologies change the nature of literacy, and literacy as a social practice— how they alter acts of textual reception and production, how they colour or transform the cultures in which these acts take place, how they transform the social spaces in which meanings are made and exchanged. Gunther Kress and Theo Van Leeuwen (1996) make a powerful plea that schools should expand their notion of literacy to accommodate visual communication and digital technologies:

> If schools are to equip students adequately for the new semiotic order...then the old boundaries between 'writing' on the one hand,...and, on the other hand, the 'visual'

arts…should be redrawn. This will have to involve modern computer technology, central as it is to the new semiotic landscape. But, above all, it is crucially dependent on having the means of analysis, the means for talking about the 'new literacy', about what it is we do when we read and produce images. (16)

These forms of analysis, the new metalanguages needed to talk about this expanded literacy, raise questions we need urgently to address.

This chapter will explore one project with 16-year-olds from 1999—a GCSE Media Studies coursework assignment in which four girls make a trailer for a millennium re-release of Hitchcock's *Psycho* (1960). The kinds of questions it will pose are partly to do with the 'languages' of visual communication and the moving image, partly to do with the pleasures and subjective investments made by pupils in such processes, and partly to do with the social and cultural contexts which frame and determine the meanings that can be made with these new technologies.

PSYCHO: THE MOTHER OF ALL HORROR FILMS!

This trailer course was set up as a way for students to use digital editing equipment to unpick the audiovisual fabric of films of their choice; to explore those sequences that had a powerful pull for them, and to reconstruct a new text which reflected their understandings of the film, and also of the processes of marketing and distribution, working delicately on sound and image to turn understanding into production.

Some students went immediately for their favourite film; others thought more carefully about how their choice of film would enable them to pitch their work for different audiences, a requirement of the coursework. This was certainly the case for Abby, Lorraine, Gwen and Holly, who chose a film that they had not all seen before, that was 'old' by their own standards, and where the re-release was actually a possibility. On the back of the *Psycho* remake of the previous year, the 30-year anniversary of the original, and the interest at the time in Hitchcock's centenary, *Psycho* seemed a good choice.

They needed to be very clear about what they had to look for. They needed to appreciate the film as a whole, consider its place within the horror genre. They needed to show in their trailer an awareness of its cult status and to recognise the needs of the young, new audience of which they were a part. This latter process would involve their own viewing history, of which part is the legacy of *Psycho*— *Halloween* (Carpenter, 1978), *The Silence of the Lambs* (Demme, 1991), the *Scream* series (Craven, 1984).

Their use of non-linear digital video editing software (a professional package called Media 100) confirmed a number of benefits we have found with earlier

projects, benefits not to be found in the analogue systems we used previously. Because strips of digital video can be stored in bins and trimmed to fit the desired sequence, the early stages of selection, ordering, constructing a sequence or montage (both audio and visual) can be much more ambitious. Because final decisions can be postponed indefinitely, students can hold a wide range of possibilities together provisionally, and can then revise, delete and insert, try out different audio tracks, try out different kinds of transition between shots. For this group, making a trailer of *Psycho* was driven by a combination of ordering frameworks. In their written evaluations, they have presented this as a rational, coherent process, largely to do with narrative structures. Holly, for instance, mentions two kinds of narrative decision the group made, for their shorter 'teaser' trailer. The first is a kind of anti-narrative of the genre:

> We decided that we did not want to show any of the film's real narrative in any linear form, but instead to use unconnected shots of stabbings and bodies in fast sequence. To keep the pace going we had to cut to black screens after many of the shots; otherwise we found that the various unconnected shots suggested a confusing narrative to the audience.

The point about the digital format is that they could set up this sequence and try it out, which would have been, if not impossible, at least very time-consuming with an analogue system. In fact, they then changed their minds:

> We then decided that this was not the best way to portray the film, even to a younger audience, as it made the film look old-fashioned and slightly confusing. So, we set up a very simple narrative so that shots linked together more.

For the main trailer, they made, again, a different narrative decision:

> In our main trailer, we decided to convey more of the narrative to both of the target audiences by building up the thriller element of the film, alongside the horror element....we re-structured the trailer on our timeline so that it was segmented, starting with an exposition of the narrative, in which shots of Janet Leigh travelling to the Bates motel, along with shots of Anthony Perkins giving her the key were shown.

Reading Holly's evaluation gives a clear idea of how the digital format allows the group to explore complex ideas about narrative as they work. Rather than a series of separate exercises, as this would be using an analogue set-up (taping from one VCR to another), in fact it works as a series of transformations of overlapping texts: they're using the same clips stored in their digital bin of material from the film; they're copying and pasting certain effects; they're making provisional decisions

to see what they look like, then discarding them. In doing this, they are able to explore and analyse, through processes of production, the Hitchcock narrative aesthetic, which Holly refers to later in her evaluation:

> In fact, the whole way through the trailer we set up a misleading narrative that focuses on the mother being the killer. We did this for two reasons. Firstly we wanted to show the audience scenes of the murders, and this is very hard to do without showing them the murderer. Then we thought we could follow Hitchcock's tradition of misleading the audience, by making them think they knew who the killer was so that the denouement would be even more surprising.

In an interview with the group as they complete the trailer, they discuss Hitchcock's suspense aesthetic, revealing an interest in the idea of frightening audiences by withholding the frightening image rather than revealing it.

> Holly: Thing is, the suggestion of it, 'cos it's so much more suggestive than if you saw the whole thing—it's the same when you look through the holes—that's why it's remembered— 'cos it was—it was a really shocking film.

They go on to talk about why the film is still frightening, and again the withholding of the horrific image comes up:

> Lorraine: The fact is, for our generation, it's not, you know, the most terrifying thing, some of the things that are out at the moment—
> Gwen: It's not as graphic—
> Abby: It is, though—you know the shower scene—doesn't it, like, make you flinch, although it's not [indecipherable] you actually see the knife going, so . . .

This engagement with the Hitchcock aesthetic seems quite ambivalent, and their trailer betrays, as Holly has indicated, a tension between narrative suspense and a withholding of the terrifying image and a desire to display it in all its glory. This ambivalence is, perhaps, not very surprising. Hitchcock's classic suspense structures arguably rest on a dialectic between concealment of the terrifying image (such as the silhouette, or the partially revealed injury) and shocking revelation of it (the closeups of the knife, or of Marion Crane's dead eye). A little analysis reveals that such a dialectic is just as much a feature of more recent popular horror, often perceived to be the polar opposite of Hitchcock.[1] Such distinctions, to use Bourdieu's entirely relevant term here (1984), are more a question of socially constructed aesthetic preferences or tastes—and it is precisely this kind of network of contradictory cultural loyalties that these girls are working out for themselves here. The girls go on to discuss other films they have watched and enjoyed, including Wes Craven's *Scream* sequence, films based on Stephen King stories (*It, The Tommyknockers*), the

Nightmare on Elm Street sequence (Craven, 1984), and the newly re-released *Exorcist*, (Friedkin, 1976) which Gwen had just seen. Holly describes how she and Gwen used to get horror videos out every weekend and terrify themselves with them. They make the point that sometimes in these films the frightening thing is not so much explicit images of horror as suggestive, tantalisingly empty images: they mention the blue light of the TV screen in *Poltergeist* (Hooper, 1982) and a 'really scary' green light in *The Tommyknockers* (Power, 1993).

The point here, however, is that they stand a much better chance of understanding the narrative effects of partially concealing horrific events and images if they can experiment with them, as the digital equipment allows them to do. The play of semiotic structures of concealment and revelation is worked out through the audiovisual text of their trailer, and through the metalinguistic understanding revealed in their commentary, as in Holly's observation here:

> We opened this sequence with the drawing back of the shower curtain in the shower scene. We felt that metaphorically this shot worked well as it drew back the curtain of the narrative we had previously set up and brought the viewer face to face with murder.

The written evaluation, however, reveals only part of the story. Its neat, rational flavour is testament more to the forms of understanding the girls are arriving at than the messier process of the journey—the editing. The interview shows that, though they had talked through narrative ideas, these quickly became inadequate and abstract when faced with the actual raw material of the film:

AB: How did you actually choose the clips?
Holly: Well basically when we first started off we—we were really unsure about what we wanted so we basically digitised like half the film—all the key images, all the horrifying bits, we digitised the shower scene, and—Abby—too key— they were so key that we didn't have any little bits so we had to go back and re-digitise them.

It looks from these remarks as though they began by selecting powerful images that represented for them a condensed version of the film. These seem to be what has been described in social semiotic theory (see Hodge and Tripp, 1986; Kress and Van Leeuwen, 1996) as *synchronic syntagms*—particularly powerful images carrying potent ideological meanings, apprehended as if instantaneously by the viewer, and used, selectively, to construct that particular viewer's 'take' on the text. Again, the tension between the suspense aesthetic and the pleasures of explicit horror are there: Holly mentions 'all the horrifying bits', but we've seen how they modify and structure these into the play between concealment and revelation, horror and suspense, that they eventually arrive at.

Abby's remark about how the clips were 'too key', and how they needed to go back and find 'little bits' suggests a feature of the visual text that works like a kind of grammar. Perhaps she is referring to those parts of the narrative that Barthes describes as *catalysers*, which fill in the narrative space between the more spectacular sequences he calls *cardinal functions*, or hingepoints of the narrative (Barthes, 1978). These parts of the narrative cannot be deleted without cost, Barthes warns: catalysers have important functions:

> in the final analysis, the catalyser has a constant function which is, to use Jakobson's term, a phatic one: it maintains the contact between narrator and addressee. A nucleus cannot be deleted without altering the story, but neither can a catalyst without altering the discourse. (95)

Abby has recognised that simply stringing together the 'key images'—the synchronic syntagms—will produce too condensed a montage, without the grammatical fullness to suggest a coherent narrative, or to address the audience clearly.

They knew they were looking for moments in the film which were not necessarily the 'peak' moments in the film's narrative (Barthes' cardinal functions), but also more subtle 'trough' moments that were going to be necessary material for the trailer (the catalysers). An example was their use of a shot of Marion driving, looking straight into the camera.[2] They rejected a part of this sequence where her boss stands in front of the car with the possibility of stopping her—they recognise the need for sequences which are not hingepoints of the action but exercise what Barthes calls the logical and chronological function of catalysers—they show consequences and sustain the temporal flow of the narrative.

Their viewing of the film showed a powerful intuitive understanding of this visual grammar, and an instinct for important moments or sounds. There was a sudden rustling of paper, a frantic noting down of the video timer's clock. It became clear, during these moments, that there was some kind of mutual recognition and understanding going on. They instinctively knew what were key moments—not always to the film as a whole, but to their future trailer. We realised that they were bringing more knowledge and intuitive understanding of trailers to this project than we had given them credit for.

Some kind of literacy process is at work here, in the process of selection, rooted specifically in the visual semiotic; though the audio component of film as a multimodal text becomes important later in the girls' composition of their trailer. We asked the group explicitly what they thought about the idea that editing might be a literacy—like reading and writing. Something of an argument developed between Holly and Abby, in which Holly saw the creation of a visual text as being largely about structure, which could be visualised, planned and then executed.

Abby thought it was more to do with experimentation, actually working with the material images:

> Holly: …you have to structure in the same way as writing, if you're a natural, if you're good at structuring, then it's, it's OK, but you have to use a different kind of—you have to use your other senses.
>
> Abby: No but the problem with that is—the structures [indec.] in theory, yeah, in theory shots that were gonna look really good and it looks like, and you put them on there and they just look really random, and they didn't make sense…

And later, after Holly has suggested that storyboarding might be useful, Abby disagrees:

> Abby: I don't think we'd have had—I don't think we would have had this idea on a storyboard—it really helped to see what went wrong.
>
> Lorraine: Yeah that was it—we started and got stuck in this rut and we had just one shot and we couldn't get any further than that, I mean we were just sitting there and getting really frustrated, just like 'Oh we're never going to finish this and another [indec.]
>
> Abby: The pace was too slow.

Abby makes two revealing remarks here. The first, that 'it really helped to see what went wrong', underlines the crucial gift of digital media, their provisionality and plasticity, allowing for real redrafting, reconsidering, continual remaking, experimentation, shaping, polishing. The second—'The pace was too slow'— makes the important point that, if there is an analogy with language here, it is partly, as Holly recognises, about working in a visual medium; but it is also about working in a time-based visual medium, and it is this feature of visual rhetoric, shared with speech but not with writing, that the storyboard, a more writing-like form, is least well-equipped to help with. They needed to see the moving sequence on screen before they realised that the pace was wrong. They wanted to give a sense of the genre, and indicate a 'whodunnit' kind of narrative, but they really wanted to give a sense to the audience of the emotional impact of the film. They wanted to create a fast, exciting pace, and recognised that fast cutting was necessary to achieve this. They wanted to use shots where the camera movement or movement of the participants themselves, had pace. Only when the shots were down on the timeline were they really able to experiment with pace. They trimmed shots quite precisely, in particular, and noticed that this immediately gave them pace when placed in sequence. They were very excited when they were shown a cross-zoom transition, realising that this again, was a perfect way to create some pace 'in 3D type way' as the images seemed to jump out of the screen at the audience, then back again.

Another important element in the visual sequence of the trailer was the use of black screens with red text. Abby describes these in her evaluation:

> Another successful technique we used to provoke interest or emotion from our target audience was to use text screens bearing captions, as these effectively catch the attention of the audience, who are almost forced to read them. In a sense, these separated different parts of the trailer. The first one, 'WATCH OUT!' (placed after Norman hands the keys over to Marion) was designed to put the audience in suspense and obviously hints that Marion will not be safe, whilst not giving too much away. The second, 'SHE'S BACK!' was placed after Norman tells Marion his mother is "not quite herself" to lead into the horror sequence (a sudden jump from the calmer narrative to fast-moving horror scenes would have looked un-natural and unprofessional) and to arouse the suspicions of the audience, who are likely to guess that 'mother' is the killer. . . . The third caption, 'THE MOTHER OF ALL HORROR FILMS' is a clever play on words for anyone who has already seen the film and was placed at the end to draw a close to the action and tell the audience about the film. These captions worked well as once we had created them and inserted them into our programme we could adjust the length of time they were on screen by lengthening or shortening the block which represented them, so that they fitted the pace of the trailer and were shown for a readable amount of time.

It is clear that these captions are important structuring devices in themselves; that they serve the purpose of Barthes' catalysers in helping construct the relationship between narrator and audience (or, in this case, two audiences); and that their digital nature, again, allows for a sophisticated operation of the time-based aspect of this medium.

The wider socio-cultural context from which all their work derives its meaning is also apparent. Abby notes that the captions are 'in black, to suggest blood and danger (connoting horror). . . The bold red colour also adds a modern element to the trailer, helping to attract the younger section of our target audience'. The bridge between *Psycho* and more recent popular horror which the girls are consciously constructing is also suggested by the wording of their captions, which recalls the numerous reappearances of the mother alien in *Aliens* (Cameron, 1986).

The timeline they have constructed using the Media 100 software gives a visual impression of their trailer (Figure 3.1). This is Abby's timeline, annotated for her evaluation. Her notes show a detailed understanding of the digital medium, as well as the semiotic intentions of the group's decisions, relating to structure, pace (use of 50% slow motion), transitions (cross-zoom between titles), and, especially, the importance of the audio tracks.

The timeline makes visually clear how non-linear editing, as well as making possible operations that were previously difficult or impossible, also restores something of the material composition of classic film editing. In particular, the

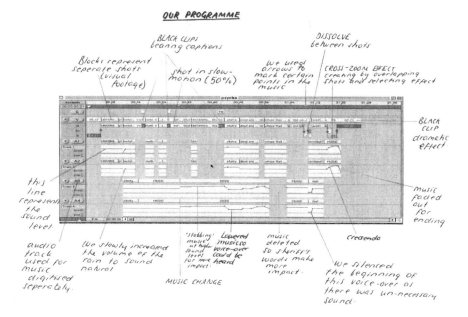

Figure 3.1 Abby's timeline from the Media 100 screen, showing the visual edit at the top and the audio edit at the bottom, and Abby's annotations.

layering of the visual track over the audiotrack evokes Eisenstein's notion of vertical montage (1968), the articulation, at right-angles to the horizontal sequence of the film, so to speak, of image and sound. The timeline shows how they have used two contrasting music tracks from the CD of the film music, which Abby and Holly describe in the interview:

> Abby: We used two different ones, we used one at the beginning, then we changed it for the stabbing, ju-ju-ju! [imitates the stabbing strings music].
>
> Holly: Yeah, we used the Prelude, which is like—doo-doo-doo-doo [sings rising sequence], and then we used—
>
> Abby: Then we brought that back on at the end, 'cos we thought it was epic, didn't we?

The timeline, which represents all of these decisions, is obviously a feature of digital video editing which makes the whole process more transparent. Analogue editing presents no visual representation of the process—pupils can only imagine what is happening as they tape from machine to machine, or feed in an external audio source to a vision mixer. On the Media 100 screen, all these processes are clearly visible. Though some of them are transparent enough, they needed, like any graphic representation, to be taught as well. In this project, we chose to demonstrate

how the timeline worked visually on the white board first, drawing small thin strips on the board to indicate the visual 'line' of shots edited together. With the marker and cloth, it was easy to show them how quick it was to change a decision—to rub out one shot and replace it with another. They grasped this quickly. Another layer below the visual line already on the board represented the audio line. Because it was on a separate though parallel line, it was possible to rub out parts or move them along the line, without changing the visual line above. Again, they grasped this quite quickly. With this principle in their minds, they were able to then look at the computer screen and recognise the same concept. Instead of wiping things out on the white board, the use of the mouse was demonstrated. They were visibly excited and motivated by the speed and efficiency of the software.

It is clearly the intention, in some sense, of the software designer to represent the mental processes of editing. We put this to the group to see what they might think of the idea, and how successful the design of the interface of the program was:

Abby: Well I've never understood those letters and what those arrows mean and all that.... But it really is so good to have chosen the titles.

Holly: 'Cos you do put things in layers [indec.]

Abby: —perfect—

Lorraine: It's so clear—

Holly: It's so simple to use—

Abby: —and the different colours—

Holly: Yeah, the colours help, the fact that you can have titles on them, the fact that you can shift things around when they're actually on the film.

Abby: And even things like [indec.] a really visual-based easy way of showing how it goes up and down—you haven't got like—

AB: What's that? The volume line.

Abby: —rather than like numbers or something, the way it just is a line—easy to use.

Lorraine: It's set out in a really clear way—you can look at it—you don't look at it and go 'Oh what's that', when you can think—visual.

AB: So you do imagine it like that in your head?

All: Yeah—yeah I do—definitely.

Gwen: You know—block—blocks—it's also that we've been taught to realise that—that the music and—the trailers and on other stuff—the music and the—thing don't—the visual—don't just come together...

It looks as though, while some features of the design are less transparent (some of these, the arrows Abby mentions, are actually about 'unlocking' more complex editing functions which the basic display leaves hidden), much of the visual representation seems transparent to them. In some ways, then, the screen does

function as a metaphor of the editing process, giving iconic form to the mental acts of sequencing, and, in Holly's term, 'layering'.

Gwen's last point, that they've been 'taught to realise…that the music and the…visual…don't just come together' raises the question of pedagogy. Buckingham, Grahame and Sefton-Green (1995) make the important point that a historical problem in Media Studies has often been a split between theory and practice, leading to 'a replication of the teacher's discourse, a matter of artfully mobilising academic terminology for the purposes of assessment'. They argue that we need to discover 'ways of ensuring an equal and dialectical relationship between theory and practice', and that practical production can open up a social space which allows for exploration of media texts which is much more subjective and playful than the kind of formal analysis often required by exam syllabuses.

While an artificial discourse recycling received ideas is worse than useless, it may be possible to develop the position presented by Buckingham et al. This study suggests four points. Firstly, the evidence here suggests that this group of girls have succeeded in combining important concepts like genre, narrative and audience with processes of digital production, working through these abstract ideas in material form, and, at the same time, appropriating them, internalising them, making them subject to their own textual decisions. This, perhaps, moves some way towards the kind of integration of theory and practice Buckingham et al. argue for.

Secondly, it may be useful to extend our ideas about the nature of 'theory'. As Buckingham et al. argue, it is damaging for 'theory' to be only associated with the analysis of, never the production of, media texts. After all, this activity offers a productive collapsing of the conventional boundaries of reading and writing—it is as much about the 'reading' of *Psycho* as it is about the 'writing' of the trailer. The key point, perhaps, is to ensure that, as well as the integration of production and analysis, there is a promotion and tolerance of a wide variety of discourses in the classroom, so that the necessary bridges can be built—and at the right time—between the subjective languages of filmic pleasure pupils will be familiar with, and the more abstract languages of analysis. This will allow for highly flexible and nuanced hybrid discourses, rather than a hierarchy of preferred forms of language—and this is, in fact, the state of the actual classroom. If teachers can be comfortable with such flexibility, pupils will be able to move between registers, selecting and combining for the purpose at hand, as these girls do in the act of editing, in conversational reflection on their work, and in more formal written exam pieces.

The third point is about differentiated work. This is an able group, capable of sophisticated abstract analysis. Other pupils will need less formal analysis in the theory/practice mix, and will find the complexity and quality of their understand-ings in the audiovisual mode and in the accompanying talk which presents their intentions, negotiates their decisions. The benefits of making explicit the forms

of language in use will still be there—as Bruner notes, 'the metalinguistic gift, the capacity to "turn around" on our language to examine and transcend its limits, is within everybody's reach' (1996:19). And the new vocabularies of digital media, visible in this group's work, will offer a first layer of metalinguistic scaffolding for such reflective work, derived from the conscious, powerful act of editing: *digitise, fade, timeline, edit, audiotrack, transition, cross-zoom, sequence, clip, drag, copy, paste, render, export*.

And fourthly, the distinctions between theory and practice, analysis and production, may be becoming unsettled in the context of digital media. In fact, the 'written' commentaries of the girls are also digital media productions: they are desktop-published pieces in Word and Microsoft Publisher, incorporating digital stills of the film, archive posters of *Psycho* downloaded from the Internet, and screen grabs of the timeline of their trailer. This may be a text-based piece of work, but many of the features of digital media make it a production-like piece of text.

The final aspect of this work we want to consider is its social nature, and in particular its implication in the sense of self held by these teenage editors. Bruner makes the three related points that human selfhood is experienced as agentive; that this sense of agentive encounters with the world consists of both past encounters and of extrapolations of these into the future—'self with history and with possibility'; and that narratives of self can only be constructed in a cultural setting (1996: 36).

These girls bring histories of encounters with popular film that are an important part of their work in Media Studies. Holly and Gwen's account of spending weekends screaming over slasher movies forms an important backdrop to how they have made sense of *Psycho*; indeed, Gwen is now able to explain explicitly how horror movies often play on our society's naive conceptions of childhood and innocence, relating this to the Bulger case; and Holly can make the connections between *Scream* and *Psycho* that appeal to viewers like her: 'There's definitely something intimidating about the young vulnerable woman, because it's part of our culture, that we're more vulnerable than men'. And in suggesting a re-release for a modern audience, the teacher here allows for different social identities of the girls to be brought into play—the part of themselves that is that new audience, its immediate points of reference Wes Craven and Tobe Hooper; and the parts of themselves that can imagine the older audience represented by their parents. The other crucial role is that of the 'media expert'—like pupils whose sense of self acquires the feeling of what it is to be a scientist or mathematician, they have a sense of special knowledge and skill:

> Lorraine: I can't watch a film now without going, 'Oh that's why they've done it—
>
> Abby: Exactly, you know why it's raining, and why she's wearing black and you know why he's wearing white and ra ra ra.

Students often complain after a few months of studying the media, that they can no longer watch anything on television without an analytical and critical eye, that it no longer becomes 'fun'. However, when you question them further, they are actually very proud and excited at acquiring this 'eye'. They speak as though they have been let in on a secret that not all of their peers know about. Watching their faces as they begin to work out how the audio, graphics, and images combine together to form meaning in, for example, the opening sequences of *Terminator 2*, is quite fascinating. They begin to strip down the layers further—to notice meaning in specific camera movements or shots, to notice the way in which voiceover and music work together on the audience. They wonder why there is a blue colour-wash on the images they see. Most of all, they begin to understand film making decisions and how all these components work together to create meanings they usually take for granted.

Their interview reveals how the act of digital editing has been for them a powerful emotional experience, one which has changed their sense of self and provided an excitement that spills out onto the street:

Abby: Like, normally staying in school till six would be just your nightmare but we actually really got into it last night, and like HEH HEH HEH! [exaggerated triumphant laugh] and we walked out, like, with a smile on our face, as we were so satisfied it had worked!

Holly: We did, we talked about it on the street, 'cos it was so satisfactory.

And this change in their sense of self, of what they can achieve, carries forward for Lorraine into her 'possible' future self:

Lorraine: I mean, after doing this, I was, like on the borderland between Film and Media [A level] and now, after doing this, I'm definitely doing Media, it's so satisfying...I'm better at—I was better I think at the written work and now after editing, I think we did this, and we're not like the most—people who are really amazing at editing, so I thought we did this...

This sense of excitement and achievement, which the speed and capacity of digital media undoubtedly helps to produce, has been a common thread in our early work on non-linear video editing, offering a practical and enjoyable experience to disaffected students, academically successful students, and a small group in Year 11 on an alternative vocational programme partly based at the local FE college, partly in our school editing suite, and partly at a local cable TV station where we jointly managed a community video editing suite.

This work raises questions for future research and practice: about the relation between verbal and audiovisual modes of communication; and about what happens

when young people gain access to the modes and resources of semiotic production unavailable to previous generations. It raises questions about how what Bourdieu describes as their cultural capital is aggregated, a productive, if at times dissonant, meeting of experiences from home, street and the classroom, itself a site of cultural encounter which we have sometimes been too ready, in the past, to deny, to render inauthentic. The digital revolution in some ways recalls the past—a profusion of the visual before the spread of print literacy; the splicing together of image and sound in film; the sociocultural shifts accompanying earlier technological revolutions in communication. But it also brings new possibilities previously unknown, the most important of which, perhaps, is the rapidly increasing access, in schools and homes, to the textual technologies which for much of this century have belonged only to the giant industries of popular culture. The distinction between author and audience is at least partially dissolved by digital interrogation, appropriation and transformation. This audience is out of its seats.

Making Your Mark: Digital Inscription, Animation AND A New Visual Semiotic

INTRODUCTION

A hundred and twenty primary school children sit in a cinema, watching a programme of animated films presented by the education officer at the cinema. They are about to embark on the making of their own animation, using computer animation software to animate drawings made in a vector-drawing software package. This chapter will try to distinguish what the particular characteristics might be of these digital tools, and of the processes of their use by children in the making of a moving image text.

This is part of a wider attempt to construct a social semiotic grammar of the moving image. This draws upon the grammar of the still image proposed by Kress and van Leeuwen (1996), the specific elements of which are partly derived from traditions of visual semiotics, and partly from the grammar of functional linguistics, elaborated in particular by Halliday (especially 1978; 1985). The new dimensions we add are partly derived from film theory, and deal particularly with movement and time. In particular, we develop constituent elements of duration, motion, rhythm, sound (see van Leeuwen 1985 and 1999 for extended discussions of rhythm and sound).

Why is a new grammar of the moving image is needed now? Film grammars are not new, of course, and can be seen as a series of historical developments from

early Russian theory and practice, especially Eisenstein's theory of montage (1968), through classical Hollywood continuity editing (see Bordwell et al., 1985), to the structuralist model of film grammar proposed in, for instance, the earlier work of Metz (1974). The arguments for a reconsideration of film grammar in the context of social semiotics can be seen as fourfold.

Firstly, film 'grammars' have tended either to privilege the act of making film—to prescribe an orthodoxy, such as the Hollywood continuity system—or to privilege the act of spectatorship, as in the practices of shot deconstruction or *découpage*, best represented by Metz's 'grande syntagmatique' (1974) . The exception, perhaps, is Eisenstein, for whom montage was both the revolutionary practice of the film-maker and the spectator's act of producing meaning from the juxtaposition of images. In general, however, theories of film language are not well-equipped to deal with the practices of viewing and making moving image texts which are now a reality in schools and in the wider community. The children we describe in this article employ digital technologies to move between acts of spectatorship and authorship, and the models of textual relations proposed throughout the period of so-called *Screen* theory fail to anticipate this historical development.

Secondly, some of the most useful insights into young people's engagements with the moving image in recent years have come from the Cultural Studies tradition (Willis, 1990; Bazalgette and Buckingham, 1995; Buckingham, 1996). However, though these accounts offer valuable descriptions of the social and cultural uses of the moving image by young people, they do not, by and large, propose a theory of signification to complement these accounts.

Thirdly, the theory of the visual semiotic laid out by Kress and van Leeuwen has been enthusiastically received by those concerned to analyse the semiotic processes involved in children's engagements with the still image, whether in the Art curriculum, or in the context of picture books used in primary schools. We consider that part of the reason for the success of this model is that it uses the relative clarity of linguistic approaches to signification, in an effort to provide an account of the visual semiotic that will be as transparent as possible, and thus as useful as possible, to practitioners. However, in order to realise the value of the different approaches summarised above, some kind of more effective synthesis needs to be made—between the specific features of the moving image identified in film theory, the cultural contexts emphasised in Cultural Studies, and the general semiotic principles proposed by social semiotics. This chapter will focus on only one aspect of these: how digital moving image texts are *inscribed*.

The research model at work here is not an experimental or intervention model: this project was not set up for the purposes of our research. There are two methodologies at work. The first is that of social semiotic analysis, which will look at the work produced by the children as texts available for such analysis. The second

is the kind of ethnographic approach typical of the cultural studies tradition, which we employ to try to capture both the processes and the cultural/social contexts which produce the texts and the grammars we are describing, through semi-structured interviews with thirteen pupils.

The school project described here was a four-week sequence of events in which one secondary school worked with four primary schools. After the viewing of animated films at a partner cinema, the Year 6 (11-year-old) pupils from each of the schools planned animations of *Little Red Riding Hood* at their own schools—divided up the story, made storyboards, drew backgrounds which were scanned into the secondary school's computer network. The pupils then visited the secondary school for two days and made animations of the story, drawing the characters in a vector-drawing program (the Acorn *!Draw* program), and animating them in an animation 'edutainment' package: the *Complete Animator* (see Sefton-Green & Parker, 2000, for other accounts of the use of this software). As well as their teachers, the children worked with teachers from the secondary school, with the Film Education Officer from the partner cinema, the Arts Picturehouse in Cambridge, and with a professional animator from the BFI (the British Film Institute). In a third day, a small group of six came from each primary school to edit their animations together; and in some cases to edit the soundtrack with the animation on a professional digital video editing package, *Media 100*. Finally, all the schools attended a screening of their films at the cinema, as part of a screening programme presented by the secondary school during its summer festival week. In this article, we will look in detail at two of the animations: one by Year 6 pupils at St. Matthews' Primary School and one by Year 6 pupils at Park Street Primary School.

These three computer packages, each with their specialised function, were the tools which allowed the children to design, assemble, animate, edit, exhibit their short films. These tools, and the material forms and surfaces they operate with, are the inscriptional resources from which this ancient narrative is remade by the children. We will look briefly at what grammatical structures are employed by them to make a moving image text and how technologies of inscription relate to these structures.

SYSTEMS OF INSCRIPTION AND THE NEW COMMUNICATIVE LANDSCAPE

A more general outline of a social semiotic approach to the moving image is provided elsewhere (Burn & Parker, 2003). This chapter will focus only on that aspect of the production of texts which Kress and van Leeuwen describe as *inscription*. This aspect emphasises the material media with which signs are made.

In writing, for instance, they might be pen and ink, typewriter, or word processor; on watermarked letter paper, exercise book, billboard poster or computer screen. Kress and van Leeuwen's point is that linguistics and semiotics have traditionally overlooked these and other media, or assumed them to be incidental to the making of meaning; but that in fact they *always* carry a semiotic burden, always contribute to the meaning of the text. Furthermore, the move from analogue to digital forms of inscription, where text might be a free-floating digital code unfixed from physical print, and capable of realisation in a vast range of physical forms, is a change in how meaning is realised in written language through its inscriptional form as great as that made by the printing press. The effects of this are extensively explored by Richard Lanham (Lanham, 1993).

In a similar way, then, we argue that the moving image has its signmaking systems in space and time, which combine different modes (image, sound, music, dramatic gesture, lighting), as well as the material media these deploy. There is no word for this as yet—we propose the term *kineikonic*—a combination of the Greek words for *move* (*kinein*) and *image* (*eikon*). Any text produced in the kineikonic mode can only be realised through physical forms of inscription. For film, this is partly to do with initial processes of design, which in the case of animation might be pencil crayons or a computer drawing package, as well as the 'material' of the text (16 mm film; videotape; quicktime file); and partly to do with the projection surface (TV screen; cinema screen; Palm handheld computer; video projector screen and so on). Before exploring how this notion of inscription applies to the work of the schoolchildren in this project, a brief summary of Kress and van Leeuwen's notion of inscription will be useful.

The production of any kind of text is physically grounded in the materials which inscribe it and sometimes re-inscribe it on other surfaces for exhibition to an audience, or for secondary forms of production. As technology develops the visual semiotic also produces new ways to read and make images. Kress and van Leeuwen describe three classes of inscription technologies that have developed over time: (1) technologies of the hand—where the inscription process is in all aspects crafted by the human hand and tools associated with such practices such as chisels, brushes and pencils; (2) technologies of the eye and ear which allow for the analogical representation of facets of the world—examples would include audio tape, photography and film; (3) synthesising technologies which allow digitally synthesised representations to be created using principles associated with technologies of the eye and ear, but which also reintroduce the artisan elements of hand technologies via 'interfaces' of various sorts (keyboard, mouse, etc.). In recent years, digital culture has transformed the creative practices of many artists, and of some creative work in the home and in the school (Sefton-Green, 1999). We will explore this idea a little here, as we describe how a digital drawing package was used by children to design the spatial grammar

of the story: the characters of the Red Riding Hood tale, and its places, the forest, the granny's house; and how they used a digital animation package to design its temporal grammar: the gentle walk through the forest, the rapid attack of the wolf by the woodcutter. To look in detail at the children's work, however, it will be necessary to develop the model sketched out by Kress and van Leeuwen, for two reasons: firstly because, in their brief sketch of the idea of visual inscription, they are not able to develop an account of the *processes* of inscription; secondly, because our model will need to refer specifically to the inscription of the moving image.

Kress and van Leeuwen, in their account of inscription and inscription technologies, focus strongly on the materiality of this aspect of representational practices, summarising their account of inscription as comprising 'the interrelated semiotic resources of surface, substance and tools of inscription' (1996: 241). While retaining this system of the nouns of inscription, as it were, we might flesh out the verbs—the processes of inscription as they appear to us in the making of digital animation. We want to emphasise the dynamic, mobile qualities of these acts of inscription. While retaining the materials of inscription—the computer tools, the screen on which the animations are displayed—we want to categorise and describe the *actions* which deploy these materials. A technology is about tools and materials—but also about the social actions which use them.

Three distinct categories of the processes of inscription are apparent in this making of animated films by primary school children. In digital moving image production, all three of these stages are governed by a quality of *provisionality*, both cultural and material (see, for instance, Buckingham et al., 1999). The three categories we propose are:

> *inscriptions of the synchronic* (creating individual images which will be combined to make the moving image sequence)
> *inscriptions of the diachronic* (creating the temporal aspects of the moving image by combining individual images: making duration, speed, movement)
> *inscriptions of display* (realizing the finished text on different surfaces: e. g., monitor, television screen, cinema screen).

Within these broad categories, we will need to name a number of subordinate processes, which we will explain in the context of the three stages. These are: *transformation; (re)combination; (un)fixing; interactivity.*

INSCRIPTIONS OF THE SYNCHRONIC

These largely refer to how the drawings for the animation were made: in particular, what tools and substances were employed in what processes. The still image and

the moving image have, since the inception of film, had a close but contradictory relationship: they are opposites in one sense, and impossible without each other in another sense. In animation, unlike so-called live action film, the moving image is built of still image designs. We might expect these to be differently composed than ordinary still images, however; and the question here is how the tools and materials of digital inscription permit, or are moulded to, this compositional intention by

Figure 4.1 One girl's design for the character of Red Riding Hood.

the pupils. We use the term synchronic to refer to elements of the moving image which, of themselves, have no time value, but are perceived as if instantaneously. We will also use the term *synchronic syntagm* (see Hodge & Tripp, 1986; Hodge & Kress, 1988) to refer to how each frame of the film has its own visual grammar. It is made up of interrelated signs (*syntagm* meaning the combination of signs), like a visual 'sentence',but again, apparently outside time. This produces meanings distinct from, though related to, the *diachronic syntagm*, or sequence of meaning produced by the temporal flow of images one after another.

It is worth remarking, to begin with, that a heterogeneous use of representational resources was in play from the start in this project: the background designs were drawn, as mentioned above, in traditional materials, and some of the character designs were also drawn in advance of the computer animation, such as the Red Riding Hood design shown in Figure 4.1.

One way to view these original designs is to suggest that the digital future is not, as sometimes seems to be implied, a uniformly bright, unscathed surface of neo-technology, like more naïve utopian future landscapes in sci-fi movies. It may be more like Ridley Scott`s *Bladerunner*, where the images of future technologies co-exist with older urban images, locations, styles: a future 'already old', as Rutger Hauer, who plays the ambivalent replicant in the film, remarked of Scott's vision (Channel 4: 2000). Children in our schools will continue to produce images, music, drama with the 'old' technologies of paint, acoustic instruments and the body alongside their digital successors, digital image manipulation, virtual sound studios, and non-linear video editing. Sinker (2000: 188) makes the point that digital media often subsume more traditional media, rather than simply replacing them; she coins a term to describe this: *metamedia*, as opposed to multimedia. Also, the computers used in this project (15-year-old Acorn Archimedes) to advance cautiously into the digital era were already old, worn, semi-redundant.

We will concentrate here, however, on the processes of digital inscription. What can we say about the act of vector drawing, particularly how it produces drawings for animation, and how its nature as a form of digital inscription makes a difference? These processes will be seen as: *transformation;(re)combination; (un)fixing; interactivity.*

Transformation

Why transformation? The drawings made by the pupils followed a model suggested to them by the teachers directing the project. In a vector drawing package, it is more effective to begin by using predetermined squares and circles, then tugged into shape by the vector points, than to attempt freehand drawing with the line tools.

Figure. 4.2 Red Riding Hood and the wood cutter.

The face, eyes, pupils, blue eyelids of Red Riding Hood all began life as circles. The hatchet-jawed face of the Woodcutter emerged from a square. (Figure 4.2 shows Red Riding Hood and the Woodcutter).

The choice of soft or hard lines by the children is an obvious semiotic choice, implying the softness of the girl and the toughness of the man. The colour-fill of the blue eyelids suggests the makeup of an older teenager, and the pop-cultural images which reiterate this blend of innocence and knowingness, are by no means irrelevant, of course, to the central symbols and narrative of the folktale of Red Riding Hood, in its various versions (see Carter, 1991; Zipes, 1983). The contemporary references are also clear. The eye-lashes are exaggeratedly long; the eyes themselves are huge and child-like; the smile is wide, white and transmits the kind of wholesome kitsch Americana current amongst pop cultural icons such as Britney Spears or Christina Aguilera. This is an example, then, of how semiotic policing is less stringent in visual modes, allowing pop culture to butt up against a children's fable without demur, leaving more room for individualistic expression. The codes and conventions for digital animation are too new to have set boundaries of acceptability.

There is a similar case to be made for the woodcutter. On the one hand this is identifiably the man who rescues Red Riding Hood at the end of the story, but

the sunglasses, the lantern jaw, the intimidating hat borrow from the iconography associated with leading men in action movies—Arnold Schwarzenegger, for example. Our point is that these cultural references are implicit in the children's early choices of circle and square, and in the series of transformations that succeeds this choice, as freehand drawing is replaced by the gradual, delicate tugging into place of vector points along the shifting outline of the drawing.

The basic semiotic resources are to hand, then—circle and square, already pregnant with possible meanings, available for transformation. This act involves seeing the image, seeing the transformational potential of the shape, and handling the vector drawing tools with enough sensitivity to get images adequate to those already in the maker's mind. That this was a difficult process is clear from the comments of students interviewed. One girl found that drawing with a computer was something you had to learn: 'you have to learn how to use all those tools and things'; whereas she saw drawing with pen or brush as something 'that you just do'. However, she was inclined to see the computer as a powerful and liberating device: 'You're more in control'; while her friend, asked if animating on computer was like writing in any way, said: 'It's like, um, writing a story, because you can, like, change your mind, and go back …'. This underlines the provisionality of digital media we have already noted: inscriptional substances which are never materially fixed, but always a set of instructions, effectively, waiting to be rewritten.

(Re)combination

As we have suggested, an important difference between an ordinary still image and the digital vector drawings for animation was that the characters were built out of aggregations of parts—a kind of reverse anatomical process. Romantic perceptions of art imply an organic unity in the represented object, which flows from the pen, brush or chisel of the artist. This organic unity is opposed, in the Romantic ideology, to a scientific view of the body as an assemblage of parts, susceptible, especially as the Enlightenment progressed, to anatomical disaggregation. The collaborative construction of an image by the combination of vector-drawn elements, we suggest, contradicts the Romantic ideology of artistic unity and individual authorship, suggesting an aesthetic exercise which is simultaneously a (digital) technology; the creation of a unity through combinations of elements (a grammar); and a social enterprise, rather than the product of individual artistic genius. A number of interesting features of this technology of inscription arose. Firstly, the parts were seen by all involved as a technology for animation—how they would move in the final film was always a consideration, not only for the children, but for the adults: the teachers, who had undergone a short training process in the use of this software; and a professional animator

from the BFI, who specifically asked the children to save parts of their character as separate files. An example of this is the arm of the wolf, used by two girls as part of a sequence they animated in which the wolf knocks on the door of the granny's house.

They only used the arm and paw of the wolf, as they had planned from the start to do this shot in close-up. One girl was very clear when interviewed about why they used a close-up for this sequence:

> Um—because—it seemed—it doesn't seem that important if you see the whole person just knocking—but it was quite an important bit because he knocks on the door and then goes and eats her...and so we had it looking as if he was quite powerful—he was bigger than most of the other characters, except for the woodcutter, which—as you know, the woodcutter kills him.

Secondly, these disaggregated elements become more freely available for inscription, as floating items—not only in the network space used by the children, but also in their minds. An example was the woodcutter's implement for killing the wolf. The boys responsible for this design drew two implements—an axe, and a chainsaw. In the final animation, the axe is the implement attached to his hand, so some kind of decision, either aesthetic or to do with teacher censorship, has eliminated the chainsaw.

Interestingly, however, it is the chainsaw that the girl cited above remembers, as if it had, uncannily, re-inserted itself in the film. She remembers the woodcutter like this:

> Um—he was also very modern—he had a—he looked a bit like Popeye with huge muscles and things, and he had a skull tattoo and a chainsaw–so—instead of an axe, he had a chainsaw.

She attributes this image to the influence of horror movies on the boys who designed it, describing how boys in her class boast about scary films they've seen. She associates herself with the appeal of horror, however, claiming to have seen *Childsplay*, 'the first Chucky movie', when she was much younger. More important for our present argument, however, is the fluidity of the film in her memory. Here, the looseness of the synchronic syntagm (woodcutter+axe / woodcutter+chainsaw) may be also a result of the combinatorial possibilities of the medium of inscription, possibilities which have their mental counterpart in the continued unmaking and remaking of the text in this girl's memory.

Another disaggregated item, the basket that Red Riding Hood's mother gives her, becomes freefloating in the virtual space of the computer network, where all the images are stored. The same girl claims that the image was 'stolen' from their

network space by one of the other primary schools, working in the next classroom; and that they also 'stole' their image of Red Riding Hood, or were influenced by it. She signals this as an exciting, illicit incident, refusing to name those involved, and beginning her account with the telltale phrase, 'I happen to know…'.

Thirdly, as is suggested by the examples already given, the elements of the character designs are made collaboratively, and are used collaboratively (or competitively!), with or without permission. The image of Red Riding Hood shown in Figure. 4.1, for instance, was complemented by a series of eyelids, complete with blue eyeshadow and eyelashes, made by her partner, in order to make the character blink in the animation.

(Un)fixing

Material acts of fixing run throughout all technologies of inscription. They may be material processes applied late in a sequence of inscription, in order to consolidate, protect or complete a piece of work. In oil painting from the late Renaissance to the present day, for instance, the act of applying transparent varnish to the dry painting would be such an act of fixing, rendering the material inscription more durable, more fit for exhibition, homogenising the surface with a uniform shine. Similarly, artists over the last thirty years or so have been able to use aerosol fixers to spray on pencil drawings, rendering them impervious to smudging or deletion. Photography, of course, uses fixing chemicals to make the print permanent.

The fixing process will always carry a semiotic function of closure; will always signal an intention to complete the semiotic act. The nature of this completion, however, will vary considerably. What interests us in the context of digital inscription is the permanence or irreversibility of the fixing and what this might signify or permit in the social domain. Though there are plenty of examples of texts in different media being reworked in some way after completion, publication or exhibition, these are the exceptions rather than the rule. Furthermore, they are accomplished in spite of the material of inscription rather than because of it. To take a recent example, the film editor Walter Murch, re-editing Orson Welles' film, *The Touch of Evil*, could only re-order sequences from existing prints of the film, and alter the soundtrack in certain places: it was impossible to access the original material from which the film was edited in the first place. Had all the original footage been converted into digital format, the process of revision could have been much more extensive. In this case, the resistance of the material closure of the text to acts of remaking has its counterpart in the power of the studio to maintain its version of the film, a form of closure duplicated through the twentieth century as the inscriptional fabric of the moving image presented

a sealed surface to its mass audiences, offering access only as spectators, never as re-makers. The advent of digital inscriptions, and their domestic users, begins to permeate this surface of finished inscription, to unpick it, reorder it, remake it, transpose it.

Our specific point here is that the material of digital inscription makes the fixing process completely reversible in a wholesale way. It not only makes revision possible more extensively than before, it positively invites the unfixing of the text, makes the act of closure less committed, less final than it always has been in the past.

In this project, the digital grouping of objects within the vector-drawing program functions as the fixing of the synchronic syntagm. Four things are notable about this act of fixing.

Firstly, this grouping is an act of completion, and an act of homogenisation, a bringing together of limbs and costumes to say 'This is Red Riding Hood'.

Secondly, it is provisional, as all the stages of digital inscription must be. In this case, it is provisional in a very specific way, as the authors intend the grouping to be undone, if necessary, by other pairs of children.

Thirdly, and consequent upon the provisionality, it subsumes the process of *unfixing*. Pairs of children will ungroup images made by their colleagues, and regroup them for their own sequence. A clear example is the image of the granny in one of the films. This image was ungrouped by the pair of children making the sequence of the wolf waiting for Red Riding Hood. In order to disguise the wolf as the granny, they removed the granny's cap from the first pair's image and placed it on the image of the wolf, re-grouping that image, and converting it into a fixed stamp for the animation.

Fourthly, the grouping and fixing follow the design intentions of the whole syntagm, obedient to the ruling kineikonic grammar. We have argued elsewhere that the grammar of the synchronic syntagm in the moving image is determined by its place in the diachronic syntagm. It makes references backward and forward to other moments in the moving sequence. It is a still image which, on viewing, is immediately pulled into the moving flow. In its design and its realisation, it shows a loyalty to the dynamics of rhythm, duration, speed which govern the grammar of the moving image. In these cases, then, decisions about grouping are made with an eye to the composition of the moving sequence, which we will consider in the next section. Most obviously, certain elements of the character designs are left ungrouped, either in order to animate limbs, eyes, objects separately; or because the children know that they will use the element in a close-up shot which needs only that element. In the case of one pair of children, their entire animated scene was of the wolf knocking on the granny's door. The only object they used for this was the wolf's arm in close-up.

Interactivity

These designs are, as we have suggested, interactive: they can be altered, remade, remodelled, revised, re-edited by other children in the group. Such interactivity, in which children rapidly alternate between modes of reception and production, at one moment admiring another's design, in the next moment appropriating it as part of their own image, employs digital spaces and surfaces for this production/reception oscillation. The computer screen, unlike the cinema screen or (until very recently) the TV screen, is a surface of reading/reception and of writing/production. The network linking their machines is a repository for finished designs, a bank of designs for retrieval, a space of temporary completion, of designs in flux. It is a space governed by contradictory motivations of collaboration and competition: they save; they retrieve; they borrow; they steal. Though in many senses a very simple process, this kind of inscriptional interactivity moves well beyond the conceptions of ICT as content delivery which dominated early thinking in UK government education policy (see, for instance, the critique of this approach in Buckingham, 2001).

The word interactivity risks some confusion, evoking its popular use in the context of multimedia. We will risk the confusion in order to problematise the term; but a little further explanation is needed. Interactivity is a term used of many media, in particular computer games, where the player makes a contribution to the text itself, whether temporary or permanent. In semiotic terms, it means the availability of semiotic resources for further design work (as distinct from, though always related to, interpretation).

Secondly, and more importantly for our immediate argument, the unfixedness of the digital medium means that the text is permanently interactive, as long as it remains in digital formats. Anyone who receives it will be both a viewer and a potential remaker. This, again, is a more profound view of interactivity than that imagined by commercial multimedia manufacturers.

Thirdly, the word interactive, as we have implied, suggests a changing text-audience relation. The social semiotic view of communication we employ in this article lays out three overarching functions of any system of communication: the functions of representing ideas, communicating between people; and forming texts. The second of these, the *interpersonal metafunction*, is where we would locate the idea of interactivity. Kress and van Leeuwen do, in fact, use the word interactive for their version of the interpersonal metafunction. For the purposes of this chapter, this association suggests a shift in the distribution of power between author, text and audience consequent upon the advent of digital technologies and the social uses which determine them and are made possible by them.

INSCRIPTIONS OF THE DIACHRONIC

We want here to think through how the kind of inscriptional practices used by the children might develop when moving from still to animated image creation; to describe inscriptions of the diachronic syntagm, the temporal dimension of the moving image text.

The movement of characters or objects through space and time is the major difference between our kineikonic grammar and the grammar of visual design proposed by Kress and van Leeuwen. Although we can see still images as holding a series of potential movements which are often articulated verbally by children as they develop their drawings, we need to find a new way of describing the criterial aspects of motion and temporality as they unfold through animation.

Transformation

With synchronic syntagms designed, fixed (albeit provisionally) and stored on a network drive, a second stage of transformations could begin. Whereas the initial drawing materials in the Acorn package had been pre-set circles and squares the pupils now had a more defined set of iconography to work with. Each moveable part, be it a character's limb or an object, could be edited by taking it out of the shared drivespace and back into *!Draw*. Certainly, some pupils did take the opportunity to rework existing drawings after having first experimented with them within the animation package. Changes in colour, line or overall style often suggested themselves only after seeing the constituent parts assembled in successive frames and set in motion. This further emphasises the provisionality referred to above. But more than this, it offers evidence of an expressive creativity which may be fostered by the freedom to revise, exchange and reconstitute visual elements using digital media. Further, the fact that the animation package added new concepts—movement, shifting perspectives, temporality—meant that the original act of inscription in *!Draw* was finally assessed through the mode of reception: and the children toggle between modes of reception and production from then onwards, viewing and transforming both their own images and those of others.

(Re)combination

The individuality of the drawn images was somewhat proscribed by the shared network of visual designs. This 'image bank' was free to be used by all groups and although some never strayed beyond using their own designs, there were others who made ample use of other pupils' vector drawings. This had implications for

the act of (re)combining images at the animation stage, some aesthetic, others pragmatic in nature. For example, one group who were responsible for animating the section of the Red Riding Hood story which takes place in Grandma's house were able to use different combinations of drawn body parts to create firstly an image of Grandma in her nightgown, but then, by importing an image from another group's file, were able to recombine aggregated images to form the wolf in Grandma's clothing. Although this recombination was primarily a pragmatic step—it saved the time it would have taken to draw a new character—there were also many different wolf heads to choose from and the selections made were based on aesthetic choices. Aesthetic choices were also always social choices—peer group allegiances, a group's discussed preference for a particular drawing, a perceived stylistic 'match' between elements of disaggregated designs. This points towards representation-as-*design*, rather than representation-as-*reference*, a shift which Kress and van Leeuwen predict will gain momentum as synthesising technologies and their concomitant ontologies replace older technologies of communication. This suggests that by using the new semiotic resources and tools made available through digital technology the pupils moved towards 'signification' rather than 'referentiality', they created new texts through combinations of visual image and movement. In this context, creativity on the part of the pupil can be assessed in terms of the varying combinations of limbs, objects and other visual 'nouns' which are drawn together from the semiotic palette. These nominal structures were communally available in our project and consisted of elements of existing potential meaning, the synthesis at different stages of the animation of circle and square, pathway and forest, wolf and woodcutter, Red Riding Hood and grandmother or any combination of these. Organising them in varying relationships creates different versions of the same narrative and these differences draw attention to the meanings held *in potentia* by the basic constituent elements.

We also need to consider how different combinatorial possibilities relate to the movement within the animations. The combinations of aggregated designs in a sequence, demarcated by 'frames' within the *Complete Animator* package, were made up from a number of discrete elements. There were different styles of drawing, ranges of colour and shape juxtaposed with one another; there were changes in scale and size to create illusions of movement in 3-D space and a sense of perspective. And, of course, there was the overriding element of duration—the length of time the frames took to play through from beginning to end. Precisely how these temporal processes were worked through by the pupils and how they contributed to the grammatical sense of their narratives requires an explanation of a number of elements associated with the 'stitching together' of time and we will outline each one in turn. Figure 4.3 shows the Animator Screen, with the play bar and frame creation tools at the bottom, and the toolbar at the left.

Figure 4.3 Animator Screen.

'Stamping' is the term used in the *Complete Animator* to describe the inscription of a grouped vector drawing. Each drawing was imported into Animator and saved as a 'stamp'. This allowed complete sets of objects or characters to be repositioned or resized without the need for re-drawing and opens up a number of devices to suggest movement.

Scaling/zooming

Using imported vector drawings gave pupils an advantage in that their designs did not pixelate when scaled up or down in size, as bitmapped images would. Using close-ups or extreme long shots to give a sense of perspective was a useful way of moving characters over a number of frames. Not only were these movements fairly straightforward pieces of animation, they also hinted at narrative developments and character motivations, point-of-view and implied audience position. A good example of this is a sequence in which Red Riding Hood is seen from inside the wolf's mouth. This sequence, in which the jaws ominously close over the young girl, was constructed by restamping the jaws in close-up and Red Riding Hood in long shot through a series of frames, each time slightly altering the position of the jaws so that they shut tight when the sequence was played through. In another animation, Red Riding Hood is animated walking along the forest path. The

character starts in the bottom left hand corner of the screen in medium close-up and then moves along the path in a direction that takes her towards the top right-hand corner of the screen. To give the necessary sense of perspective the pupils scaled down the drawing, a decrease in size of approximately 10% each frame. This gave the illusion of the character moving away from the spectatorial position and alluded to Red Riding Hood's motivation to take the ill-fated short cut through the forest. So on a number of levels, semiotic choices are made here in terms of size and position, direction and orientation in respect of a goal, all of which move the story forward and give the moving images an organising grammar to anchor choices within an overall schema of design possibilities.

Movement within the frame

One of the concepts made explicit during the project by the BFI 's animation officer was frame rate and the way the fluidity of movement within animated stories is always relative to the standard film speed of 25 frames per second. The closer each movement in the frame corresponds to this rate, the smoother the animated sequences would be. This developed an understanding of the concept of frame rate for most of the pupils (though it needed to be revisited frequently), and that even if the 'real-time' represented by the 25:1 figure could not be attained, a smoother animated sequence would still be possible if the ratio of frames to movements was kept high. This understanding of duration and the role it played in conveying the drama of a story was manifest through many sequences. In constructing the movement of objects relative to other objects—eyes rolling, crossing, winking, or an arm knocking at a door, for example—pupils who repeated a relatively long sequence of frames and then altered a single referent in relation to all other objects (the pupil of the eye, for example), created sequences that flowed very smoothly indeed.

At the other end of the motion spectrum, there were examples of establishing shots (Red Riding Hood's house or the kitchen inside it, for example). In these sequences there was often no need for movement at all, yet the frame rate was still significant in the sense that the length of time the shot would remain onscreen depended entirely upon the number of repeated frames and the speed at which they were replayed. Both of these examples suggest that pupils had internalised the relevance of frame rate to their work, but more importantly, it also implies that they understood where to use the knowledge most effectively within the context of a short narrative.

Transitions

Throughout the editing phase of the project—when smaller groups of children returned to Parkside to create a final combination of the separate sequences

designed during the animation phase—more transition devices were added to the cuts composed in Animator: dissolves and fades were used to create a series of (re) combinations. There was a traditional film grammar at play in this (re)combining. The splicing together of images in montages or juxtapositions created certain visual and spectatorial effects, which illustrated how the Eisensteinian principle of montage could be redeployed using the tools of digital inscription available in this software. One girl described how when using Media 100 to edit together her classmates' animation, she found the dissolve feature provided a useful visual metaphor for the power relationship between the wolf and Red Riding Hood:

> We used quite a lot of dissolves ... so two scenes would come together, and the, the next one, er, would overpower it.

By overlapping the image of wolf and girl she was able to dissolve from one to the other. As the outline of the girl dissipates, replaced by the sharper lines of the wolf there is a split second where the girl and her potential attacker overlay each other, a merging of actor and goal, or in traditional language grammar, subject and object. Her use of the verb 'overpower' seems to suggest that the transition is an inscriptional choice underlining the conflict between the characters.

(Un)fixing

During the animation phase the process of (un)fixing was linked to the combinatorial possibilities each group explored through the kinds of (re)combining outlined above. It was through the *experience* of temporality, the testing out of movement in real time by sequencing frames of grouped vector drawings, that decisions were made about the fixedness of each visual design. The kinds of revising they were able to undertake after seeing their embryonic narratives 'brought to life' by the animation package were an important feature of the digital animation package, which contains an instant fullscreen play mode—an example of what we refer to below as inscriptions of display, in this case provisional. The particular characteristic of this digital mode of inscription, toggling between composition and exhibition, is, again, the extreme provisionality and plasticity of the medium.

The ability to revise and rework material is, as we have repeatedly shown, a defining aspect of this kind of digital creative experience. For the pupils there were a series of possibilities which could be chosen, but which were never completely closed. There were always alternatives and provisionality was always present in the work. However, as pupils moved through the verb-like processes outlined above their visual designs became increasingly fixed (though even when at their most

rigid, they were always just a mouse-click away from disaggregation). As the number of animation frames increased the disaggregated items stored in the image bank were revised less and less. Changes were made more often within the Animator package which meant that images were not ungrouped but were altered at the micro level using colour palettes, erasers and snapshots.

At the post-production stage, different kinds of unfixing and fixing became available. Four children, editing their class's animation on Media 100, were able to import the whole animation, edited in Animator, place it on a timeline, and chop it up again into segments. They could then decide whether to keep these in the same order (they did), change the transitions, as described above, and whether to keep all the footage. They decided at one point on the most drastic form of unfixing: deletion. They decided to cut a scene made by a classmate because 'it was too long'.

Interactivity

The understanding of 'interactivity' in the context of digital media is apparent throughout the compositional and editing process. These films, up to the final inscription on VHS or digital videotape for exhibition, are offered by one group of children to another group as a provisional assemblage of visual units, available to be entered, reordered, remade, employed as raw material for a new text. As we have mentioned above, this implies an oscillation on the part of the children between modes of reception and production, reading and writing.

INSCRIPTION OF DISPLAY

This phase of the process of inscription is the one most oriented, in Kress and van Leeuwen's scheme, towards the aspect of inscription they categorise as 'surfaces'. The dominant impulse in this process is towards closure and towards the repositioning of the (provisionally) finished text in a place of what the film industry traditionally calls exhibition. There were, in this project, however, degrees of closure, and degrees of completed exhibition.

Firstly, there was the exhibition of completed sequences of animation on the computer screens of the Acorns. This form of provisional display is invited by the software, which includes a tool, represented by an icon of opening stage curtains, for fullscreen display. This function was employed frequently by the children, both to view their own completed or partially completed sequences and to show their friends their sequences. As, in many cases, these friends are sitting next to them, and working on the preceding or succeeding sequence, this form of display could

inform the production work of the neighbouring groups. In this case, the oscillation between modes of production and reception is rapid, fluid, and turns on the screen's ambiguous nature as both a surface of working production and a surface of display. It should be noted that, as frequently, pairs of children did not make use of this tool, or provisional display mode, where it might have been useful, so that discontinuities between sequences arose where they might have been avoided.

Secondly, the selected groups who edited the films as the second stage experienced the partly-completed sequences displayed in a different way—on the screen of powerful Apple computers, within a professional editing package. They also moved towards the final process of completing the films for translation to their final display contexts: on TV screens and on a full-size cinema screen. The degree of closure at these stages becomes more complete; and the question of agency increasingly complex, as the processes and choices are governed as much, or more, by the adults in the project as by the children.

The surfaces of the various screens through which the animations pass are laden with specific cultural values. The Acorn screens, as display vehicles, possessed low value, as they did in their role as tools of production, because of their age and shabbiness. On moving on to the Macs for the editing phase, one pupil remarked 'Wow—so this school does have good computers', comparing the Macs to the powerful PCs some of the children had at home. As display surfaces, then, a hierarchy of value was in evidence, determined by how well the children regarded the computers as examples of modern technology.

By contrast, we can assume that the cinema screen would be invested with a high level of cultural value. In this case, the use of a cinema screen reflects the institutional values of the partnership managing the project: a Film Consortium of which the school is a member, along with a local Arts cinema and a university. The intentions for the exhibition are to do with a harnessing of the cultural value of the cinema screen and context to re-present and re-value the work of the children. Surfaces of display on which children's moving image texts are exhibited are usually ones that carry low status: cheap TV screens showing poor quality VHS videos, in school classrooms, libraries or halls. Kress and van Leeuwen argue that the surface of inscription carries its own semiotic—that glossy photographic paper will signify quality at one level or the cheap aspiration to quality at another. For this project, the cinema screen and the physical environment of the cinema announce the children's films as part of the world of film that, until recently, their makers could only belong to as consumers, spectators, paying customers. The ability to digitally project on this most valued of all surfaces, replete with a century of cultural associations, moves the work beyond the kind of simulation,

pretend, pale mimicry of 'the real world' that educational work is so often confined to. This, then, is a form of the inscription of display which makes a historical loop: the grammar of the moving image, made through access to widely-distributed digital technologies by those who used to be confined to the role of audience, is inscribed on the same screen as the films made by the older technologies of ana-logical recording, by those whose role as author was protected by a triple alliance of economy, ideology and technology.

CONCLUSION

Digital inscription needs to be seen as a series of processes which deploy the tools, substances and surfaces that Kress and van Leeuwen describe. We have distinguished between the design of the synchronic syntagm, using drawing tools in such a way that the intentions of the moving image are crucial to the design, and to the design of the diachronic syntagm, inscribing the effects of movement and duration. We have emphasised that the availability of the tools of digital inscription offer a kind of text-making that is highly plastic, fluid and reversible, subject to the kinds of revision essential in the development of young artists and essential to the collaborative combinatorial processes of composition which mark this making of a moving image text.

We have also argued strongly that the growing proliferation of these kinds of inscriptional technology accompany a shift from engagement with the moving image largely confined, for the mass audiences of the twentieth century, to spec-tatorship, to one where such spectatorship slides easily into, and is informed by, modes of production. In the early 1980s, Raymond Williams argued, in a prescient essay, that an epochal change was about to occur in which the technologies of media production would become so widely distributed that the resulting shift in power between producers and consumers of the media would produce profound social change (Williams, 1981: 191). Even five years ago, we could not easily have designed the complex of collaborative digital inscriptions that have allowed these children to make their own digital animation and screen it on local cable TV and in the cinema. The interplay between digital, synthesising modes of inscription and the social action which this educational project represents has produced a partial dissolving of the usual production/consumption relation. In terms of the broad cultural history of literacy and communication, this development is perhaps best imaged by Bakhtin's vision of dialogic utterance (1981), where the acts of speaking and response are dialectically related, the first utterance anticipating the response, the response remaking the initial utterance.

Red Riding Hood has travelled a long way. From the dramatised oral modes of the mediaeval folk-tale through the specialised requirements of the seventeenth-century French bourgeoisie to the digital bricolage of twenty-first century primary school children. These young digital writers become their own first digital readers; a new generation of digital reader-writers goes to the movies, makes the movies, makes its mark on surfaces of inscription both new and old.

'Two Tongues Occupy My Mouth'—Poetry, Performance AND THE Moving Image

INTRODUCTION: THE MOVING IMAGE IN ENGLISH

The moving image occupies a troubled place in the English curriculum—always the bridegroom to the blushing bride of language. Many arguments have been deployed by its campaigners and devotees over the years, and the British Film Institute (BFI) especially has lobbied for its inclusion in more substantial form in the mandatory curriculum.

This chapter will explore four arguments for a greater emphasis on the moving image in English, looking at an example from my own teaching at Parkside Community College in Cambridge.[1]

The first argument is about the nature of the moving image as a form of communication. In some ways, it seems obvious that English is about language predominantly—the English language and literature and its associated literacies are the base of the historical rationale of 'English'. However (and without getting too stuck in the familiar despondencies about a subject in crisis), for many people this model has outlived its usefulness; or at least needs some serious expansion. For me, it has always been constraining. At university in the mid-1970s, I already felt quite frustrated by a course whose unremitting privileging of language as print produced a complete bypass of the illustrations of the *Beowulf* manuscript, the music of the English ballads, the drama of Shakespeare, the paintings of Blake,

the film adaptations of the Victorian novel, Ralph Steadman and Leonard Baskin's illustrations of Ted Hughes. In recent years, multimodality theory has proposed ways in which we might conceive of how different communicative modes are, in practice, integrated in most of our real-life engagement with texts (as opposed to the kind of engagement required by an English exam). This theory, most prominently presented by Gunther Kress and Theo van Leeuwen (2000), argues that language is losing its privileged position in an increasingly multimodal world. A good example is the mobile phone, which used to be, in the days of its early design, all about language and is now increasingly about music, photography, web pages and mobile gaming. Interestingly, the telecommunications industry also uses the word 'multimodal' for this phenomenon, though independently of Kress and van Leeuwen.

This multimodal view would make a greater emphasis on the moving image in English a logical move. It would extend the expressive and representational repertoires available to students and bring resonances of the audiovisual cultures of the late twentieth and early twenty-first centuries closer to the classroom. The debate about such an expansion of English has often, in recent years, centred on the idea of literacy, and whether media, digital, silicon, visual, cine- or other literacies could be defined with language as the analogy. This debate is contentious—Gunther Kress, for instance, argues that to use literacy so generally loses the specific value of the term for language (2003). But it is also a productive debate, since it is, in the end, a debate about how English might really be about semiotics—how students can learn to make and interpret texts, understanding the specific characteristics of different sign systems but also how general principles and patterns (such as those of narrative) work across and between these systems.

The second argument is about media education. For many years, media education has explored forms of representation and communication quite distinct from those of language, in particular the moving image as film, television and video. Furthermore, it has located these practices in the daily cultural lives of ordinary people, forcing open a space for popular culture in a curriculum traditionally dominated by heritage models of culture of one kind or another. The argument for the moving image in English is not the same thing as an argument for popular culture in the curriculum (the moving image has its own forms of exclusive practice and textual canon), but it is closely associated with the argument for popular culture in the history of the media education movement.

The third argument is about information and communication technologies (ICTs). It is tempting to regard computers as transparent vehicles for content delivery rather than as integral parts of the stuff of meaning-making. In this view, we make poems through *language*: it doesn't much matter whether we write them or design them in a desktop publishing package, whether we record them for a

CD-ROM or film ourselves performing them—these choices are simply about the delivery mechanism. The multimodal argument, by contrast, would be that these choices of mode and medium can and do make a difference to the meanings made, and not just a trivial, secondary, decorative difference. More specifically, with the advent of digital video, there is a tendency to collapse the moving image into the technology through which it is edited, so that it becomes just another computer application, and, as in the view above, therefore just another 'delivery vehicle' (sounds like a mail van). The result of this, as an evaluation of a BECTa DV (digital video) pilot argues (Reid et al., 2002), is that the moving image as a signifying system is in danger of neglect.

The fourth argument is about rhetorics of creativity. English traditionally invokes a post-Romantic rhetoric of the creative act built on metaphors of the organic and natural. Behind these is the literary Romantic sensibility, from Blake's Garden of Love to Wordsworth's Lake District, from Dickens's Sissy Jupe to Yeats's wild swans. We have learnt to suspect this tradition, to see through its mystification of creativity, which for learners results in creativity as a natural gift which a few are born with and the rest forever miss out on. In its place, the tradition of media education offers a view of creativity as a technical, transparent, democratic process which can be unpicked and learnt by anyone. The mystery of creativity is replaced by the transparent exploration of representation which can be analysed both in the texts students view and in those they make. Self-expression becomes self-representation.

By a curious series of political inversions, the radical creativity of the Romantics, opposed to the inhuman technologies of the Industrial Revolution, has become a conservative force of natural selection while technology has become the champion of the democratic and inclusive impulse in education. However, like many binary oppositions, this is a false one. These comfortable rhetorics don't fit a multimodal English curriculum. Teachers of poetry need to understand the semiotic power of new technologies and the creative processes they contribute to expressive work. On the other hand, media educators, traditionally uncomfortable with talk of bodies, voices and feelings, need to build into their model of creativity some way to recognise that the 'hard' technology of digital editing and three-chip cameras fuses, in the creative act, with the 'soft' technologies of voice, face, gesture. From a semiotic point of view, these are all representational resources that need to be thought about in an integrated way.

Beneath all of these arguments, there is another theme which I will address explicitly—that of performance and identity, the performance of self. Whenever a child makes a text, they are saying something about themselves. In moving image texts, especially when it is their own voice or face they have framed, modelled and edited, such representation is strongly performative. In the examples

considered here, this is especially true, as the explicit theme of the pieces is identity and bilingualism.

MAKING THE FILMS: POETRY AND THE KINEIKONIC MODE

The project described here involves work with my Year 11 group on the poem 'Search for My Tongue' by Sujata Bhatt, part of an anthology of set texts for GCSE English. The poem evokes narratives of bilingualism, diaspora, the loss and redis-covery of mother tongue, and the way identity is not only expressed in language but is made out of the stuff of language, amongst other things. It is also a poem about the body—specifically, about the organs of speech. It operates organic metaphors of plant life to signify the decay and regrowth of Gujarati in the mouth of the speaker—her tongue, literally and figuratively. The poem proved difficult for the class to engage with. It seemed remote from the experience of many of them. So we got together five bilingual students in the year group and asked them to write, perform and film poems modelled on Sujata Bhatt's. The films consid-ered in this article are by Ayi, who speaks Mandarin and English, Fatima and Nayana, who speak Bengali and English, and Sophie, who speaks French and English.

We gave them a day off timetable to make short films of their poems. Two further signifying systems came into play. First, performance—they had to per-form their poem to the camera. Second, the signifying affordances of camera and editing software—they had to do the filming and editing (on the digital video editing system Media 100).[2] These short films of the students' poems are what Kress and van Leeuwen call 'multimodal ensembles' (Kress & van Leeuwen, 2001). They combine a variety of signifying modes—speech, facial expression, posture and gesture, the built environment, music—and the two representational systems which together make up the mode of the moving image—filming and editing.

The first point to make about multimodality is to note how the spoken per-formance of the poems changes the written versions they bring to the filming day. The speech used by these young poets is not the speech of oral composition—there is no improvisation, formulaic composition, or any of the other elements of tra-ditional oral craft. These are recited poems—in fact, they are partly read from improvised autocues held up off camera by their friends. Still, they do privilege the oral mode in many ways, and the written poems become secondary in some ways, preliminary to the performance and filming. And, as in any speech, there are improvisatory elements—the tonal contours, the tempo, volume, vocal timbre—all of these are not merely material appendages to the signifying properties

of language but contributors to the meaning. For instance, in Nayana's English/Bengali poem, 'Brothers and Flowers', there are the lines:

> *I imagine my two tongues, each budding out of my mouth.*
> *My physical tongue, the stem of two flowers, each flower*
> *A marked presence in my personality,*
> *Colouring my thoughts, scenting my dreams, shaping my life,*
> *Shaping me.*

In the written form, the four clauses making up the last two lines are a repeated structure, a present participle followed by its object. In the spoken form, the second one is different, marked out by a rising tone on the word 'dreams', suggesting either a note of question, or incompleteness, or an invitation to assent by the listener.

Fatima, in her English/Bengali poem, imagines her two languages as 'unidentical twins', who behave differently, so that one can become disobedient and needs to be quietened. The command to be quiet employs the emphatic features of volume and a decisive falling tone, both in the English 'Quiet!' and in the Bengali 'Chup thako!', as well as Fatima's use of the so-called paralinguistic sign of a stern frown to accompany the imperative.

Already, a monomodal view of language as a single signifying system is beginning to break down here. Not only does this look like two systems—writing and speech—but the frown extends the repertoire to a complex signifying system of human expression central to the moving image, a mode which has its own history of representations of the human face in close-up.

If we stack up word, speech, gesture and facial expression, we get something which is integrated, in which the separate modes produce articulated meanings; something which, in short, is a performance. In a small way, these are dramatic texts, though the students wouldn't have thought of it in that way, and neither did I at the time. But they are dramatising something specific—the bilingual identities of the young poets. It is identity across languages, cultures, countries and communities which is represented in the central metaphors of Sujata Bhatt's poem, and of these teenage responses to it. These performances, then, are what the sociologist Erving Goffman called, in his classic study, 'the presentation of self in everyday life' (1959). But they are more than the daily enactment of bilingualism in the home and school—they are self-consciously artistic expressions of these selves, so that the performance of selfhood is not only of someone who is bilingual, but someone who is a poet, a film-maker, an exam candidate, a school student. All of these selves and their respective social motivations inform the construction, performance and reworking of these pieces.

This work of construction also employs the signifying properties of the moving image. David Parker and I have coined the term 'kineikonic' for this mode (literally move + image), since no neutral term exists for this mode; words like 'cinematic' and 'filmic' privilege cinema, which we do not wish to do (Burn & Parker, 2003). For us, though, the kineikonic mode has a double meaning. It can never simply exist as filming and editing—it is always dependent on other modes such as speech, costume, visual design, music, gesture, script, dramatic action. The point is to consider how they all work together.

Let's take, then, a central idea of these poems, and see how the modes combine to deal with it. The central paradox the poems deal with is the schism and the unity of bilingualism—how it makes a whole person in whom the two languages are harmoniously united but at the same time is an effect of cultural difference. Fatima says:

> *My life is split into two pieces*
> *Like a fruit that has been cut into two halves.*

For her, the difference between Bengali and English is a marked thing: the voices jostle for control, like disobedient children, emphasising the schism of bilingualism, the split between worlds and cultures it enacts. She is also cannily aware of the confusion and difficulty of language, how it can trip you up as well as bravely represent your dual identity:

> *Voices can make a fool out of you.*

She chooses to perform against a stark brick wall, whose uncompromising materiality carries messages of its own. She decides to film it from two different angles, so that she is shown in three-quarter profile, from one side for the English parts, from the other for the Bengali. This strong device is a visual transformation of the first lines of her poem but says something different from the fruit simile—something more like 'I am a speaker who faces in two directions'. The distinction between the languages is sharply marked by the transition between the alternating shots, which is always a cut.

She also chooses different framings, which change the meaning of the lines. The command to one of the voices to be quiet, cited above, is a good example. The English version—'Quiet!'—shows a head-and-shoulders close-up, facing left; the Bengali version—'Chup thako!'—is an extreme close-up of her mouth. The second shot associates the spoken Bengali more emphatically with the organ of speech, representing this language more intimately.

Nayana's poem, 'Brothers and Flowers' (also in Bengali and English), uses an editing technique to distinguish between the two languages—she makes the

English sections black and white, and the Bengali sections sepia, which suggests a kind of starkness across the whole poem but one tinged with nostalgia for the Bengali shots. She speaks with a serious, musing tone of voice—the paradox here seems more to do with the way bilingualism is for her a completely everyday fact, but at the same time a fascinating mystery:

> *Everybody says that it is amazing.*
> *I never saw anything great about it.*
> *It's just me, a part of me, the way that I always have been.*
> ...
> *Two tongues—a strange thought.*
> *I look in the mirror——I open my mouth.*
> *Go cross-eyed in the attempt to focus*
> *On the pink muscle that is the source of this mystery,*
> *The solution to which remains*
> *Forever elusive.*

Where Fatima has used a constant camera distance and frame (a head-and-shoulders close-up), Nayana uses in the first three shots a long shot with a slow zoom in to close-up, situating her in a wider outdoor landscape with trees, houses, roads, before emphasising her speaking presence. She also locates herself in different positions—against a tree; walking from an open background; sitting on a park bench. The effect, in combination with the words, is to suggest both an exploration of a self constantly on the move but also to suggest a self-confidence—the positions are controlled and calm, and the camera angle is often low.

Ayi's poem in English and Mandarin uses quite different camera techniques—dramatic close-ups, sharp variations of horizontal angle (frontal, profile, back view, mobile frame moving around her). These techniques are more reminiscent of the audiovisual forms of popular culture, especially music video. This, along with her leather jacket, her proud movements, her confident voice, the smile which lightens the tone of the whole piece in the penultimate shot, means that the very specific aspects of selfhood in this piece are represented in these modes, rather than through language. The words, unlike Nayana's and Fatima's, set up a formulaic structure representing her tongue as the actor in each line, the author of her experience of migration:

> *My tongue tells the story of my life*
> *My tongue tells that I am leaving*
> *My tongue knows when I am sad*

In many ways, the poem is not about the two distinct languages of bilingualism; for her, English is a recently learned language, and less eloquent, so that sentences begin in English and end in Mandarin. It is a poem about herself, about

her leaving of Hong Kong, about her mixture of sadness and excitement at the turbulence of the past year. And, just as the words do not construct the duality of bilingualism, neither does the sequence of shots in her film. There is no parallel structure as in Nayana's and Fatima's poem—rather, a single structure of montage, stitching together a representation of Ayi herself.

The other mode she employs, unlike Fatima and Nayana, is music. She chooses a piece written by a GCSE music student from the year before, in a traditional Chinese style, using the pentatonic scale and an electronic simulation of a Chinese stringed instrument, such as the *zheng* (Chinese zither), or the *yangqin* (Chinese hammered dulcimer). Unlike the camerawork and its suggestion of contemporary popular forms, this suggests Chinese tradition and amplifies the slight melancholy of the words. Sophie's poem, in French and English, employs the organic metaphors modelled by Sujata Bhatt, like Nayana: her two tongues 'live' and 'breathe'; they are 'like a pair of twins'. However, some of her imagery represents exactly the performative aspect of language which her video enacts—the twin languages both speak, but 'sound different, like an actress who plays a part with many characters'.

Her video begins with a medium long shot of her, sitting cross-legged on a stage block in a studio space, lit with reds and blues, looking down pensively. The choice of space—a drama studio, furnished and lit with the apparatus of theatre—is a visual complement to her image of the actress. There's a slow zoom into her face, then a dissolve into her speaking face with a blue filter as she speaks the first lines of the poem in English:

> *Two tongues occupy my mouth*
> *Both living and breathing inside*

There's then a dissolve into a bigger close-up, in black and white fading into colour, speaking the French lines. The dissolve suggests a continuity between the two identities and languages—the message of the next lines is exactly that:

> *I start a sentence in English, et je finis en Français*

The video continues to alternate between English in medium close-up and French in close-up; the transition always dissolves, the following shot always beginning with the colour washed out and gradually introduced. The camerawork generally locates her in a medium long shot, except for one extreme close-up, suggesting intimacy and, again, complementing the message of the line, which declares her strongest sense of the identity of self and language when she dreams and thinks:

> *Et quand je rêve ou je pense*
> *Je sais que ma langue est à moi,*

Et ma langue, c'est ce que je veux dire.
(And when I dream or I think
I know that my tongue is my own,
And my tongue, it's what I want to say.)

THE CASE FOR MULTIMODALITY AND THE MOVING IMAGE

What can we say about these short films with regard to the four arguments for the place of the moving image in English raised at the beginning of this chapter? Pieces of work like these make the multimodal case very clear. These are complex integrations of a wide range of signifying systems, and to think of them simply as language doesn't do them justice. In terms of creativity, this can be seen to depend on three things.

First, it depends on the motivation to say something important—in this case, to make a declaration of cultural identity, most explicitly about bilingualism but with important markers of teenage girlhood as well.

Second, it depends on the use of representational technologies, or resources. These include the obvious technologies of digital video but also the technology of poetic metaphor and structure. They also include the less self-consciously deployed resources of dramatic performance. It also depends on explicit understandings of how these technologies work. The value of the digital technology here is its ability, in the medium of digital editing, to offer the same plasticity and instant feedback to the student editors that the written word does when they rework, revise, edit their poems.

Third, it depends on artistic intentionality. All acts of meaning-making are creative, the banal utterance as well as the self-consciously artistic, but these pieces declare themselves as art. This might mean 'originality', as in the National Advisory Committee on Creative and Cultural Education's definition of creativity (NACCCE, 1999); but equally it means modelling, imitation, apprenticeship. Originality, in the post-Romantic conception of creativity, is fetishised, but more importantly I suspect it is confused with the stylistic markers of artistic genres. A child can be original in both thought and expression in a newspaper article or a report on a chemistry experiment, and we would want them to be. Similarly, in their poems and their films, we would want them to be. Here, then, creativity is about making something new—as in any genre. But, paradoxically, to make something new needs competence in the conventions and technologies of that genre; something new is always also something old, or there are no new stories under the sun, as James Joyce once remarked. In the context of media production, David Buckingham gives extensive examples of how really creative production work

depends heavily on imitation and apprenticeship, as well as demonstrating how such work is embedded in social motivations and processes (Buckingham, 2003).

In terms of media education, however, the films are unconventional. They exploit the 'popular' medium of the moving image; but they are emphatically not an imitation of a recognisable genre of the mass media—of film or television, for instance. But they are clearly a kind of creative media production, employing the signifying properties of the moving image, and the affordances of digital video, producing texts that can be distributed and exhibited in many different ways. They have, in fact, been screened in a cinema, at an event attended by Sujata Bhatt; and are also on the Worldwide Web as part of a site made by Jenny Leach and colleagues at the Open University (www.open.ac.uk/movingwords).

In fact, Parkside is, it is worth remembering, a specialist media *arts* college, not a media *studies* college. This is not to disparage media studies, which is a vital part of the work of this school. But it is to say that media production, whether in English, Design Technology, Art or Music, may be located in an arts education model as well as in a media education model, invoking pedagogies, cultural preoccupations and forms of evaluation quite different from those of media studies.

So—there are some challenges here for conventional models of media studies. But also for English. Our way of conceiving of 'English' notoriously privileges the written word, and these poems are, predominantly, written texts. But, as we have seen, they are also texts performed through voice and facial expression in particular, and made up of other physical signifiers such brick walls, park benches, human faces and musical melody; and of the signifying properties of filming and editing. The subject of English has no way to recognise such a complex of signifying practices. Its curriculum, in the UK, can only conceive of drama as an adjunct to speaking and listening, and so has nothing to say about the body and can only conceive of moving-image work as an adjunct to 'reading', whereas here it is clearly more like 'writing'. In any case, these films are unrecognisable by the assessment mechanisms of both English and Media Studies at GCSE. They would not easily fit the assessment criteria of either though, curiously, they would be admissible as coursework under the national GCSE assessment criteria for Art and Design.

CONCLUSION: TECHNOLOGIES OF PERFORMANCE

We have looked, then, at a kind of performance which students enact within media texts, through media technologies.

They show cultural roles, in which these young people take on the function of cultural makers, as poets, film-makers, game-players. But they also show how

the roles made available by media genres and technologies allow dramatic reworkings of aspects of the world closely related to identity—cultural passions, fashions, play, narratives of self, family and friends. At the same time, it becomes clear that we cannot reduce these representations to disembodied forms of text, whether these be the narrow perimeter of print literacy or the wider field of film, animation or interactive media. Nor can we reduce them to the technologies which provide part of the representational resources of these media. We need to recognise how signification is also made out of the material properties of voices, faces, fingers, bodies, trees, bricks and guitar strings; how the signifying apparatuses of the body integrate with those of the digital media of video, animation, game, to produce the elusive thing we call 'text'—something woven, as Walter Ong (2002) and others have pointed out, citing its derivation from the Latin verb *texere*, to weave.

In practical terms, the obvious message is that Drama, Media and English teachers need to talk to each other more, and overcome their separatist histories: Drama emphasising the value of unmediated dramatic presence; Media ignoring the bodily semiotic of face, voice and gesture in the vast majority of its textual canon; English blind to the extra-linguistic. In a world where texts are increasingly multimodal, then to profitably muddle the regimes of English, Media and Drama is no bad thing. All texts in English are about performance, at least potentially; and many of them (some would say all) depend on modes other than language. Most media texts are about drama. And most of the drama people see, as Raymond Williams once remarked, is mediated through television, contributing to what he saw as a 'dramatized society' (1974/1983). What we need to be specific about and clear about is not the illusory subject boundaries and the histories that prop them up but the common semiotic principles that underlie them. How to practise these, in as wide-ranging and well-resourced a way as we can, and how to help students reflect on them metalinguistically—these are what we should be about.

More specifically, media education reminds English how important the moving image is in contemporary culture. It also reminds us that a full engagement with the moving image demands production as well as analysis. Nayana, Ayi, Fatima and Sophie don't just use digital video—they learn how to set up and film shots, and how to edit their film in ways closely analogous to the processes through which they edited their poems. In doing so, they build a performance of self and language which points in one direction towards some exam question about the poetic word, but in another direction towards a world where such performances really have the cultural value that, too often, schools can only thinly simulate.

Potterliteracy: From Book TO Game AND Back Again— Literature, Film, Game AND Cross-Media Literacy

There is something Janus-faced about the Harry Potter novels. As Nicholas Tucker observes (1999), they look backwards in time to their sources in folktale and children's literature: to the orphan changeling stories of fairytale and of Frances Hodgson Burnett; to the magical characters and anthropomorphic animals of Victorian and Edwardian children's literature, from *The Princess and the Goblin* to *The Phoenix and the Carpet*; to the portals and parallel worlds of the *Chronicles of Narnia*; to boarding-school stories from *Tom Brown's Schooldays* to *Jennings Goes to School*; to the obsession with tuck in the post-war stories of Enid Blyton. On the other hand, as Tucker also points out, they are also rooted in the contemporary moment. Tucker's argument here is that they contain structures influenced, above all, by the images and practices of video-games. He cites, among other things, the arcade-like game of Quidditch; and the lists, maps and other means of puzzle-solving and game-survival that characterise the books.

The question of whether games influence books or the other way round is perhaps debatable in this case: Tolkien's stories also have maps, lists, puzzles and so on; *The Lord of the Rings* gave rise to one of the most popular of modern game-genres, the RPG (roleplaying game); and, as Marie-Laure Ryan observes, some stories are ideally adapted to serve as the basis of games (2001). In the same way, the Potter stories may be organised around the kinds of structures that make good games: quests, magical objects, helpers, monster opponents, a bounded fantasy

world, a puzzle dynamic. However, Tucker's thesis is generally convincing and, in the context of the film and computer game adaptations which form part of the AOL-Time-Warner franchise which has acquired the Potter rights, prompts some urgent questions for the teaching of literacy and literature. We can no longer afford to see literature as an entirely distinct mode and culture, with its own distinct literacy, as early studies of the relation between games and writing show (Beavis, 2001; McClay, 2002; Mackereth & Anderson, 2000). The books have grown into a cross-media craze, in which children's engagement extends across novels, films, computer games, the internet, and a range of merchandise worthy of *Star Wars*. We need to think, then, how different literacies come into play, how they connect, what they have in common. We also need to consider how these are located in the context of children's contemporary media cultures—the games they play, the films and TV programmes they watch, the comics they read. However, it is worth remembering that such cross-media cultures are not by any means a new phenomenon; Margaret Mackey (2001) compares the Potter franchise to the growth of Frank L. Baum's Wizard of Oz series a hundred years ago, and its extensive (and lucrative) adaptation into plays, comic strips and trading cards.

This is an opportunity to think hard about the rhetorics of multiliteracy and media literacy. What exactly do these mean when we look at the detail, at the 'micro-level' of literacy (Buckingham, 2003)? How does a particular image or narrative moment 'translate' across different media? If we expect children to learn about the notion of 'character' in literature or film, what does this mean in the context of a game? If they learn the category of 'verb' in language, how do we talk about this category in film? How is the 'verb' different in the interactive media of computer games? And how do these processes relate to macro-literacy, to the broader cultural experience of books, films and games within which such meanings are situated?

And what are these different formal structures representing? At the heart of this question, I want to place the question about the social purpose of Harry Potter for children and the forms of agency the character represents. This question runs through the literature: is the figure of Harry Potter essentially like the fairytale proxy for the child, pleasurable because he offers at least a fantasy of power in a world run by adults (Black, 2003)? Or is he more like the child hero of manga and animé (Japanese comic strips and animations), attractive because of his recuperation of techno-magic 'scavenged from an inherited Wasteland in a Romantic gesture of faith in humanity' (Appelbaum, 2003)? And are these two figures in fact different versions of each other? Finally, what of the wistful appeal of the orphan changeling, a figure which runs from folktale through the history of Victorian,

Edwardian and post-war children's literature (Tucker, 1999)? Does this trope allow children to fantasise about (or exorcise) the death of a parent, or the betrayal of a guardian, or the idealised parent, or simply the pleasurable lack of parent figures altogether? A further question we might add, which does not appear in the literature, is: why might some children *not* like Harry Potter? His appeal is not universal; and there is some evidence in the research reported on here of boys, especially beyond a certain age, becoming distinctly unhappy with what the character represents.

My approach in this chapter will be to look at one specific moment in *Harry Potter and the Chamber of Secrets* (Rowling, 1998; Columbus, 2002; Electronic Arts, 2002) across book, game and film; and to integrate this analysis with observations and interviews with children in two schools in Cambridge and London, UK, in 2003 and 2004.[1] This work forms a subset of two research projects in computer games at the Centre for the Study of Children, Youth and Media in the Institute of Education, University of London. The first project is *Textuality in Videogames* (2001–3), funded by the Arts and Humanities Research Board in the UK, a study of roleplaying games. The second is *Making Games* (2003–7), funded by the Economic and Social Research Council and the Department for Trade and Industry, a research and development project in partnership with Immersive Education Ltd. to develop a games authoring software tool. While this chapter will draw generally on these projects, it will refer in most detail to an interview with ten 12–13 year-olds in Cambridge (five boys, five girls) in 2004, specifically focusing on the episode analysed in this chapter, and an interview with one girl in London in 2004.

The analysis will draw on social semiotic and multimodal theory. In some respects, this will produce answers to questions about the literacies in play, both at micro-textual level and at a wider cultural level. It will also throw up questions, however. What kinds of literacy teaching would be needed to deal with this cross-media engagement? How might such pedagogies refer to traditions of children's literature, to children's contemporary media cultures, to forms of media and literacy education? I will return to these questions at the end of the chapter.

ARAGOG THE SPIDER—CROSS-MEDIA NARRATIVE TRANSFORMATIONS

Towards the end of *Harry Potter and the Chamber of Secrets*, Harry and Ron find the secret lair of the monstrous spider, Aragog, deep in the forest. They suspect

that the spider may be responsible for the sinister events happening in the school, in which children have been paralysed, and threats made of dire consequences obscurely related to the mysterious chamber of secrets. When Harry talks to the spider, she reveals that she is innocent and gives a clue to the identity of the real culprit. When Harry thanks her and says he must be going, however, she urges her offspring to attack Harry and Ron. In the book and film, they are then rescued by the flying Ford Anglia car which we have met earlier in the story. In the game, something rather different happens.

I want to look at aspects of three main functions of this sequence across the three media. These three overarching functions are derived from social semiotic theory (Kress & van Leeuwen, 1996; 2001; Lemke, 2002). Firstly, their *representational* function—in particular, how they convey what in language is a series of transitive sequences. Transitivity is central to narrative—the grammatical representation of who does what to whom, who performs an action, who or what is the goal. Our expectations of a hero, for instance, are that they will play a large part in the transitivity structures of the narrative—the implied overall structure is that the hero will combat and overcome the villain, and this is, of course, the basic structure underlying all the Harry Potter novels. In this respect, transitivity is used as a general narrative category—but this general structure will also be reflected in the equivalent of sentence level in book, film and game, as will be shown later.

Secondly, their *organisational* function. In particular, how are these texts differently organised to allow certain routes through by readers, viewers, players?

The third function is the *orientational* (Lemke, 2002) or *interactive* function (Kress & van Leeuwen, 2000), or *interpersonal* (Kress & van Leeuwen, 1996)—how the text orients itself towards its audience; how it functions as a communication between social agents. In particular, in this case, there are three interesting questions in this respect. Firstly, how are we encouraged to position ourselves 'with' Harry—what Genette (1980) calls 'focalisation'? Secondly, how are we brought into an affective relation with the text—how does it function to excite its readers within the context of an episode of high dramatic importance? Thirdly, how does the text convince us of its authenticity, its credibility? How does it create a claim of high modality, that aspect of language and other semiotic modes which makes truth-claims? How does this work in a fantasy narrative of this kind, and how does it work differently for different readers, spectators, players?

Finally, a word about the use of the interview material. My intention here is to regard the texts (book, game and film) and the talk of the children as one semiotic and cultural continuum, which can be analysed using the same framework. The children's engagement, response, interpretation will be viewed as a cultural and social process, but it will also be viewed as a semiotic transformation of the

texts, and a transformation which implies the possibility of educational intervention.

REPRESENTATION

In the book, this entire sequence is quite brief—less than half a page. Here it is in its entirety:

'Go?' said Aragog slowly. 'I think not...'

'But—but—'

'My sons and daughters do not harm Hagrid, on my command. But 1 cannot deny them fresh meat, when it wanders so willingly into our midst. Goodbye, friend of Hagrid.'

Harry spun around. Feet away, towering above him, was a solid wall of spiders, clicking, their many eyes gleaming in their ugly black heads...

Even as he reached for his wand, Harry knew it was no good, there were too many of them, but as he tried to stand, ready to die fighting, a loud, long note sounded, and a blaze of light flamed through the hollow.

Mr Weasley's car was thundering down the slope, headlamps glaring, its horn screeching, knocking spiders aside; several were thrown onto their backs, their endless legs waving in the air. The car screeched to a halt in front of Harry and Ron and the doors flew open.

'Get Fang!' Harry yelled, diving into the front seat; Ron seized the boarhound round the middle and threw him, yelping, into the back of the car. The doors slammed shut. Ron didn't touch the accelerator but the car didn't need him; the engine roared and they were off, hitting more spiders. They sped up the slope, out of the hollow, and they were soon crashing through the forest, branches whipping the windows as the car wound its way cleverly through the widest gaps, following a path it obviously knew. Harry looked sideways at Ron. His mouth was still open in the silent scream, but his eyes weren't popping any more.

'Are you OK?'

Ron stared straight ahead, unable to speak.

They smashed their way through the undergrowth, Fang howling loudly in the back seat, and Harry saw the wing mirror snap off as they squeezed past a large oak. After ten noisy, rocky minutes, the trees thinned, and Harry could again see patches of sky.

In terms of representation, we have expectations of Harry's performance as hero. The genre of the story, a fantasy quest narrative, would suggest that Harry will be performing most of the action. I have explored elsewhere how the protagonists of the narratives of popular culture operate through forms of external action (Burn & Schott, 2004). In Walter Ong's terms, they are 'heavy heroes', and 'agonistically toned' (1982), which is to say that they approach the problems of their quest through external action rather than internal psychological processes, like the warriors of the Homeric oral formulaic narratives.

It is remarkable, therefore, that in this sequence, Harry only performs four actions proper:

> *Harry spun round*
> *…he reached for his wand…*
> *…he tried to stand…*
> *…diving into the back seat…*

None of these actions accomplish the function of hero; those closest to the agonistic role of the hero, involving the weapon and the stand against the enemy, are markedly incomplete—*he reached for his wand*; *he tried to stand*. Both are about survival—they have no Goal, in narrative terms, since they are reactive movements to Aragog's threat, which positions Harry as the Goal of the transitive narrative sequence here (if not strictly of the linguistic goal, which is the *wand*).

This feature of the passage in the book is recalled very clearly by one of the girls in the Cambridge interview:

> IONA: He uses [his wand] in the book, he uses it for the Lumos spell, and then I remember they say 'He was prepared to fight to the death', cos when they're surrounded he said, 'He drew out his wand and he was prepared to fight to the death, even if, even if he drew his wand he knew there were too many' or something, and, um, I don't think he actually cast a spell but he got his wand out [*waves hand clasping imaginary wand*].

This clearly replays, lexicogrammatically and gesturally, the representational structures of the book, with minimal changes. It is also an interpretative transformation, in which the clause 'I don't think he actually cast a spell', suggests that she is keenly aware of the surprising lack of action here.

The grammar of the text suggests that the real hero of the episode is a *deus ex machina*, the Ford Anglia, which is responsible for the sounding of 'a loud, long note' and the flaming of 'a blaze of light'; which *thunders* down the slope, *knocks* spiders out of the way, *slams* its own doors shut, *accelerates* away with complete autonomy, and winds 'cleverly' through the forest, the adverb neatly anthropomorphising the vehicle.

In fact, the car is so heroic and decisive in its actions that it completely outdoes the spiders also, which do very little in this sequence other than clicking and gleaming in a threatening manner and getting knocked over by the Ford Anglia.

Three of the children recall this very clearly:

> OGEDEI: I thought—yeah—the car comes along—it honks or something—and then—the spiders get scared away by the light—and er—

IONA: —and he bowls over some of the really big spiders—it like smashes into them, and there's a mass of hairy legs or something, like long hairy spidery legs…

ALI: I remember that they, um, the car, um, bowls over a few spiders that are trying to stop the car, so it just kind of jump—makes them jump out of the way.

Again, their interpretation clearly underlines the representational structures which present the car as the heroic actor of the sequence.

Perhaps this analysis of action is not so surprising. Aragog and the spiders are, in a sense, not real enemies but a diversion, a smaller obstacle in the path of the main quest and its attendant villain, a composite of force of nature, the basilisk, and evil magic, Voldemort. In this respect, the structure resembles the hierarchy of opponents in action adventure computer games, where end-of-level boss monsters may hold you up for a while, but the big battle is reserved for the boss at the end of the last level. However, such hierarchies are arguably inherited from older forms of narrative. Tolkien's stories have similarly escalating episodic conflicts which lead up to a final confrontation, in *The Hobbit* with the dragon, in *Lord of the Rings* with Sauron. Indeed, Aragog is suspiciously similar to one of Tolkien's minor 'bosses', Shelob the spider.

The children reveal specific kinds of knowledge of such characters, three of them naming Shelob as a similar kind of character to Aragog, for instance, when asked to make a comparison between the *Chamber of Secrets* and other books or films.

Another explanation for Harry's relative inaction might be that he is generally, at least in the first two books, a mixture of action and vulnerability. He is certainly constructed as brave, kind, self-sacrificing and the bearer of powerful magic. But he depends heavily on magic helpers, such as Dobby the house-elf and Fawkes the phoenix, on friends who are equally brave, like Ron, or cleverer, like Hermione; and on the good adults, in particular Dumbledore. If he is, then, a typical fairytale representative or proxy for the child, the courageous small person against the giant threat, then a winning component of this construct is his vulnerability. Certainly, his appeal for children is rooted, for some critics, in his similarity to the protagonists of European folktale (Black, 2003; Tucker, 1999). We might add that the narrative function of folktale protagonists is structurally related to the function of helpers of one kind or another, in that the protagonists belong to character-clusters whose members are mutually dependent, as Propp's morphology of the folktale demonstrated (1970).

When asked to compare Harry to other characters in books, films or games, three of the children in the group named Frodo as a similar character, which suggests an awareness of a hero-character as marked by his vulnerability and need for helpers as by his courage. One boy, Stephen, mentions that if Harry is similar to Frodo, then

Ron is like Samwise Gamgee. Josie, from the London school, also mentions Frodo as the comparison which is most obvious to her, and when asked why, the characteristic she selects is that Harry and Frodo 'are always coming to harm'.

However, Harry's vulnerability was not seen by all the children as positive. One boy, Ogedei, clearly perceived him as annoyingly weak, and compared him to the Orcs in *Lord of the Rings*, because he was 'irritating'. This may be part of a tendency for boys to distance themselves from Harry's 'goodness', subverting it by demands for violence or toughness. In the observation of 11 year-olds from the previous year, a number of boys in the class of thirty expressed forms of ironic subversion of Harry. Iona explains Harry's inability to kill the spiders in the book as evidence of the 'goodness' the character has to maintain, to which Ogedei responds with another dismissive remark about his weakness:

IONA: If he killed spiders in the movie everybody wouldn't like him because he'd be a coldblooded killer. You have to keep Harry Potter as nice as possible.

OGEDEI: Yeah but Harry Potter's like sad, he's just like such a little, um, um, he's like a teacher's pet, he's just running around doing this stuff....
 I'd like it if he could get better spells—

IONA: Like Avrakedavra, a killing spell?

OGEDEI: No, like flame, like a flamethrower [*laughs*]

Both children seem to recognise that goodness is an essential feature of the character, but they value it differently. If Harry Potter provides raw material for children's fantasy play, it may be that for some children it is a kind of play that is too safe, too regulated ('teacher's pet'), too close to the ordered form of play Caillois calls 'ludus' (2001), and Sutton-Smith (2001) calls the 'progressive rhetoric' of play, easily incorporated into the moral and socialising frameworks of education. Ogedei, like many boys of his age, is looking for something altogether more subversive and anarchic, his gleeful proposal of the flamethrower closer to the chaotic and dangerous forms of play represented by Caillois's 'paidea', or chaotic play, and Sutton-Smith's rhetoric of play as Fate, a more ancient, adult understanding of play, predating the rational orderliness of Enlightenment formulations.

The Aragog sequence in the film displays subtle differences in the representation of Harry. Although we see him from a high camera angle during the conversation with Aragog, emphasising his vulnerability and the spider's giant size, in subsequent shots the angle is much lower, so that he appears as a much stronger figure. There is no evidence in the interview of the children noticing that the film represents him as more powerful, however. The only person to mention the camera is Sam, who cites the moment when 'the camera moves' to reveal a mass of spiders slowly descending on Harry and Ron, as the moment which made him

jump most. His reconstruction of this filmic structure relates, then, to Harry as victim rather than Harry as hero.

In the film, Harry's actions are presented as decisive and powerful—he uses his wand, which does effectively knock over a number of spiders; he directs Ron in various ways; he saves Ron from falling out of the car. However, the children do not remember these actions; asked several times whether Harry uses his wand in the film, they insist that he doesn't. Again, their memory is of the character as victim.

Furthermore, the sequence is extended at greater length than the one in the book, which, as we have seen, occupies only half a page or so. The narrative temporality in the book is a mixture of telling detail ('Harry saw the wing mirror snap off as they squeezed past a large oak') and what the narratologist Gerard Genette called ellipsis, in which the time of the story is squeezed into much briefer passages of narrative ('After ten noisy, rocky minutes'). In the film, the reverse happens— these ten minutes are played out more fully, and the more they are extended, the more the spiders become credible enemies, and the more Harry becomes a powerful hero. Indeed, he and Ron are constructed in this sequence in ways that are comparable to last-stand heroes in other movies: the series of temporary triumphs against the spiders, succeeded by a moment of ambiguous silence, and then by the dawning horror of more massed ranks of the enemy coming over the next ridge, are typical cycles of suspense and resolution in many action movies. The Potter generation will have learnt such cinematic conventions from Frodo and the Orcs in *The Lord of the Rings* trilogy; or Anakin Skywalker and Queen Amidala against the cloned warriors in *Star Wars Episode II: Attack of the Clones*; or Sam Neill facing growing numbers of dinosaurs in the *Jurassic Park* franchise.

Penny (Cambridge) clearly recognises these peaks and troughs:

> PENNY: There's a bit where they're in the car, and you think they've escaped, cos Aragog's kind of, held back, and the, and the, and there's a couple of smaller spiders running round, and then suddenly there's a huge spider which just JUMPS [*violent forward thrust of right hand*] onto the back of the car [*same hand on forehead*], and even if, even if the spider itself isn't that scary, it's kind of, it just kind of makes you do that [*demonstrates jump with face and hands*], cos you think they've kind of got away.

Another semiotic mode film employs is speech. While Harry has most of the speech, as in the book, Ron says very little, but pulls the comically-terrified face that has become something of a trademark of the actor, acts under Harry's direction, and offers moral support. However, he is given one extra line in the film, and it is significant enough to be remembered by Iona, who speaks it with a convincing mimicry of Ron's comic expression: 'Can we panic now?' In these specific ways, as in general, he is constructed as the loyal but not-quite-so-bright sidekick. As

we have seen, Sam points out that if Harry is like Frodo, then 'Ron's like Samwise Gamgee'. Josie, in London, also makes the comparison between Ron and Sam, and extends the comparison to point out that, just as Frodo is supported by the fellowship of the Ring, Harry is supported by his friends, as well as adults such as Dumbledore, whom Josie compares to Gandalf.

More generally, the speech of the books and films is perceived quite differently by different children. For Iona, part of the appeal of the texts is that the characters speak like those in her world: the teachers speak like her own teachers. For Josie, entirely the opposite is true—the appeal is that the characters and their school are nothing like her own but are an ideal she can fantasise about.

The game represents a marked shift. In representational terms, Harry's actions are quite different from book or film. At the end of the cut scene (a pre-rendered animation which presents the conversation with Aragog), Harry has to fight the spiders, cut the masses of web that hold Aragog aloft, and then fight Aragog herself as she descends. He cuts the web and attacks the spider by casting the Rictusempra spell (left mouse button); and evades the attacks of Aragog and her children by running (arrow keys) and jumping (control key). These actions are effectively the verb-stock of the game-grammar—we have control over six actions Harry can perform (four directions of movement, spell-casting, and jumping). In narrative terms, this might seem profoundly impoverished. but in game terms, it is entirely normal to work with a 'restricted language' (Halliday, 1989), and the pleasure lies in the skill of the player to deploy these resources well to meet the challenge of the game. Furthermore, while we and the protagonist-avatar can only perform six actions, the sense of agency is hugely increased (the avatar is the player's representative in the game-world, from a Sanskrit term referring to the descent of a god to earth). While there are more (but not many more) verbs in the equivalent passage in the novel, they represent Harry effectively as Goal in this scene, as we have seen. In the game, we only need to be able to run and cast spells in order to defeat the giant spider. This narrative, then, becomes a very different kind of narrative, in which the transitivity sequence of the book and film is effectively reversed, or at least, rebalanced, so that Harry becomes Actor, Aragog Goal and vice versa, the balance depending on the skill of the player.

It is worth noting, however, that it is not only skill that is in question here, but aspects of the social contexts in which the game is played. Annie admits that she was killed twice by Aragog, and then asked her sister to complete the level; so that the agency of the character in the game narrative was affected not only by the player's skill but by the help she was able to summon. In my case, as a player, I arrived at this sequence with insufficient health, since I had not collected enough magic potions along the way. After being killed by Aragog several times, I found a cheat on the internet which allowed me to edit a program file in the game to give

me full health, so that I could complete the level. However, the ideal way to balance the power of the avatar against the boss enemy would have been tactical, as Ogedei pointed out in the interview. He was the only member of the group who argued the need for tactics in fighting bosses. The implication here, then, is that his level of game literacy was greater than either mine or Annie's though both of us reached for legitimate support mechanisms common in game culture: peers and cheats.

However, other children in the group are aware of the differences in agency in the game and how this relates to the ludic aspects of the game as well as to its narrative. Annie is very clear about the differences in action between the game and the book or film:

> ANNIE: In the book and the film you just kind of, you talk to Aragog and then you jump in the car and you have to get away as quickly as you can, but in this one you actually have to do something.

Iona makes the point that you have specific goals in the game:

> IONA: In the game, you actually have to actually play as well, and they change it quite a lot as well, don't they, I mean it's difficult, you actually have to have goals, like Annie said, you have to actually shoot the web, and, um, it's just very different, because, I mean, you can't really imagine Harry and Ron sort of trying to poke their wands in Aragog's eyes or something.

This game-grammar—a limited stock of actions but operated by the player —is reflected by the language of the box of the game, which says, on the back, 'Dare to return to Hogwarts! Be Harry Potter in the Chamber of Secrets!'. These imperatives in effect invite the player to become the protagonist in some sense. In what sense exactly is worth considering—we certainly adopt the 'agonistic' function of the hero (Ong, 1982), fighting his fight; and as we have seen, this function is much more strongly developed in the game than in the book or film. On the one hand, it can be seen as a return to the bolder, simpler structures of folktale narratives, in which two-dimensional heroes, unencumbered by psychology, battle external forces. On the other hand, it can be seen as a cultural (and technical) connection with fighting games, such as third-person shooters, generic elements of which this game contains.

The 'heavy heroes' of oral narrative can also be related to the protagonists of popular narratives in film, television and animé. In the case of Harry Potter, this derivation is configured in quite specific ways. Harry the game character learns his power, literally—he acquires the necessary spells for later challenges by attending lessons in the game's version of Hogwarts; while we, the players, simultaneously acquire the skill to deploy the spells. In game culture and technology, this is

completely to be expected and follows the pattern of 'training levels' in other games, such as *Tomb Raider 4* (Eidos, 1999), in which the 16-year-old Lara Croft and her player are simultaneously taught their tomb-raiding skills by Professor von Croy (for an analysis of the learning processes in this sequence, see Gee, 2003). However, this kind of learning also reminds us of how the heroes of popular film acquire and learn to use their powers—an example likely to be familiar to the Potter generation is the instruction of the young Luke Skywalker by Yoda and Obi-wan Kenobi in the skills of Jedi knighthood in *Star Wars*.

At the same time, this trope has its equivalent in fantasy children's literature— we might think of the Wart being instructed by Merlin in *The Sword in the Stone*, or (more similar to Harry Potter), the apprentice wizardry of Ged at the School for Wizards on Roke island in Ursula le Guin's *Wizard of Earthsea* trilogy.

ORGANISATION

An important principle at stake here is the notion of 'reading path' (Kress and van Leeuwen, 1996). This is the route the reader will take through the text, a route partly determined by the textual organisation specific to the communicative modes in play. So the book of Harry Potter will be read sequentially, insofar as reading is a time-based activity and print follows a linear progression. However, as it is also a spatial medium, and as the reader has control over the time and spatial dimensions of the book, the story can be skipped, read out of sequence (the end before the beginning, for instance), and so on. The film is more resolutely time-based in ways that, at least in the cinema, the spectator cannot vary although viewers of the DVD can fast forward, freezeframe, and select 'chapters' in ways closely analogous to the book. The reading path in the game is a very different matter. Lemke (2002) distinguishes between the *trajectory* of hypertexts (the route implied more or less strongly by the text) and *traversal* (the route actually chosen by the reader). In the case of this game, then, there is a strong trajectory across the major blocks of narrative and gameplay. Where there is more room for different traversals by players is quite specific. In between the major narrative events and challenges, the player has a kind of free time. This can be used to wander around Hogwarts, exploring, picking up extra resources (there are a number of rewards hidden around the castle and grounds); to play Quidditch; or to challenge characters to duels.

Penny explains some of the differences in structure, from the reader's and player's point of view:

> PENNY: Well, sometimes, well with Harry, well with the book, you'll be, you're just you're just reading it and everything just falls into place, whereas in the

> game you have to walk around quite a lot and sort of make sure you find so
> you know what to do what the next step is and sometimes you have to
> maybe talk to a character so you can find out where you're meant to go next,
> but it's not like one thing leads after another and you're just automatically
> transported to the next bit you have to complete.

In ideal terms, it might seem that the player has the power to 'write' the story—but
of course, there are limits, and a series of tradeoffs between the need to maintain
a relatively fixed narrative structure which will replicate the story of the book and
film and the need to offer the player some control over the sequence of events. In
this game, then, the most fixed elements of narrative representation are the cut
scenes, which are very frequent, and which contain all the backstory, all the dia-
logue scenes, and all the dénouements or conclusions to each level. The next level
up is the order of events. The levels are organised around four challenges, to
acquire the spells necessary to accomplish essential moves through the narrative.
The order of these challenges is fixed; as is the order of narrative events which
Harry must act in, such as the raid on the Slytherin common-room, disguised as
Crabbe and Goyle, or the duel with Malfoy, or the battle with Aragog, or the final
battle with the basilisk.

The question of choice provokes an argument among the children. Ogedei is
fairly dismissive of the game, arguing that players have very little choice, and that
much of the game is pre-determined, while Iona argues that there is real choice,
though she does not give specific examples. In some respects, this may reflect the
different perceptions of experienced and less experienced players. Iona and Annie,
who both claim there is choice, are relatively inexperienced and have been attracted
to the game through its association with the Potter franchise. Ogedei is a com-
mitted gamer, as we know from earlier research with his group, and can compare
the experience of this game with a wide range of others (here, for instance, he
compares fighting Aragog with the tactics you need to fight one of the monsters
in the first *Lord of the Rings* game). The less experienced players are more likely to
be impressed by the appearance of choice than those who have played with different
game systems and have a more varied experience of what choice might mean.

So reading path, or traversal, is central to literacy, but specific to different
modes and media. In the case of the game, to read the choices on offer tactically,
as Ogedei does, is to know how the game is likely to develop, to read predictively
in ways analogous to the predictive skills of reading print, though for different
reasons. Myrtle, from the London school, also points out how the Harry Potter
games can be explored in quite specific ways if you know what you are looking for:
her example are the Wizard cards that are buried around the game, which will
provide payoffs later if you have collected enough. Again, this is a tactical chal-
lenge, quite distinct from the narrative drive of the game, and an example of how

a game-literate player will explore the game-world differently from one who is not so experienced.

ORIENTATION

The *orientational function* of the sequence in the book is unsurprising, in many ways. Harry is effectively *focalised* (Genette, 1980)—he appears as the subject of more clauses than Ron; he is foregrounded in the first part of the passage when Ron is not mentioned at all; he utters three lines of dialogue, whereas Ron doesn't speak; we are party to his thoughts ('Harry knew it was no good'); and we see through his eyes at the end: 'Harry could again see patches of sky.' These focalising devices are consistent with the rest of the book, indeed all the books, and offer us a position close to the protagonist.

The affective quality of the passage is created, again, partly by verbs, which often represent extreme or intensified sensory experience: *flamed, thundering, screeching, knocking, yelled, seized, slammed, crashed, howling.* It is also created by the pace of the narrative, especially by strings of short clauses built around these intensive verbs. It is these verbs which are recalled by the children as they select what is significant about this passage, Iona and Annie turning 'knocking' into 'bowled', and Ogedei turning the 'screeching' of the car's horn into 'honking'.

However, it is also created, perhaps, by the knowledge of Harry's plight, and the explicit threat of death, which is quite differently managed in the game, and arguably not explicitly present at all in the film. This relates in two ways to the overall representation of death in the books. On the one hand, death has always been a threat, from Harry's near-escapes from Voldemort, to the much-publicised death of a character in *The Order of the Phoenix*, which turned out in the end to be the death of Sirius Black, a kind of second orphaning for Harry, to whom Sirius had become a substitute father. On the other hand, the death of Harry's parents is a running theme in the book, and they appear as mournful ghostly presences at regular intervals. The children show some awareness of death in the books. Iona, as we have seen, recalls Harry's readiness to 'fight to the death'. Annie predicts that the series of books will end with a death; and Iona goes on to suggest that it will either be the death of Harry or of a friend, so that there can be some grief but then a recovery. Josie, in London, also predicts that in the last book, 'Harry's going to die to save everyone'. However, how children engage with this increasingly sensitive area of the books and films raises interesting questions for future research.

Finally, the modality of the piece. In this case, 'modality' refers specifically to the 'truth-claim' made by the text, rather than to other aspects of modality in

functional grammar. This depends partly on the location of this sequence in a wider world whose reality has already been produced as a set of shared beliefs between the text, the genre, the tradition of fantasy and fairytale, and its readers, past and present. In this world, it is not the existence of giant spiders that will lower the modality, in other words, reduce the truth-claim, of the text. Rather, it will be how well such fantasy structures are rendered that will raise the modality. In this respect, the sensory detail invested in the fantasy elements is important: the clicking sound of the spiders and the gleaming of their eyes or the intense effects of the verbs representing the action of the flying Ford Anglia. In this respect, the intense fascination for children of magic is important—a fantasy technology empowering the child. This is the appeal of Appelbaum's gundam child, and Josie, in London, is emphatic that magic is the appeal of the books for children: 'Kids are supposed to like magic'.

In orientational terms, the film realises similar meanings in visual terms. Harry is, again, focalised—we are close to him visually throughout the sequence, and again, he has a larger proportion of the action than Ron. We are connected through frequent close-ups, over-the-shoulder shots that locate him in the foreground with his back to us and the spiders in the background, and, perhaps most importantly, through our familiarity with the audiovisual representation of the character and our memory of his prominence earlier in the film, and in the previous film.

The affective structure of the sequence is also different from the book. It is structured, as we have seen, round a series of false resolutions and shock attacks, so that the affective aspect of the battle with the spiders is organised as a series of peaks and troughs rather than a constant level thrill. This structure is generically typical of modern thrillers and horror films, which organise high moments of conflict as, effectively, rollercoasters. As we have seen, Penny recalls this sequence vividly, and her gestures represent the violent thrust of the image of the spider from the text, followed by the hand on the brow to show the shocked response of the viewer. Annie agrees that this moment made her jump but adds an important qualifier: that what made her jump more is a kid who screamed behind her in the cinema, reminding us that the communal viewing experience in part creates its own affective climate.

In terms of modality, there are some similarities between book and film. Again, the truth-claim made by the fantasy elements is grounded in an intense sensory modality (Kress & van Leeuwen, 1996), with both visual and auditory details of the spiders and the flying Ford Anglia powerfully enhanced. Fantasy needs to be more real than real to be credible—to achieve the hyperreality Kress and van Leeuwen argue is characteristic of the sensory modality. However, there are also differences. Film must realise more fully aspects of representation which

language need only sketch. Important examples of this here are Harry's face and physical presence, realised as Daniel Radcliffe. This, as a semiotic syntagm, or string of signs, makes its truth-claim partly through signifiers derived from the book (the black hair, green eyes and scar); and partly on the replication of the features of the actor already successfully established as 'Harry Potter' in the first film.

The children mention other details. Iona remarks on the trees in the film:

> IONA: I thought it was good because the trees looked really kind of real and quite sort of haunty [laughs]—is the only way I can think to describe it, they were really tall and absolutely huge, and they spinned, and imagine being chased by little hairy things, and very big hairy things as well! [laughing]

The two adjectives used to describe the trees here emphasise the complexity of modality judgments made by viewers. On the one hand, the credibility of a textual detail is judged by its versimilitude (*real*); on the other hand, by its truth to the fantasy genre (*haunty*).

It seems clear that a high modality will depend on the function of Harry as the folktale protagonist: Harry is believable and convincing for some of these children because of his mixture of bravery and vulnerability. However, there is also a tissue of cultural references to the popular narratives of contemporary cinema and television, which have the general effect of heightening the agency of the protagonist, and the modality of the film in general. The frequent references made by the children to *The Lord of the Rings* recognise some of these references, and Iona makes explicit how the similarity of Harry to Frodo revolves around a particular set of characteristics: 'They're both plagued by honour'. However, the modality judgments made by the children will depend on what genre in particular the film is judged against. While the girls in particular are comparing it with fantasy films, Ogedei is thinking of horror films, in which context he finds Harry Potter wanting:

> OGEDEI: I didn't find anything at all scary! It's only a PG!
> IONA: Are you saying if it's an 18 you'd find it scary?
> OGEDEI: I prefer, like, really scary movies, like, er, Friday the something, no wait, I haven't seen that one, but I've seen the Jason X film, which isn't really scary, but it's really bloody, really disgusting.
> IONA: What about Sleepy Hollow?
> OGEDEI: Yeah, that's—no, not scary! That's for little kids!

While the film's modality depends partly on its fidelity to the book, then, in a different sense, it depends on its truth to its genre, or its 'presentational' modality (van Leeuwen, 1999).

In the game, again there is a dramatic difference. If Harry's repertoire of actions has much greater power than in the book or the film, we are no longer addressed as spectators who simply sit and watch these actions unfold. Rather, we are addressed in the ludic equivalent of the second person—you must fight the spider, you must be Harry Potter.

If game has an equivalent of focalisation, then it is even more strongly built around the figure of Harry. Since he alone is constructed as the player's avatar, we are addressed by the game as if we are Harry. An implication of this is that we are more distant from the subordinate agencies of Ron and Hermione. In the book and film, their agency is essentially the same as Harry's—it is a sequence of actions which we observe from the outside. In the game, we play Harry, but cannot play Ron or Hermione—an absolute distinction. In the third game, *The Prisoner of Azkaban*, this structure has been differently designed—we play Harry, Ron and Hermione in turn, which offers a quite different set of resources for our imaginative engagement with the game and the narrative.

The children are quite specific about how the game locates them. Three of them say, when asked if they feel they become Harry Potter, that they don't; they observe him from the outside and manipulate him. Two of them argue that they would feel more like Harry if it was a first person game and they could 'look out through his eyes' (Jake). However, Josie (London) feels quite different:

> JOSIE: You're controlling it, really, and it's actually like you're there, and you're the one that's doing it, you're Harry Potter.

There are no representations of Harry's emotions during the conflict, as there are in both book and film. If anyone feels these, it is the player, who feels considerable anxiety as the spiders attack, as the huge Aragog looms up and threatens to overwhelm us, as the insistent call 'Bite him, my children!' repeats through the sequence.

The children are clear that the emotional experience of playing the game is quite different. When asked if they feel like Harry Potter, they say no; Iona says that 'in the adrenalin thrill' of the game, you don't have time to worry about Harry's feelings. Of course, this observation registers a different kind of affective engagement with the excitement of the game.

The modality of the game, like the film, depends on two dimensions—its fidelity to the original (though this might now be seen as either book or film); and its fidelity to its genre, in this case action adventure games. Josie finds the game authentic because it allows her to be Harry Potter in certain specific, exciting ways: she mentions the ability to do spells, to jump, to play Quidditch, to fly on broomsticks. These make the games compelling, even if aspects of them disappoint—she

mentions the quality of the graphics in the Gameboy Advance version of *The Chamber of Secrets*, for instance.

MEDIA LITERACY: MULTIMODAL OR MODE-SPECIFIC?

It is clear, then, that in related but rather different ways, all three versions of *Harry Potter and the Chamber of Secrets* construct a child-hero with whom readers, viewers and players can empathise, as a vulnerable but courageous opponent of assorted monsters, adults, and metaphors for fear of the dark, an admirable character for some of the children, 'plagued by honour', but for others, a 'teacher's pet', too good to be really interesting. These are the kinds of meaning which children construct, and which connect with their changing understanding of the place of children in the world, the possibilities of contesting adult power on the one hand, but looking to it for protection on the other, the importance of friendship and the culture of their age group.

If Harry Potter does reach back to traditional themes and tropes of children's literature and folktale but also derives some of its substance from the images of the present day (or Rowling's youth), then in some way the children seem aware of this in indistinct ways. Iona's phrase 'plagued with honour' strongly implies an awareness of literary traditions and idioms; while Josie argues that the important thing about Harry Potter is the magic: 'Kids are supposed to like magic'. This idea cannot exist without a cultural experience of magic as an element in children's narrative, and what it offers by way of solution to the problems of real life, or as the kind of glamorous alternative Josie enjoys.

However, while the job of the critic may be to dig out the provenance of the narratives, the job of the reader, viewer and player is to engage transformatively with book, film and game. The most marked feature of the children's intertextual awareness, unsurprisingly, is their relation of Harry Potter to other texts current in their popular cultures, in particular *The Lord of the Rings*. For some of them, this is a literacy centred on book and film, a comparison of character types and narrative themes. For others, in particular Ogedei, it is a literacy centred on games, where the salient comparisons are playing tactics and boss monsters.

But the question of literacy also requires an account of the different systems of signification children engage with across these media, and how meanings are made both within each medium and across the different media. At one level, there is a detailed understanding and interpretation of how these different texts work at a micro-level—what particular words or phrases mean in the book; what particular images or sounds mean in the film; what particular actions mean in the game.

At the whole-text level, there are interpretations and understandings of narrative, of character, of theme, and of game-structure. At a wider cultural level, there are comparisons, evaluations, connections being made on the basis of generic similarities, narrative similarities, formal similarities, thematic similarities.

But more, these understandings and interpretations run across different modes and media. English teachers have been familiar with comparisons of film and book for a long time, though arguably it is less common to find work of this kind which really exploits the grammars of language and film at a detailed level as well as the usual broader attention to character and plot. However, games raise a number of different questions, which these students' discussion emphasises. How, in these three different media, are such functions as point-of-view, location, narrative action, narrative temporality, narrative space, system of address, emotion, reader/viewer/player engagement, to be understood and mediated in the English classroom?

We should avoid the risk of simply homogenising representational structures and their attendant literacies across these media, however. Ogedei's argument about the need for tactics in fighting boss monsters or Iona's point about the goals of the game makes it clear that game-literacy is different from print and moving image literacy in spite of sharing certain representational structures. Similarly, Penny's observations about the temporal structure of the film make it clear that this works very differently from the book. If we are to recognise and build on these literacies, we must take account of media-specific features as well as ones which operate across and between modes and media. We also need to recognise the transformative work of the users of these texts. How they connect them with their everyday lives will vary dramatically, as Iona and Josie's opposing perceptions of the similarity of Hogwarts to their own schools shows. How they experience the interactivity of the game will also vary, so that for the children in Cambridge, the Harry-avatar was more of a puppet, whereas for Josie, it felt as if she was there, was 'being' Harry. How they judge their 'presentational modality' will also vary, depending on the structures of taste and value in which they locate them, as Ogedei's low opinion of the film compared to his experience of the horror genre demonstrates.

The 'grammar' of media literacy needs to be considered in tandem with the cultures of these media. We have always attended to children's literature in English because it is a living part of their culture, part of a pattern of engagement with powerful fictions that begins with fairytale, and which inducts them into frameworks for making sense of their world, morally, affectively, imaginatively. Traditional valuations of print literacy and culture are likely to be suspicious of newer media, especially games. However, enthusiasts of children's digital cultures are quite likely to reverse this valuation, representing the culture of the cyberkid

as a rupture with older technologies and communicative practices. What the present study suggests is that we need also to look for continuities. The Potter phenomenon demands a cross-media literacy, attentive to both general principles and to media-specific features; but it also demands a historical depth and continuity, a literacy which, like the Potter novels, is Janus-faced.

'Writing' Computer Games: Game-Literacy AND New-Old Narratives

The idea of writing is taken for granted as one side of the literacy coin in English and literacy curricula, classrooms and research, of which the obverse, inseparable, complementary, somehow made of the same metal, is reading. In the world of media education, things are not so simple. For historical reasons, 'media literacy' has been heavily weighted towards 'reading', variously constructed as practices of consumption, interpretation, analysis, critique and (more rarely) appreciation. The first influential motive for 'reading' the media in these senses in classrooms came from Leavis and Thompson's proposal to English teachers that they should arm children against the depredations of the mass media with the weapons of critical analysis (1933).

The development of media education since those days of 'inoculation' against ill effects has seen the growth of a consensus, albeit unevenly distributed across the Anglophone world (and differently again across Europe), around a more positive model, which recognises, especially in the wake of the Cultural Studies tradition, the value of popular media, and the need to explore them both critically and appreciatively (Buckingham & Domaille, 2003). Along with this has come the development of a critical apparatus of conceptual tools on which learners can hang understandings of media institutions, texts and audiences.

However, to return to the central focus of this chapter, this growing consensus has also increasingly emphasised the importance of the production of media texts

by young people. In a simple sense, this is an obvious logical step towards a complete idea of media literacy: 'reading' media texts needs to be complemented by 'writing' media texts. Needless to say, in practice and in research, things have been a bit more complicated. The rationales for media production have certainly included the idea that production is another way for learners to grasp the key concepts; but also other rationales: media production as expressive, aesthetic work; as identity work; as a challenge to dominant ideologies; as a form of pre-vocational training (Buckingham et al., 1995). At the same time, the nature of the key concepts changes or becomes differently specific when children make their own media texts: do they learn about media industries by simulating studio production? What do they learn about the 'grammars' of comic strip, film or computer game by making their own? How do they understand 'audience' differently by addressing real or imaginary audiences?

The other important element in this growing and complex field is, of course, the arrival of new media. The long debate about media literacy has, in this context, become implicated in the debates about multiliteracies, multimodal literacies, and digital literacies.

This chapter will explore three texts by secondary school students in the UK in order to steer a way through some of these complexities. However, it will also add its own questions. One question that dogs the media literacy debate is to what extent it is useful to construct 'sub' literacies related to specific media: television literacy (Buckingham, 1993); cine-literacy (FEWG, 1999); moving image literacy (Burn & Leach, 2004). Such sub-divisions, while running the risk of clouding the picture, do at least allow more specific notions of the formal properties, signifying structures, semiotic affordances and cultural milieux of specific media; though it is necessary also to pay attention to cross-media practices, understandings, technologies (Burn, 2005; Mackey, 2002).

In this spirit, then, this chapter will propose a notion of 'game-literacy', involving both the 'reading' and the 'writing' of computer games by school students; though the emphasis, for the purpose of this special issue, will be on the latter.

STUDENTS' GAMES

The analysis here derives from a three-year research project, 'Making Games' (2002–6), funded by the PACCIT-Link programme in the UK. PACCIT (people at the centre of computers and information technology) brings together researchers and IT industries to develop prototypes of products built around the needs of specified user-groups. 'Making Games' is a partnership between the Centre for the Study of Children, Youth & Media at the Institute of Education, London

University, and Immersive Education Ltd, an educational software developer in Oxford. The research is funded by the Economic and Social Research Council; the development is funded by the Department of Trade and Industry.

The aim of the project was to develop a game-authoring software for use in education. The rationale was based in the premise and practice in media education referred to above: common in media education: media literacy needs to be defined as the ability to both 'read' and 'write' media texts. While such combinations of analysis and production are now relatively easy to achieve in digital video editing, web-authoring, radio production of music composition and editing, games have remained elusive, and at the time the project began, there were no examples that we knew of which showed students actually making computer games within a model of media education.

The project has largely consisted of development work by Immersive Education, related theoretical work by the researchers, and fieldwork based on the use of successive iterations of the software. These have mainly been in two secondary schools: one in Lambeth, London, and one in Cambridge.

This chapter will analyse two games made by students at the Cambridge school along with a written proposal for a game by another student from the same school.

The analysis of these texts will be based in a model of media literacy (Buckingham, 2003), in a social semiotic theory of multimodality (Kress & van Leeuwen, 2001), and in models of literacy and new technologies applied in previous research to children, games and literacy classrooms (Beavis, 2001). It will also draw on recent developments in game studies. Because many computer game genres are narrative-based, a debate which has been vigorously exercised (but never quite resolved) is the 'narratology-ludology' debate, between approaches which adapt narrative theories to analyse games and others which argue that narrative is incidental and dispensable, and that ludic structures are the criterial elements of games.

Our argument has been, at least in the many game genres which are narrative based, including our own authoring software, that we need to theorise game and narrative together, attendant to their separate properties but also to how they fuse and integrate (Carr et al., 2006). In this respect, we are close to specialists in the field of game-studies like Gonzalo Frasca (1999), who argues that the structures of game and narrative have many similarities and are often closely implicated but are absolutely not identical. This leads us to explore how the students in our project designed games using this software but also designed narratives. Both game and narrative elements can be seen in terms of the metafunctions of systemic-functional linguistics (Halliday, 1985), variously adapted in social semiotic theory by Kress and van Leeuwen (1996), Lemke (2002) and Burn and Parker (2003). I

will mix between these versions, adopting the categories of a representational function, an interpersonal function, and an organisational function. The first represents the world or an idea of it; the second constructs relations between participants in the act of communication; the third constructs texts out of these representations and communications, by organising them into coherent wholes. The students' games, then, will be considered in terms of their constructions of game and narrative, and the social semiotic metafunctions will be referred to where they are relevant.

The purpose of the analysis, in this case, is to work towards a detailed notion of some aspects of game-literacy, seen as a subset of media literacy. These aspects will include the cultural provenance of the students' game designs in their own experiences of the media; the semiotic and specifically grammatical features of the designs; the conceptual frameworks within which their explicit understandings of their designs develop; and the multimodal work, including writing, which surrounds the process of making games.

In the context of the school curriculum, it will be important to think of how game-literacy relates to print literacy and specifically how game design relates to writing. These relations will be raised throughout the chapter, but may be briefly anticipated here. The argument will be that game design:

- has a grammar, which can usefully be seen in relation to the grammars of other semiotic systems, including both language and visual design, and these systems can all be approached through general semiotic principles of the kind derived by social semiotics from systemic-functional linguistics;
- develops conceptual awareness of narrative as well as providing new opportunities for the production of narrative, and such processes will both consolidate old understandings of narrative encountered by children (and teachers) and challenge them;
- involves writing in a literal sense, as part of the design process, as an integral element of games, and as forms of interpretive writing of the kind performed by game fans.

ELEANOR'S GAME

The context in which Eleanor's game was made is a series of media studies lessons over 6 weeks in the summer of 2005, with a Year 8 mixed ability group (12–13 years of age). The class teacher was James Durran, an Advanced Skills Teacher in

the Cambridge school, Parkside Community College, and a partner in the project. The lessons were co-taught by James and myself. The research was conducted by the project manager, Caroline Pelletier, myself, and David Buckingham.

Eleanor's game is a simple two-chamber game (the software allows the construction of gameworlds of as many chambers as will fit into the tile-editor, which can be seen at the top right of the screen in Figure 7.1). The two-chamber game was intended as an introduction to the software and to principles of game design: while constraining the length and complexity of the game, it allowed the students to build an environment, set a mission for the player, program rules which would determine events, and produce a simple narrative.

Her game is based around a simple narrative, which she was asked to produce as a written proposal:

> The story in our game is that Rose Tyler has landed inside a spaceship. She is in a room containing a still robot, a blue gem, and three identical levers. The one door out of the room is closed, and when she tries to open it it stays closed. Rose goes to the gem, it says 'one of these levers will open the door, the others will give you a little extra time before your oxygen runs out.' She tries each lever in turn opening the door. The robot is still there though. She goes over to it and it speaks. 'You must follow me and save the crew of this ship.' Rose follows as it heads through the door and into another room. The robot stops and the door closes behind them. The robot speaks again. 'I have run out of energy bring me four correct batteries and I can save the crew but beware there are 10 batteries not all are mine. You must be quick oxygen levels are low.' Rose tries every battery and finally, just before the oxygen runs out, she has all four. She has completed her mission and the robot can save the crew.

Rose Tyler is the female companion of Doctor Who in the BBC series of 2005. The students have been asked to make a Doctor Who story though Eleanor has made the decision to have Rose as the player-character. At this point, three aspects of our tentative model of game-literacy can be indicated.

Firstly, it concurs with both popular understandings and earlier academic formulations that literacy is a form of *cultural* competence. In media literacy debates, the emphasis here is on how young people draw on their experience of popular culture to make sense of new media texts they encounter or make. In this case, then, Eleanor's experience of Doctor Who provides possible protagonists and story structure.

Secondly, it demands that these thirteen-year-olds find a solution, at their own level, of the academic debate about narrative and game. This will involve *conceptual understandings* of both game (as a rule-based system) and narrative (at least in terms of character and plot); and so it will integrate with existing conceptual frameworks of media education, under the general expectation that students will

learn about the languages, codes and conventions of media texts. However, while understandings of narrative will be a familiar category in media education, understandings of game structures will not be.

Thirdly, as Eleanor translates her proposal into an actual game using the software, she quite quickly begins to develop an *operational* literacy: an ability to manipulate the compositional and editorial features of the authoring package.

The students in this course have explored narrative and game as well as certain specific features of game design, in particular rules and economies, which will be discussed in detail later in this chapter. For the moment, it is worth observing that Eleanor's story, while it is slight and undeveloped, fits both a computer adventure game and Doctor Who extremely well. Games need puzzles to be solved, rules to be followed, interlocking environments to be explored, 'technological' fixes to quantified problems, resources to be managed, missions to be accomplished, lives to be saved. And these are exactly the qualities that also make a good Doctor Who narrative.

There are good reasons for this, which will be developed further below. For the moment, it is enough to say that games enact certain kinds of narratives well, in particular those which feature action, which have quest-like structures, which have their own kind of rule-systems that more or less determine generically what can or cannot happen and how.

So, Eleanor's simple narrative emphasises the principal function of Doctor Who's assistant (to save lives); and the function of the robot, as a helper. These are both basic character functions of the kind specified in Propp's typology of folktale characters (1970). Further, Eleanor's game develops a narrative tension through a time constraint. It specifies particular rules: only one lever will open the door; only the four correct batteries will power the robot. The key thing is that these features are also ludic, or gamelike, features: what makes a good formulaic narrative of this kind also makes a good game.

The narrative in Eleanor's written proposal can be seen in terms mainly of the representational metafunction of language. It represents a series of transitive sequences: a sequence of actions performed by the protagonist in the third person, upon the objects found in the narrative space. When she translates this into her game design, however, she is doing something different. The actions performed by Rose are all allocated to the player, and thus become subject to a degree of player choice, and to player manipulation of the PC keyboard and mouse controls. Actions represented in Eleanor's written proposal as the finite verbs 'tries', 'goes', and 'follows', for instance, become, technically, *clicks* and *presses up arrow*, for the player. In this respect, then, what was part of the representational system of the written narrative has now become part of the interpersonal system: actions offered by the game to the player. This dimension of the game is associated with the

interpersonal function also proposed by Caroline Pelletier (Pelletier, 2005), who uses the term *transactive* of such sequences, to distinguish them from the purely representational function of conventional narrative sequences. This fusion of representational and interpersonal functions can serve as a semiotic definition of interactivity. However, while the player's actions are confined to a finite set of keyboard moves, they are connected with the representational system of the game, in particular its 3-D visual design, so that these actions are experienced by the player as a much wider variety of actions within the narrative.

This game uses the software in its second iteration (it has now reached a third and nearly final version, in which characters can also be created). It can be used to make environments, to place objects, and to program 'rules'. Figure 7.1 shows the design interface as it appears with Eleanor's game. At the top right, the tile-editor shows how chambers, selected from a large library of different genres (sci-fi, Egyptian, Victorian, Mini-world) can be placed and connected through interlocking doorways. The large panel shows the chamber in which the game-designer is currently working (in this case, the second chamber of Eleanor's game). The three-section panel at the bottom shows the rule-editor. This is a unique feature of this software, and represents the level at which, in this project, we decided to construct

Figure 7.1 The design interface of Eleanor's game.

the ability of the designer to program. The rule-editor determines how events in the game will happen, in a system of conditionality. In this case, the desired event is that the robot moves forward. The trigger for this action is that the player clicks on an object. The object clicked is specified in the Rule as the robot. So the programmed rule reads as an 'if'clause: 'If Robot 1 is clicked Robot 1 [moves] forward'.

What the rule-editor is intended to do is, firstly, to give the young designers control over at least some of the programmed elements of the game they are making; and the ability to use it correctly and effectively can be seen as part of the *operational* aspect of literacy (Durrant & Green, 2000), in which the writer is gaining fluency in the use of the design tools. However, the rule-editor is also intended to model an important concept in game design: the notion of rule. Rules were explicitly drawn to the attention of the class in a previous lesson, through a class discussion of what rules meant generally in society, and then what they meant particularly in games. This discussion then led into a demonstration of the rule-editor, followed by the students working in pairs to practise it on desktop computers. Finally, they were asked to write a homework explaining what they understood by the idea of 'rule'.

In general, the idea of 'rule' was understood by the students in terms of game rules, or rules apparent to the player. So Jack, for instance, listed:

Call of duty: you must not shoot your ally
tennis: the ball must not leave the court
pool: the white ball must not go down any of the pockets
cards: (pontoon) you must not score more than 21 to win
cricket: you can't touch the wickets with your bat.

In social semiotic terms, it is clear from the language here that rules operate as part of the interpersonal metafunction, and that they are demand acts, framed as second-person imperatives. They register, in this way, one of the characteristic features of games which distinguishes game narratives from literary or filmic narratives, whose mode is typically (perhaps exclusively) indicative, as the narratologist Gerard Genette argues (1980). Narratives usually make statements; in games, however, they also ask you questions and tell you to do things.

This kind of game-rule is compared by Frasca (1999) with narrative rules. Frasca points out that narrative systems can be seen as offering structured potential sequences which look very similar to those of games. However, he points out that the similarity is at a different level: potential sequences in narrative exist above (or previous to) any actual realised narrative; whereas an actual, realised game preserves the potential sequences for the player to decide upon. So, in Eleanor's

game, the narrative choice of characters and setting is already made; the set of potentials relate to ludic events to do with puzzle-solving.

Social semiotics would also seek explanations of the social motivation of any semiotic act. In the same piece of writing, Jack addresses this issue:

> The reason games have to have rules is because if there wasn't rules in a game, you couldn't have any challenges or boundaries, limits etc., and that would spoil the fun and cause you not to have anything to complete.... People enjoy following rules because it creates suspense of trying not to lose the game by breaking the rule, and people like difficult challenges.

The notion of constraint related to pleasures of play here can be related to theories of rule-governed, structured play, such as Frasca's use (1999) of Caillois' notion of *ludus* (1979), where a strict rule-system is structurally associated with victory or defeat, as in Jack's definition, and as distinct from Caillois' *paidea*, in which less defined rules operate to define pleasurable play not necessarily orientated towards an outcome of quantified gain or loss.

The other key concept in game design which the software makes explicit, and which we built into the course, is the idea of economies: quantified resources allocated by the designer and managed by the player. Again, the idea was introduced through class discussion, modelled in the software, practised by the students, and consolidated in a written homework. Economies the designer can incorporate into the game include time, health, weight, strength and hunger.

Eleanor's homework explains economies like this:

> Economies are things such as lives, strength and score in a game. They add to the challenge of a game, for example you might lose a game if you have no lives left so you have to think about how to get more and when to risk them. This shows that they also add to tactics because you need to think about them and what to do with them. Economies could also be to do with the aim of the game; for example, the aim could be to have most points at the end of the game. Sometimes economies are not connected with winning the game but might just increase the sense of achievement when you win: e.g., you might win a game by reaching the centre of a maze and you don't need points to win but if you won and had a large amount of points it would make you feel even better. Also if you did not win the game, but before losing you had a large number of points it would lessen the dissapointment [sic]. So they can be like sub-aims in a game. Economies complicate a game by adding challenges and rewards which make the game more interesting.

She goes on to give an example of a game-economy in a children's game called Skid the Squirrel (an online game in a wildlife-themed website of Children's BBC). The economy here is life and health; as Eleanor explains, 'every time your

health goes down to zero because you have hit prickly bushes you lose a life and start the level again'.

Eleanor's game also contains economies: the levers in the first chamber either give time bonuses or reduce time, so they introduce an element of chance into the game. As she says in her homework, the economy here adds a subordinate challenge, rather than determining the win-lose state at the end of the game.

The understandings of rule and economy in these children's work are evidence of conceptual complexes informed both by their own experiences of games in general and computer games in particular, but also by classroom work which builds these experiences into generalisable abstract concepts at the same time as practising them through concrete game-design activities.

Eleanor's own game, as we have seen, has rules visible to the player, and these are the kinds of rules the children in this project have learned about, and which Frasca describes in relation to *ludus*. However, there is another kind of 'rule'. Figure 7.1 also shows a circular black shape between the robot and the wooden level. This is a trigger volume, placed there by Eleanor to define an active space, but invisible to the player. The programmed rule in the rule-editor here is 'If anything enters Trigger Volume, lever goes down'. This whole rule is invisible to the player, who perceives this action as a consequence of the game rule: 'if I click on the robot, it will move forward and press the lever'. This game rule, then, is an effect of the two programmed rules: the one which makes the robot move forward, and the one which makes the lever go down. A third programmed rule combines with these two to complete the series of actions which appear to the player all to be effects caused by clicking the robot: 'if the lever is in a down state, the sack of coal becomes active'. The sack of coal is the final goal of the game: it will re-power the spaceship.

Conceptually, then, the rules of the game are distinct from the programming logic which underlies them. Programming, even at this simple level, is a logical, rule-governed system, here expressed as a conditional proposition. Game rules are also logical and conditional. This difficult relationship between the apparent effect in the game and the logic system performing the magic beneath can be seen as an example of a general meeting of the functions of the computer with older cultural forms. Lev Manovich described these as the 'cultural layer' and the 'computer layer' (1998). His model of the meeting of the two raises the question of how computer scientists need to learn about the representational texts which their machines are now producing; while those of us whose expertise lies in representation and culture need to find new ways to think about how our texts have changed now that they are computable. In the context of the media and literacy classrooms we are describing here, this question becomes, 'How do we help children to understand the relationship between a computer and a game (or indeed a digitally-edited video or word-processed essay)?' This is a question which the present research project has yet to address.

In the next example, the analysis will look more closely at aspects of the game and narrative grammars. In the case of the organisational functions of Eleanor's game, it is worth briefly observing that the ludic aspects of the game display a particular kind of cohesion (in terms of the organisational metafunction): each cluster of ludic events is related to its neighbour by either by conjunctive links (if this, then that; this and then that); or by redundancy, as in the repeated levers, which teach the player what consequences to expect, but also conceal the chance element. By contrast, the narrative coherence works by reference: so the mission given to the player at the beginning, to find the fuel for the ship, refers to the sack of coal which appears at the end. However, these references also serve a ludic purpose, in the sense that they present the challenge which motivates the player through the game.

OCHIRBAT'S GAME

Ochirbat was in Year 9 when he made this game (14 years old). He has been with the project since its first year, when he participated in a class on computer games co-devised by the project team and his media teacher, James Durran, even before the first iteration of the software was produced.

His game demonstrates that game-literacy is culturally situated: his design draws extensively on his own experience of games. He has told us in interviews of the games he has played, which cover many different game-genres (he refers to adventure games, horror games, online games, strategy games, platform games, first-person shooters); he has shown that he can generalise about game structures across different games (see Burn, 2005, for a discussion of his knowledge of the games of Harry Potter and the Lord of the Rings) and across different but related media (books, games and films). He has shown expertise as a player and also as a proto-designer, able, for instance, to use the level editing provision in the game *Timesplitters 2* with fluency.[1]

His game, *Maniac Maze*, was made over six weeks, in an after-school club, in the summer term of 2005. It can be seen, then, as a more developed example of game-authoring than Eleanor was able to achieve in just a couple of hours with the two-chamber introductory activity. It is analysed below in terms of narrative and ludic design.

NARRATIVE 'WRITING'

The initial consideration for the students in this project was how to construct their game world, or space of play. However, this is also a narrative space,[2] much as a child writing a story or making a video narrative might be encouraged to construct

a setting. The software allows students to choose from and combine chambers and corridors from a library of 'building blocks' and assemble them using a tile-editor: a 2-D grid on which they design their game-world, which they can then view and enter in 3-D. So Ochirbat's world on his tile-editor, in plan view (Figure 7.2) shows that it is a complex assemblage, with a maze-like structure on the right. Though not visible in this image, it is also significant that he has chosen from different representational genres available: he built into his game a sci-fi segment, an Egyptian segment, and a Victorian segment. These spaces represent narrative potential: they are designed to be explored by the player (who is also a first person protagonist); they represent a sequence, which implies a narrative journey from a point of outset to a final destination (a mysterious locked room).

Ochirbat has also designed characters—which was not easy in this iteration of the software, in which visible, animated characters were not yet available.[3] He has constructed an idea of a mysterious keeper of the maze, who only appears as a graphic image of a face at the beginning of the game (which Ochirbat has found and imported into the software: Figure 7.3), and as a voice who instructs the player through the first two levels. Ochirbat takes some care to give this character, though he only has rudimentary narrative properties, dramatic and affective power. The image itself is strong and mysterious, and he makes a series of statements as voice files for the character to speak when certain triggers are activated by the player. Though he improvises these himself in one version of his game, he is not satisfied with his own voice or with the hesitant improvised wording; so he scripts

Figure 7.2 Design interface for Ochirbat's Game.

Figure 7.3 Ochirbat's Maniac Maze-Keeper.

the words on a scrap of paper, and asks me to record them in a suitably spooky voice. The first voice file locates both player and the maze keeper: 'I am your captor! This is my little maze for you to explore. For the first few rooms I am going to guide you, let you get used to your surroundings. First of all, go to the safe room to get your orders'.

The game has, then, certain narrative properties. It has a protagonist positioned as captive, and an ambiguous magical controller, both antagonistic and mentor-like. It also constructs a space which is in many ways a narrative space, implying a sequence with an Aristotelian beginning, middle and end. The beginning is technically defined: the authoring software allows the designer to determine where the player will start. The end point is defined by the solution of a complex puzzle, by a dead-end in the spatial design, and by a pop-up which announces 'Congratulations! You have won!'

At this point, readers might justifiably be asking what kind of narrative this is—it sounds much more like a game than a story. And this is true, in a general sense, and also in more specific ways. In a general sense, Ochirbat's 'game-literacy' could be said to be weighted heavily towards the ludic aspects of games rather than the narrative. In previous interviews, he has shown interest in properties of games such as weapons, boss enemies, level structures, and game logic. Also, we could look specifically at the coherence of the narrative elements of his game. In certain ways, these could be further developed: the captor character, for instance, is developed through the first two levels by repeated use of voice cues for the player; but is absent from the last level. Similarly, while the player character is introduced as

a protagonist with no memory, the implied promise to reveal a hidden backstory or narrative motivation is never fulfilled. This kind of promise is familiar in adventure and role-playing games: in the roleplaying game *Planescape Torment*, for instance, the player assumes the role of a nameless character whose quest is in part a search for identity. Similarly, in the massively popular Japanese roleplaying game *Final Fantasy VII*, the player-character's past history is revealed through a series of flashbacks that appear throughout the game.

Arguably, Ochirbat's interest, then, is less in telling a story than in making a game. However, another point relevant to the literacy and literature curricula is to observe that the ostensibly clear distinction between game and story is by no means as straightforward as it may seem. In particular, some stories are game-like; and as such as particularly suitable for adaptation into games. Marie-Laure Ryan makes the point about game-like narratives in the inaugural issue of the academic journal *Game Studies* (Ryan, 2001). She proposes that games are 'a matter of exploring a world, solving problems, performing actions, competing against enemies, and above all dealing with interesting objects in a concrete environment'. The kind of characters she suggests are at home in this kind of narrative are Alice, Sherlock Holmes, Harry Potter and the heroes of fairytale rather than Emma Bovary, Oedipus or Hamlet. Within this kind of emphasis, Ochirbat's game is more narratively rich than might at first appear. While there is no kind of psychological development, there is problem-solving, exploration and competition in a mysterious, fantastic world which mixes familiar narrative genre elements: the kind of experience that Alice or Harry Potter might feel quite at home in. Furthermore, a fundamental and explicit feature of Ochirbat's design is the maze: a figure in which game and narrative often fuse, from Daedalus's Minoan labyrinth to the icy maze at the climax of Kubrick's *The Shining*, in which Shelley Duvall and Jack Nicholson enact their final confrontation.

LUDIC 'WRITING'

If the narrative coherence of Ochirbat's game can be said to be relatively weak, its ludic coherence and cohesion are high. The player has to navigate through a training level, learn how to 'kill' white robots with a knife found in a safe, manage health levels by recharging from a health pack picked up in the first level, complete a mission by finding three objects, negotiating a maze, and opening a locked room by placing the three objects in the correct order on a table.

This involves a knowledge of a specific kind of grammar, as we have seen, involving programmed rules constructed with the software's rule editor, which underlie game rules apparent to the player. Unlike the modality of conventional

narratives, in which causality follows a pre-determined pattern, causality in games is at least partly determined by player decisions, so that the dominant mood is conditional. These pervasive structures of conditionality are most effectively expressed as 'if' clauses. So, in Ochirbat's game, white robots are surrounded by a 'trigger volume'—a defined space which is visible in the editing mode of the game as a transparent balloon but invisible in the play mode. He has constructed a rule that says 'if the dagger enters the trigger volume, the robot becomes inactive' (that is, disappears). He is, then, like Eleanor, constructing two kinds of rule. The one just cited, which appears in the 'rule-editor', is a programming rule, and underlying programmed cause-and-effect is inaccessible to the player. The other is a game-rule which is accessible to the player, and depends for its realisation on the underlying programming rule: if you stick daggers into robots, they die. At the same time (to further develop the close implication of game and narrative), this is also a narrative rule typical of game-like narratives, such as the one in *Lord of the Rings* which states 'if orcs are near, Frodo's sword Sting will glow blue'.

This is just one rule, in which narrative and ludic effect are created by programmed conditionality. Ochirbat's game has ninety-three such rules, constructed in the six sessions of the after-school club. On such a basis alone, this is quite a complex and extensive game, which takes some time to play: the Year 10 students in the other partner school, in London, took 45 minutes to play it.

Like Eleanor's, Ochirbat's game design also contains economies. Ochirbat has decided that his player will have both health and hunger. These are economies that constitute on the one hand part of the player character, who can be defined as a bundle of such economies (health, strength, hunger, point score); and on the other hand constitute dynamic properties of objects in the game which connect with the player. In Ochirbat's game, then, there is a vermin-infested area in the second 'level'—rats and skulls distributed round an Egyptian corridor. A trigger volume determines that the player's health points decline dramatically on entry to this area. Here, then, the programmed rule produces an invisible cause and effect (entry into the trigger volume depletes the score by a determined amount); while the ludic rule visibly produced is that the vermin themselves cause the effect. Again, this is also a rule with narrative logic: this space is semiotically produced as dangerous; the rats are deployed as signifiers of danger and disease. If the notion of economies as part of narrative seems odd, we can again think of *Lord of the Rings*, in which, if the Company of the Ring find their energy depleted, they eat elvish lembas cake to restore it.

Finally, we can ask what kinds of cohesion are apparent in the ludic design. It would be entirely possible (indeed, it was true of the games produced by some of the children in this project) for the ludic design to consist of a series of unrelated puzzles laid out in a sequence in no particular order. By contrast, the ludic structure

of this game is marked by strong cohesive relations between elements. For instance, the acquisition of the knife is related to the two white robots encountered later; while the acquisition of a 'sickle sword' in the Egyptian level is similarly related to the 'killing' of two black robots later on. These examples, like the levers in the first chamber of Eleanor's game, show something like lexical cohesion in language through repetition: they display a form of redundancy by repeating a process several times. In an oral narrative, redundancy exists partly for the sake of the audience, to give them a chance to grasp important narrative elements. Here, in a similar way, the redundancy is to give the player several chances to do the same thing and to learn to do it better. Ochirbat has a cultural interest both in making the game challenging, and in inducting his player through procedures he has learnt from other games, in particular the idea of a training level, which is explicitly signalled in his opening voiceover.

A different kind of cohesion exists between elements of the game that refer to each other. Just as reference across different parts of a text ties elements together, so here there is, for example, a bomb, found very near the 'end' of the game (in terms of the spatial design), which disposes of a barrier to an essential room very near the 'beginning' of the game, thus sending the player right back through the maze. This strong cohesion produces an effective and satisfying piece of game-play, as well as contributing to the overall ludic coherence of the whole design. However, an interesting feature of the bomb is that it gives minimal information: it can be inspected by the player after being picked up and produces a message which reads: 'Bomb: use this to open the secret barrier'. Two features of this are of interest. First, the function of the bomb is signalled, like many elements of games, multimodally. The visual sign operates as a kind of imperative, demanding to be used somewhere; while the verbal sign disambiguates and amplifies the function. This multimodal sign combination coheres, as we have seen, with the invisible rule: 'if bomb enters trigger volume, barrier becomes inactive'. However, the second point of interest is that this event can only be designed as a textual potential. It must be realised by the player. So some elements of the cohesion here are provided by the player, who needs to: read and respond to the verbal instruction; recognise the function of this kind of object both by reading its visual connotation, and by relating it to similar objects in the wider class of 'pickups' familiar to a game-player; connect it with the barrier which must have been encountered earlier for this cohesion to work; carry the bomb back and thrust it into the trigger volume (or 'throw it at the barrier', in narrative-ludic terms).

Cohesion here, then, is designed as a potential by the teenage author and realised by the player through interpretation, through recognition of external cohesion with similar objects in other games, through pursuing a particular traversal of the game-space both before and after picking up the object.

In general, then, Ochirbat's game can be seen as a more complex example of the features of game-literacy derived from Eleanor's. It draws heavily on a cultural experience of games; it displays operational fluency in the authoring tool. It produces evidence of both ludic and narrative composition, the former strongly cohesive, the latter weakly cohesive. It is multimodal, the different modes often used to amplify ludic cues, though also to produce narrative information and affective element of the game related to his interest in horror texts.

PERIPHERAL LITERACIES

In our tentative model of game-literacy, we have adopted the notion of peripheral literacies to describe forms of communication or design which surround the game proper but are not directly integrated into it. These can fall either into the processes of design and production; or they can be part of an explicatory post-hoc process. In the former category we could place design drawings and diagrams, backstory writing, script-writing, sound production. In Ochirbat's game, for instance, we have seen that he (reluctantly) scripted the vocal performance of the mysterious captor. In this sense (in relation to the notion of writing literally as print), he has actually written this part of the game; though writing here exists as a design mode only, as in a film script; in the actual text, this has been transformed into speech.

At the end of the project, the students are asked to write walkthroughs for their game. Walkthroughs are a well-established genre of fan work published on the internet and produced by players who are motivated to make step-by-step guides for how to play the game. They represent the cultural interest of fans whose chief preoccupation is the ludic imperatives of the game (rather than its narrative dimensions); and they are invariably literally couched in the imperative mood.[4] Ochirbat wrote a walkthrough for his game, which gives quite detailed instructions about how to play the game. Like all walkthroughs, it elaborates the ludic aspects of the game rather than the narrative aspects (these are more typically addressed in fan work by writing genres such as spoilers, fan fictions and poems). This reflects Ochirbat's cultural interest, in which ludic features are, perhaps, of more interest than narrative features. The walkthrough also reflects some aspects of the game's cohesion: so, for example, the cohesion by reference is dealt with also by reference to other parts of the game, via a prepositional phrase, and to other sections of the walkthrough, in parenthesis:

> The upper rooms have the map and the mine switch which give [sic] you the mine which can be used to destroy the barrier in the tube room (I will explain that later in the skeleton key locations page).

Ochirbat's walkthrough provides further evidence of two aspects of the model of game-literacy we are building. Firstly, it provides further evidence of a cultural experience of games, and of this genre of writing associated with them. Secondly, it is evidence of an operational literacy, in two senses. Ochirbat clearly knows how to play games in an operational sense: he is a skilled player in a variety of complex ways. He also knows how to author games in an operational sense, too: he can manipulate the software to construct environments, rules and economies.

His walkthrough, then, provides another example of the range of different kinds of written language which surround and inform the playing and design of games. So far we have given examples of written proposals for games, written explanations of abstract principles of game design, and the walkthrough. The final example of students' work to be discussed in this chapter is a more developed form of written proposal.

NEW GAMES, OLD STORIES

Ochirbat's game, then, fuses narrative and ludic elements in its design and displays a cultural experience of games and game-narratives as well as an accomplished ability to operate the grammar of the game.

The last selection of student work presented here is a piece of writing produced at the end of the same Year 8 media course in which Eleanor made her game. Students were asked, once they had been through the production experience and learned about the principles of rules and economies, to write a proposal for a game based on an existing story. One boy, David, chose to make a game based on *The Odyssey*. It is apparent from his proposal that the work on game design had given him a very different understanding of narrative from the conventional models often used in English and Media Studies:

The Odyssey

My idea is for a game following the story of Homer's *Odyssey*, in which Odysseus travels back to Greece after a long war to capture Troy. He is blown about in a storm, and must face several challenges to return to Greece. I think that this will work as a game because although it has discrete levels, each consisting of a single challenge, the levels relate to each other somewhat, such as Circe warning Odysseus about the Sirens, and about Scylla and Charybdis....

This game will be aimed at boys aged 10–14 who may (or may not) have some interest in the Greek myths. This target audience should be interested in role-playing games, as the player would be expected to negotiate information and assistance out of the other characters, as well as a certain amount of puzzle-solving, as these also will be included to some extent....

The player characters are Odysseus and his men, who are desperately trying to get back to their homeland, the difficulty of which is a cruel twist of fate after their glorious victory in Troy. There are various NPCs (non-player characters) who help or hinder the PCs (Player characters) or do both. An example of an ambiguous NPC is Circe, who attempts to lure the Argives to their doom, but after they have resisted her temptations, she gives Odysseus some advice as to the nature of the challenges he will have to face. In addition to these NPCs, the narrative contains monsters (who do not talk to the PCs, but merely attack), such as the one-eyed Cyclops, who although they cannot be convinced not to attack, tend to be rather stupid and (relatively) easy to outwit.

I think that the game will be enjoyable to play because of the pleasures it offers to its users. The game offers a strong aim for the player—to get Odysseus back to Greece. I think that this aim will be powerful because it is easy for the player to identify with— how many of us haven't experienced that feeling of being lost and unable to get back to the ones we love. I think that the narrative could act as a metaphor for a child's experience of a previously pleasurable trip which goes horribly wrong when the child loses their parents, each challenge in the story representing the child's fight to maintain a spirit of confidence and optimism despite the disappointment of turning a corner and finding that their parents are not waiting around it. Odysseus's wife, of course, represents the child's mother. . . .

The game will involve skill in three respects: Role-playing and diplomacy; problem-solving, and dexterity. The player will be expected to navigate his way through tricky interactions, to gather information, and to pacify (or not) NPCs. In addition, he will be expected to come up with ways to bypass the seemingly impossible challenges he is presented with. Lastly, he will have to be fairly handy with the mouse, and good at simulated combat. . . .

My game, being largely concerned with narrative, will not contain exceptionally large amounts of rules and economies. One example of a rule, however, is involved in Odysseus's encounter with Scylla (an huge, six-headed monster) and Charybdis (a deadly whirlpool). A rule used in this section states that if the ship enters a special trigger volume by getting too close to Scylla's cave, she flies out and carries away six of Odysseus's men (one for each head), reducing the crew economy by six. This economy is a fairly close equivalent of the standard health economy, in that the game is ended if it gets reduced to zero, although it varies in that the player is hampered when its value is reduced to close to zero, as the ship becomes more difficult to manoeuvre. In this respect, then, it is closer to a strength economy. . . .

I have, briefly, presented my game, and it would, I hope, do Homer proud, although, of course, whether it would be possible to sell it to the manufacturers is quite another (and, arguably, a far more important) question!

This piece of work presents a complex understanding of narrative but one that is informed by the game concepts learned in the course as well as those he knows from his own experience. *The Odyssey*'s episodic structure is realised here in terms of game levels; monsters such as the Cyclops are conceptualised as NPCs

(non-player characters), and Odysseus and his crew as PCs, or player-characters: in role-playing or adventure games, players can sometimes choose which character to play, or can play groups of characters as a team. The skills David identifies as those the player will need—role-playing, diplomacy, problem-solving and dexterity—are typical of role-playing games, but are also features of the Homeric narrative, being the key characteristics of the wily Odysseus.

The two key concepts of game design which the use of the software has rehearsed—rules and economies—are important in this rendition of *The Odyssey*. David conceives of game rules, such as the one which states that if the player gets too near to Scylla she will carry off some of the ship's crew. He conflates, though, the game rule and the programmed rule underlying it, that this event is triggered by the ship entering a trigger volume. Where this structure is directly transferred from the software he has used, the use of 'economy' here is novel: he imagines an economy in the game related to the 'strength' of the ship, depleted by the men carried off by the monster.

These conceptions of narrative as rule-based events and formulaic characters contrast starkly with the ideas of narrative in literacy and literature curricula, which are arguably largely modeled on the tradition of the European novel. This tradition emphasises naturalism, the psychological development of character, and, despite well-charted exceptions in, say, the Gothic tradition, the rationalism of the Enlightenment. In effect, it renders its newly literate readership deaf to the ancient traditions of oral formulaic narrative and infantilises the irrationality of fantasy and folktale. These, as Janet Murray argues (1998), are the forms of narrative closest to the computer game. David's proposal for the *Odyssey*-game makes us realise that the analogy goes further than character—the episodic structure, the economies of health and magic, the strategic skills required of protagonist and player alike, the function of narrative and ludic rules: all of these suggest strong affinities between game and oral narrative, which demand new understandings of writing in literacy curricula, and new valuations in literature curricula.

Perhaps the implication of this for new conceptions of 'writing' provoked by computer game design is that literacy is not always the best metaphor. It needs to be at least complemented by the more fluid, performative kinds of utterance which Walter Ong saw as 'secondary orality': a residue of the oral mindset in the electronic texts of highly technologised societies (Ong, 1982).

Two key implications flow from these kinds of suggestion. Firstly, English and literacy teachers may need to re-evaluate the familiar aesthetic usually privileged in work on narrative in classrooms and consider what is usually anathema—the idea of narrative as formulaic. The advantages would be a more inclusive attitude to popular texts, whether from folk literature or contemporary popular culture, and also a more transparent approach to the construction of narrative,

more accessible to more children. The second is to recognise the connections between dramatic forms of representation and popular culture, especially games: both, after all, involve improvisation, imaginary worlds, role-play and bodily engagement (for an extended discussion of the connections between games and drama, see Carroll, 2002).

TOWARDS A MODEL OF GAME-LITERACY

The games and game-proposal made by these students, then, suggest that the model of game-literacy which we are tentatively evolving, then, will have something like the following elements.

1. It draws on *cultural experience* of games and other media texts.
2. It requires specific forms of *access* to appropriate technological tools, and the ability to use them.
3. It requires specific kinds of *operational literacy*: a fluency in the use of the tools for game design provided by the software.
4. It both requires and develops an understanding of *key concepts* important to game-texts: in this case, rule and economy but also principles of narrative, such as protagonist, quest. It recognises how these concepts are elaborated in building the grammar of the game. The programmed rules and the associated game rules and economies construct the interpersonal function of the game (in social semiotic terms): they provide opportunities for the player to act within the game-world to meet challenges, overcome obstacles, complete missions, achieve a win-state. The construction of these rules also performs organisational or compositional functions, such as different forms of cohesion and coherence across the game.
5. This whole process is *multimodal* and *multiliterate*. It involves visual design, writing in different genres, sound, music, speech, and simple programming within the limits of the rule-editor.
6. A wider notion of game-literacy will also involve *peripheral literacies*, many of which will involve writing, in genres such as proposals, interpretative and critical writing, walkthroughs, fan fiction, narrative backstories.

Of course, game-design of the kind enabled by this software package could easily find a curriculum home in any subject where aesthetic and technological design are of relevance. It would be entirely possible to construct different rationales for game-making in Design and Technology, Art, Music, and ICT. The argument here, however, is that to see game-design as a form of writing in relation both to

print literacy and to media literacy is to see it as a valuable extension of concepts of narrative, grammar and textuality for learners.

But games also require that the literacy curriculum does some hard thinking about what kinds of narratives it values and how it conceives of them. Doctor Who in Eleanor's game, Odysseus in David's proposal, and computer game protagonists more generally, stand in a tradition of popular heroic narratives which stretch back through the superheroes of twentieth-century comic strips, film and television but also much further back in the oral formulaic narratives of Europe, from Robin Hood to Beowulf; and even further back to the Homeric narratives, as Janet Murray has argued (ibid.). By contrast, the literacy and literature curricula are more accustomed to privilege the forms of psychological 'realism' typical of the European novel. We need to be wary, then, of simplistic value judgements about formulaic narratives in contemporary media: we might find Superman or Spiderman reductive texts which value action over psychology compared with the *Brothers Karamazov* or *Jane Eyre*; but we would not make the same judgments about Beowulf, Achilles or Robin Hood, who are similarly formulaic. To accommodate game-writing in the literacy and English curriculum, then, productively extends and challenges our ideas of literacy at all levels: cultural, aesthetic, technological and conceptual.

Machinima, Second Life AND THE Pedagogy OF Animation

Animation has a long history in media education, though it belongs equally in art education. The two domains bring different emphases: the one exploring animation as popular culture and as a filmic production medium; the other looking at it as an art form and emphasising its component elements of drawing, painting and model-making as well as its aesthetic properties. However, in recent years this traditional distinction has diminished to some degree with a disciplinary shift in art education towards a curriculum for 'visual culture', involving a move away from the institutions of fine art towards a more inclusive engagement with practices of visual representation (e.g., Duncum, 2001). This effort represents a move from a conception of art education as elite, cut off, and situated firmly within the project of modernity to a postmodern diversity of practices (Addison & Burgess, 2003). In this new dispensation, traditional oppositions between word and image, artistic medium and technology, the sense of sight and the other senses addressed by contemporary multimodal texts are challenged. Importantly for this chapter, this new diversity also implies a breaking of disciplinary boundaries, a new collaboration with other education practices occupied with visual culture.

At the same time, it is possible to see media education shifting away from its traditional character and curriculum location. Where once its central emphasis, inherited from its origins in English teaching, was on literacies and the critical analysis of texts, recent moves have involved a more pluralistic engagement with

the Arts. Media specialist schools in the UK, for example, are formally designated as 'Media Arts Colleges' by the government's specialist schools programme, and while this term is arguably intended to locate such schools within a rationale of training for the 'creative industries', it has also given impetus to productive collaboration between media educators and educators in drama, music, art and dance (see Burn & Durran, 2007: ch. 8, for an account of this kind of work).

At the same time, the digital era has brought new possibilities to both subject domains, and this is true of the cultural practice of animation as it is of other media forms. Where a few schools used to make animations using traditional stop-frame techniques and a rostrum film camera, the arrival of digital video allowed the easy capture of individual images as frames, editing with a non-linear editing program, and a wide range of formats for exhibition and publication.

The most recent cultural form in the world of animation—both shaped by and shaping new technologies, in this case those of 3-D computer games and virtual worlds—is the art of machinima. Machinima, as has often been noted, is a portmanteau word combining machine and cinema, with a substitution of the 'e' by an 'i', implying animation and animé. It is defined by Kelland et al. as 'the art of making animated films within a realtime 3-D environment' (2005: 10). It can be thought of as animation made from the 3-D environments and animated characters of computer games or virtual immersive worlds. The first machinima films were produced by players of the game Quake in the mid-1990s.

Machinima-making in schools requires a rethink of animation as an artistic practice and as a form of media production. How is it different from, or similar to, earlier kinds of animation, in terms of its cultural context, its technical resources, the skills it requires, the pedagogies it implies, the creative possibilities it affords?

This chapter will focus on the work of artist, animator, machinimator and teacher Britta Pollmuller, who has taught animation to teenagers in many ways, ranging from stop-frame and claymation techniques to machinima made in the immersive virtual world Second Life. It will explore the interface between media and art education, and between new technologies and adaptive uses of them by teachers and students.[1]

ANIMATION AND DIGITAL VIDEO

This story begins with a project recorded as a case study for the BECTa DV (Digital Video) evaluation[2] (Reid et al., 2002). Britta was working with a Year 8 group in her school in Norfolk on animations of African folktales. BECTa had provided one i-mac and a DV camera, and like many teachers in other schools,

Britta had found creative ways round this restricted provision. One group of children were animating plasticine models against painted backdrops with clip-on lights, filming and recording frames onto the i-mac with a freeware capture tool. Other groups were scripting, storyboarding, painting backdrops, designing characters, and writing haiku-form credits.

As with the animation project discussed in chapter 4, this work can be seen as a hybrid of media and art education. In respect of media education, the children were learning through production about the language and grammar of animation and of the moving image more generally. They learnt through design and practice about the speed and duration created by the quantity of frames, about the meaning of lighting and set design, about the grammar of shot composition and camera angle, about the function of sound, dialogue and music. They also learned collaboratively, through group work, a process typical of media education production projects, where responsibility for authorship is shared, students may adopt different roles in the production process, and practices of the industry may be simulated (Buckingham et al., 1995). Group work is much less typical of art education, where individual endeavour is still a common model for creative production.

At the same time, a number of emphases were in evidence which were more characteristic of the art classroom. The 'word wall' at the back of the classroom displayed words like 'harmony', 'composition', 'rhythm'. In fact, the wall combined media and art-related terminology, as Britta explained in an interview:

> Well, I have got, to start with here, animate, abstract films, storyboard,
> digital, focus, rhythm, composition…tone, 2D, find a sense of space,
> harmony, and so on.

The process paid a good deal of attention to the component craft skills involved, especially drawing, painting and model-making, and to the aesthetic effects of these elements. Britta insisted on quality, overseeing the careful production of the artwork, demanding reworking or reconstruction or refilming where necessary, and conducting frequent discussions to reflect on the quality of work so far.

Something which emerged from the case study was a sense of the varied cultural contexts which animation work invokes and the different kinds of cultural value attached to them. While the chosen subject of the work, the African folk-tales, and the craft skills of the art classroom invite fine art references such as the tradition of European animation, the children's own experience imports references to popular animation which appeared in aspects of the visual style, especially those constructing ironic or parodic humorous effects. This oscillation between a fine art and popular aesthetic can be seen as a consequence of the cross-disciplinarity of the project.

Finally, this project was infused by the status and experience of the teacher-as-artist. This kind of role varies through the arts: found most strongly in teachers of Art and Music, and perhaps least strongly in teachers of literature, with Drama somewhere in between. Britta had worked as a painter, was familiar with a range of digital media, had completed an MA at the Norwich School of Art, and worked part-time for a regional arts education project. The teacher-as-artist can be seen as complementary to a pedagogic role though it brings other practices, such as co-creator, quasi-professional mentor, studio director. It can be seen as a pedagogic stance, which backgrounds the statutory frameworks of schooling—curriculum design, assessment requirements, compulsory attendance—and foregrounds the creative endeavour and the social context in which it takes place.

A number of issues arise from this kind of animation work. Three are raised in the BECTa report, which, though general, are applicable here. One is the importance of the 'language' of the moving image: the projects perceived as the most successful in the evaluation, including Britta's, were those which made the 'grammar' of moving image composition explicit.

A second was the nature of creativity: teachers in the project all strongly emphasised the creative nature of students' work though all had difficulty in defining exactly what was meant. Recent research studies and literature reviews of creativity in education have shown that creative work in schools is beset by competing definitions and interests of different stakeholders (Banaji & Burn, 2007; Loveless, 2002).

A third issue was the affordances of digital media. Clearly, many instances of classroom work in the BECTa pilot could have achieved their results using analogue equipment. To distinguish the specific benefits of the digital filming and editing tools, the report focused on three affordances, derived from Moseley et al. (1999): *feedback, dynamic representation* and *iterative opportunities for editing*. An important reservation made in the report, however, is that these affordances could not be guaranteed by the technology alone but depended on pedagogic intervention and the quality of reflection the teacher could encourage during the production process.

In addition, there are specific issues raised by Britta's work. These include, as suggested above: the nature of animation and the specific cultural and semiotic resources it offers for creative work with students; the constraints of formal educational settings; the meeting of art education and media education and their respective practices and pedagogies; and the identity of the teacher-as-artist.

The next section will follow Britta's move into contexts of informal education, new contexts of artistic production and exhibition, and her current work with machinima. The questions raised above can be followed through; though it will be necessary to ask new questions too.

THE ARTIST IN SECOND LIFE

Britta left her job as a classroom teacher to work as a freelance educator in anima-tion, running projects in schools in Norfolk. These projects continued to develop a range of animation techniques and hybrid practices of art and media education. Students were encouraged to learn specific filmic conventions, and to consider the artistic quality of their work, while incorporating resources from their experience of popular animation. Britta helped them to use the work as an expressive tool for their own interests and preoccupations and the exploration of their social roles and identities.

At around this time, she came across Second Life, the immersive virtual world created by the American internet company Linden Lab. It shares some character-istics of a Massively Multiplayer Online Roleplaying Game: it offers avatar-based interaction in a persistent online world; it provides resources for roleplay, fantasy and the building of communities; its aesthetic is derived in many ways from gam-ing cultures. Nevertheless, in other ways it is not a game in the same sense as an MMORPG: it provides no ludic resources, goals or other structures.

Britta had no background in gaming culture but was intrigued by the possi-bilities of Second Life for an artist. She exhibited her own paintings in Second Life galleries and sold her first painting for a couple of hundred Linden dollars (the currency of Second Life). In an interview with Diane Carr, project leader of our own research in Second Life,[3] Britta described her feelings about exhibiting her paintings in Second Life:

> I had to present my paintings in this world of modern technology; wondering how relevant painting is in our digital age? This grows out of a certain anxiety I sense about the influence of technology on art and our culture as a whole. How can art reposition itself in relation to image production in our technological age?
>
> Second life certainly transforms the ways art is produced, exhibited, and valued, and how new art forms, new tools for representation and new conditions for communication are now generated. There are private views where avs [avatars] can drink virtual champagne and talk to the artist, poetry readings in an Irish pub, museum exhibition tours and talks, photography exhibition, avant-garde video art, scripted kinetic sculpture exhibitions, music live performances and even ballet. The SL art learning experience is endless, resourceful and stimulating.

Britta's remarks, though inspired here by a new medium, recall older debates about what happens when works of art are produced by mechanical means. Perhaps the best-known discussion of this question is Walter Benjamin's influential essay on 'The Work of Art in the Age of Mechanical Reproduction' (1938), which is still relevant to Britta's comments in three ways.











Firstly, Benjamin's original question about the effect of mechanically reproducing a work of art with a unique original applies here. What is still at stake is the ontological and aesthetic status of different technologies of inscription (Kress & van Leeuwen, 1996). Equally at stake are the social practices which deploy these resources. What is already clear is that the art of the machine in Second Life does not imply the inevitability of the forms of corporate exploitation that the Marxist thinkers of the Frankfurt School anticipated. Corporate motives continue to co-exist with independent artistic motives; popular art styles with fine art. Furthermore, Britta's *perception* of the images of her own paintings as they are exhibited in Second Life is not of reductive, mechanical copies, their aesthetic quality flattened and depleted. Rather, she is surprised by their 'strength':

> My first day in SL was to see a photography exhibition, and I was offered a show so I learned to set up my first virtual exhibition. I was amazed how strong my paintings looked, digital.

It seems likely that, while the technical production of high resolution images plays a part here—what Sinker calls the 'digital aesthetic' (Sinker, 2000)—at least as important is the participant's view of the authenticity of the images and their context of exhibition and interpretation. In social semiotic terms, this would be seen as a modality judgment (Kress & van Leeuwen, 1996). The credibility, truth to genre, authenticity—all qualities relating to Benjamin's 'aura'—can be seen as a meeting of claims made by the representation, and judgments made by the participant.

What Benjamin could hardly have imagined, however, is the immersive, persistent virtual world which in this case provides the social context, in which the avatars of artists, spectators, critics and poets can conduct replications of the social genres which surround the exhibition, consumption and interpretation of art in the 'real' world. The artistic community of this world, as Britta describes it, reinstates the social practices of the art world, from the meetings and exhibitions of independent fine art, to the commercial practices of professional studios making corporate videos using the resources of the virtual world.

As well as producing the work of art, artists and spectators are producing themselves, with an emphasis on fluid performance, whose semiotic resources range from the customisation of the avatar to the typing of chat dialogue, the deployment of emote repertoires, and the use of expressive and functional animation resources in Second Life to sit, fly, play musical instruments, drive cars, and so on.

This kind of performance replicates aspects of performance in 'real' life (RL), of course. In Goffman's sense of the presentation of self through dramaturgic

structures (1959), artists, students, critics and spectators have always performed their social roles in studios, galleries, museums, streets and cafes. The simple but difficult question begged by Second Life is, how to specify the differences?

These can be considered in terms of semiotic resources. For instance, Britta is able, as avatar, to adopt and change appearance much more fluidly, and with considerably more freedom, than she would be able to in RL. Her avatar, Pigment Pye, is a colourful figure with flying braids, patterned translucent garments, tattoos and cyberpunk decorations. Figure 8.1 shows her in conversation with me on her own island on Second Life.

At the same time, there are constraints. The communicative repertoires of gesture, facial expression, intonation are much more limited than in RL, for instance. However, the consideration of affordance in semiotic terms doesn't entirely explain the performance of self here. Britta's accounts, like those of other occupants of virtual worlds, insist on a strong feeling of presence in this world, a sense of embodiment which invites a phenomenological consideration. The identity of the participant is projected onto the avatar, as you become the actor in your own movie—except that it is played out in real time. At the same time, there is a concern for, a cognitive centring on as well as an affective commitment to the virtual body of the avatar; a dissolution of the barrier between the objective viewing of the image on the screen and the subjective experience of embodied selfhood.

In relation to Benjamin, we can recall, of course, that his interest was not limited to the artistic object and its mechanical proliferation but extended later to contexts of consumption and the social figure who occupied them—to the Arcades

Figure 8.1 Pigment Pye and Juniper Mapp in conversation.

of his unfinished final work and the flâneur who strolled through them (1999). These metaphors are still resonant and applicable to the avatars and islands of Second Life. Indeed, while the technology of Second Life might have been beyond Benjamin's imagination, he would surely have recognised the fantastic figures who loiter in its art galleries and shopping malls. The difference is in the application of the word 'mechanical' in Benjamin's earlier essay. In Second Life, the world itself and its social agents are mechanically reproduced, struggling between the attempt to capture the aura of the original and the dawning recognition that it can produce its own aura, a mechanical aesthetic, sensibility, habitus.

Having exhibited her paintings in Second Life, then, Britta encountered the art of machinima. For professional animators as well as educators, machinima offered many attractions. Because it is made in realtime, it avoids the laborious process of frame-by-frame animation. It makes possible forms of character behaviour which are hard to achieve in amateur animation: a 'walk cycle', for instance, is hard to achieve with frame-based animation, whereas machinima in SL merely needs to capture footage of the avatar walking. In many respects, it is closer to live film, with avatars acting parts, events filmed in real time, and virtual camerawork which in conventional animation would be simulated by the animation process.

In relation to Benjamin's argument, machinima is a recent example of his category of the technological *generation* of an art which has no original, and therefore no aura to be dispelled. For Benjamin, the exemplary instances were of course photography and cinema. In the case of machinima in Second Life, it is the common sharing of resources made in Second Life itself, using scripting tools and other authoring devices. No discernible 'original' seems to be generated by the artist here, so that no possibility of the aura remains. Rather, existing representations: characters, landscapes, sounds, objects, are adapted and incorporated into new productions. In fact, however, many entities in Second Life are conspicuously authored, retaining the signatures of their makers, sometimes freely available, sometimes for sale, paid for in Linden dollars. In this respect, some sense of an originating text remains, with claims either in the aesthetic domain, to be an original creation, or in the legal-economic domain, to intellectual property rights or to payment.

Britta taught herself the art of machinima, becoming acquainted with the Second Life machinima community, learning from them, and meeting them at specialist events. She attended seminars, festivals and exhibitions in Second Life, such as one addressed by Spector Hawks (real name Paul Jannicola), a member of the ILL Clan which made the first machinima films. Britta made a number of films of her own and exhibited them on YouTube and elsewhere. One film was made as an entry for a film competition and festival in Second Life: the Ed Wood festival. Films had to address a given title and had to be made in 48 hours. Britta's entry won first prize in the festival, which was sponsored by the machinima

company Shortfuze, based in Cambridge, UK. The film is notable in two ways for the purposes of this chapter.

Firstly, it exemplifies Britta's parallel life as an artist, involved in the professional production practices which inform her work in education. She describes in interview how she found a suitable online location, used a horror-film avatar as a character, and worked with other machinimators to produce the film:

> I went to the site Sleepy Hollow, excellent location of an orphanage...but this is why machinima is so amazing in SL as you have all this fantastic sets...so the title the origin where bad things come from...I worked with two or three people so we all had an input of what that might be? Pure evil...so we had to have pin head. Oh, Dalinian helped..he is a crazy artist...he makes weird avatars all the time...but has not been online in ages.

Secondly, the aesthetic of the film represents something of the range of cultural contexts in which Britta is working. The film is redolent in many ways of the surreal folktale animations of Eastern Europe, such as those of the Czech animator Jan Svankmajer. At the same time, it retains something of the game aesthetic, a residue of its inscriptional source. It also makes intentional reference to popular horror, in deference to the theme and title of the festival, employing the iconic villain of the horror film *Hellraiser*, available as an avatar in Second Life. This range of contexts, as observed above, might be expected also in the classroom of an educator whose pedagogies and cultural rationales are derived both from art and media education.

More broadly, we might note the nature of the social contexts of fine art, avant-garde art, and independent film-making here. They are replicated in Second Life, not only through forms of mechanical representation, but through systems of belief, commitment and social networking. While 'communities of practice' may be rather more open to anti-social practices than their proponents sometimes recognise (Oliver, 2008), in this case they do exhibit the forms of solidarity and organisation which are often claimed for them. Perhaps a better term is the one borrowed by Henry Jenkins from Pierre Levy: 'collective intelligence'. The processes of self-education, knowledge-sharing, and communal viewing and critique undertaken by the machinima groups in Second Life closely resemble Levy and Jenkins' new knowledge communities, which are 'voluntary, temporary, and tactical affiliations, defined through common intellectual enterprises and emotional investments' (Jenkins, 2002).

TEACHING MACHINIMA IN SECOND LIFE

Having taught herself the rudiments of machinima, Britta became involved with the Open University's Schome project (a portmanteau of school and home). Schome has built an island in the Second Life Teen grid (Schome Park), in which

young people are separated from the adult Second Life in a protected environment, to which only accredited adults have access.[4]

Britta has developed within the Schome project's general remit a specific project growing out of her long-term interest in animation. She teaches an after-school class in machinima, working with students aged between 13 and 17 to create animation using the virtual world, avatars, and creative tools provided in Second Life to make short films.

Britta described in an interview[5] how her work here began:

> I started 3 weeks ago [July 2007]. First, I set up a film-makers forum where Schomers (under 18s) and Sparkers (their supporters) can learn all about machinima. We meet from Monday to Friday, from 17.00–19.00 on an airship that I transferred over from the main grid [the teen grid is for under 18s, the main grid is age open].

> Schome Park has a media centre that is entirely made, organised and set up by Schomers. Between meetings we 'talk film' and get organised via the discussion forum, which is regularly visited by all.

In many ways, this project displays continuities with Britta's earlier work: a strong commitment to animation as a cultural medium for her own work and for students' expressive needs, a fusion of art and media educational aims and pedagogies;,a productive interplay between her own professional identity as an artist and the pedagogic practices of the classroom.

However, while there are also differences, these are surprisingly difficult to pin down. Britta comments in interview on what feels different in this project:

> I taught media studies for 12 months in a secondary school in East London a few years ago, and as part of my work and research I'm teaching new media technology to all ages (see www.schooltoons.com or www.mediaprojectseast.co.uk).

> Teaching in a virtual environment is a very new experience. There is no classroom I have to walk into. No bell, no stress, no staff room (hurrah) Pupils are not sitting and waiting for their lesson.

> In Schome Park the students are independent learners, they are in this world because they want to be. By the time I arrive at the machinima session the core group is already IMing [instant messaging] me to get started. We teleport each other to the ship and discuss what scene we can do and who is in world for acting. Sometimes we have to wait for a particular team member to log. But we ALWAYS talk, type, which is amazing. There is never silence. The team is always very keen to demonstrate props they made for the movie. I had one student build a grand piano in 10–15 minutes!

Some of the differences here can, of course, be accounted for in terms of the shift from formal to informal educational contexts. The latter can change the emphasis from the preparation of students for a future world of work to an emphasis on their

immediate expressive and cultural interests and their engagement with the world of leisure. More practically, it can escape the constraints of compulsory attendance, mandatory curriculum and assessment frameworks, and disciplinary regimes.

However, there are differences. The physical context of informal education, often based in school buildings, carries its own cultural overtones; and, most significantly, the students are present as themselves, in the flesh. All their performances of self through speech, clothing, gesture, could never eliminate certain fixed points of identity in the body, and, indeed, in such fixed social conventions as naming. Britta's students, by comparison, are not present in her class except as avatar presences: the names they choose are recently-adopted and mutable; their physical appearance is freely editable; their gender might have been changed.

These identities accomplish social purposes and desires arguably distinct from those they might adopt in school, though the comparison cannot be directly made. Britta makes the point that one of their purposes may be to escape the identities required by traditional schooling:

> Well, it is such a new field to investigate how these kids already take on a virtual identity with 12 years of age, but they feel safe in this new 'skin' and e.g., voice somehow was neglected as it is too close to RL.
>
> They enjoy to be what they cannot in RL…as of peer pressure, schooling and so on. School is limiting most of them, so they like to express themselves differently and not like the norm. We have one teen who is a blue fox or raccoon; one is a giant marshmallow who changes colour; one always wears a top hat…

While these performances of identity may be frequently re-designed, the markers of difference from the conventional performances of pupil identities can be generally described as playful. Exactly what kind of play this might be is difficult to pin down. In some respects, in that it fits well with a clearly-structured educational project, it resembles the form of play Sutton-Smith (2001) describes as 'progressive', in the educational sense: pro-social, collaborative, developmental. However, the avatar forms chosen by the students and the names they adopt also display elements of Sutton-Smith's notion of play as phantasmagoria: anarchic fantasy operating quite outside the regulatory structures conventionally imposed by education and parenting. The 'ambiguity of play' proposed by Sutton-Smith challenges older oppositions between work and play which have bedeviled play theory. In the case of these young machinimators, a productive confusion between these categories is helpful in the manner proposed by T.L. Taylor in her discussion of the playful work, or the work-like play, of power gamers (2006).

For Carroll and Cameron (2005), educational drama specialists who have explored the pedagogy and practice of process drama in relation to roleplay in computer games and virtual worlds, both educational drama and roleplay in games

and machinima offer 'role protection'—the 'psychosocial moratorium' which protects the roleplayer from real-life consequences. Here, the performance of teacher and student roles themselves are subject in various ways to the role protection Carroll and Cameron describe. Students—and teachers—can wear clothing or hair styles which might occasion comment or even prohibition in a school environment but which are in Second Life subject to a modality of identity play and fantasy. Students may adopt social roles quite different to those they would feel obliged to play in RL classrooms. However, the Teen Grid has more limited resources, so Britta has to create a different avatar for her Schome work, and says:

> It took me two weeks to finally have a moment to change my avatar because I was always busy when logged on. It is relatively limited in Schome Park as you have no access to other shops. Yes, I do miss my outfits from the main grid! In fact, I miss a lot from the main grid. It is frustrating to move between the Teen Grid and the main grid because you're always aware of what you have to leave behind—like my Dragon avatar!

So, while there are considerable freedoms available for teacher and students in terms of dramatic expression and the representation of self, the resources are by no means unlimited, and the limitations are subject to a range of social motivations. Main grid avatars have access to outrageous tattoos, highly realistic skins, even graphic representations of full nudity; while the Teen Grid, for obvious reasons, is debarred from some of these resources.

Similarly, SL has a dramatic topography—selfhood can be realised not only by what you wear but where you visit. Again, there are many freedoms here. When Britta visited a seminar we held in SL as a visiting avatar-lecturer,[6] she took us to an SL machinima studio, where our M.A. students were able to question professional animators about how they made their films. By comparison with RL, this was remarkably easy: no lengthy negotiations, complicated and time-consuming travel, difficulty of access: we teleported to the studio in a matter of seconds, and the educational 'visit' was in full flow.

However, Britta comments on the constraints which apply to her students:

> We can't take the teens out of the Teen Grid for obvious reasons ... but I still imagine taking 'day trips' with the students to visit machinima facilities and neighbourhoods on the main grid. Similarly, there are so many amazing educational sites in the main grid, but we can't take the teens there. For instance, I recently met a Geologist in the main SL. She built an entire island on the History of Geology. Amazing! I'd love to take them there and meanwhile the Geology island has no visitors!

In some respects, then, the barriers existing in RL between the worlds of adults and teenagers, permeable because they are mostly legal, social and conventional

rather than physical, are rendered impermeable by the technological divide between the Teen Grid and the Main Grid. Similarly, 'no-go' areas in the Main Grid are defended by technological barriers which will not allow an avatar to pass through them. While such physical barriers—to property and so on—exist in the real world, they seem to be strengthened here.

Nevertheless, it may be that the context of Second Life does make a shift away from the constraints of formal education that conventional informal teaching and learning never quite manage. While the aims, curricula and evaluation practices of informal education may escape the constraints of formal schooling, the pedagogic practices may remain very similar. Indeed, it can often be the case that 'informal' classes are curiously formal and instructional, while 'formal' practices can be fluid, innovative, student-centred and collaborative. In the case of Britta's Schome class, the agency of the student-as-avatar perhaps determines an informality in the teaching and learning process which is complemented by the fantasy setting—a huge airship on which Britta and the Schomers meet.

Britta's comments about how she has adapted her teaching for Second Life are worth considering in detail.

> As a classroom teacher you are always taught and reminded about classroom management. After ten years of teaching in real life I think I established a good routine of what works and what doesn't. I have worked in a variety of schools, with a variety of learners of all abilities. But teaching in a virtual world is totally different. First of all, most obvious, there is no physical presence of the teacher and students, so there's no eye contact, no voice to raise if you need them to be quiet, a very new personal space.

This seems a startling juxtaposition of affordance and constraint. While the sense of presence and social agency is strong, the sensory experience of this is quite different. The noise which all teachers experience as stressful, something necessary but also necessary to constantly manage, is gone, and though Britta sees this space as 'never silent' in the sense that the students are always typing chat and instant messages, it is clearly 'silent' in sensory terms. The lack of eye contact might be read as communicative constraint though there is also a sense that to make eye contact with 30 students in a 'real' classroom might be a heavy responsibility from which the teacher is relieved in the virtual environment.

If we look at the chat dialogue between teacher and students, the sense of constraints becoming affordances becomes stronger still. The nature of chat dialogue, with its variety of affective devices, abbrevations which also serve as neo-tribe argot, and adaptation to specialist purposes (in this case, the teaching and learning of animation), deploys a range of features strikingly different from

the genres of traditional classroom discourse. The effect is to foreground humour, speed up turn-taking, and flatten social hierarchies.

In other ways, however, Britta acknowledges some similarities with the conventional teaching context:

> However managing a group is still similar—you need to be fast! The first two sessions were totally mad as I organised everyone and gave everyone jobs to do. Here I found myself in a situation not very different from being in an ordinary classroom. You speak and ask the students what they like to do and about how they think they can do it—and what they think they are best at, and so on.

One specific difference between teaching in Second Life and RL depends on a technical resource—the private instant messaging function available in SL:

> The thing is that I found that I had more 'quality' time with the students because I could chat with them in IMs too…I never had time to talk to real life students in schools.

The ability to switch instantly into private communication with a student is impossible to achieve in a conventional classroom, where a 'private chat' inevitably requires a highly visible movement of the student to another space, even another room. However, the question arises about whether the 'quality time' Britta refers to is replicated in other ways in conventional school environments, whether in informal after-school activities, school trips, or 'corridor' talk, all opportunities which teachers use to build relationships with students which escape the limitations of classroom-bound subject teaching. The difference, perhaps, is that such communication is here integrated into the teaching session rather than found with difficulty in the interstices of the school day.

STUDENT MACHINIMA

The students' main production to date has been a 12-minute film about the destruction of the airship *Hindenburg* in 1937. It was inspired by the airship Britta transported from the Second Life main grid to the teen grid:

> …so I had the chance to take a few things from the mg to SP so I took the ship: my first pirate home I had in SL. So I gave that to the teens. Very tricky to move objects from mg to teens…so that inspired their idea to make the *Hindenburg* film.

The process of devising the film is an important aspect of the pedagogy. Media, Art, Drama and creative writing classrooms always have a choice here: to specify

the topic (perhaps under constraints from exam syllabuses) or to leave it to the students. In this case, Britta strongly feels the students should choose what to film:

> I am just a technician you see, and let them imagine. But sometimes I do interfere...like with the plan to refilm the TITANIC. I challenge them to tell me WHY? AGAIN? I encourage them to think again..to explain why they want to do this movie in that style—it has been done so what do they want to make different
>
> Juniper Mapp: creativity?
>
> Pigment Pye: yes...as I think teens refer first to what they know, but than once encouraged refer to their imagination. I think so. But once their imagination is going there is no stopping.

This raises a number of questions about the creative process which are not specific to machinima or teaching in virtual worlds. The relation between freedom and constraint (Sharples, 1999) was a theme of the BECTa DV pilot project evaluation, in which many teachers considered that freedom was the key to creativity, yet the evaluation repeatedly found that the most effective projects were those which constrained what the students did in some way. In Britta's *Hindenburg* project, there is both freedom and constraint. Importantly, this includes the freedom to choose the content: though, as Britta's account makes clear, this choice is challenged and refined. Creativity may involve the deployment of cultural resources students retrieve from their prior experience of the media, but it also involves the transformation of these resources in two ways. As Britta says, one aspect of the transformation is imaginative: the ability to rework remembered or found cultural resources into something new. But as her account implies, another aspect is reasoned discussion. In Vygotsky's account of creativity (1931/1998), this element is criterial to creativity, seen as the alliance of imagination with conceptual understanding, rational thought. While it is commonplace for models of media literacy to specify a critical and a creative dimension (Buckingham, 2003; Burn & Durran, 2007), this instance shows how closely connected these apparently discrete dimensions can be. The ability to critically evaluate and assess the function, meaning or aesthetic effect of a media text is closely associated with the ability to imagine how it might be different. Conversely, the ability to produce something which has never existed before depends not only on re-imagining images, sounds, spaces and events, but on a rational assessment of what these resources might be made to mean.

A perennial debate in media education concerns the collaborative nature of creative work. Successive models of media education have resisted traditional essentialist post-Romantic notions of individual genius and inspiration, preferring accounts of group production which rationalise the creative process, democratise the

function of authorship, and promote social ideals of co-operation and solidarity (see Buckingham et al., 1995, for an extended account of rationales and practices of group production work in media education). It is possible, even desirable, to challenge these ideals to some degree. A case can—perhaps should—be made for individual creativity, and this remains, as noted above, the dominant model of creative work in Art education. Similarly, the virtues of collaborative work can be overplayed, even sentimentalised. Group work can easily conceal emergent hierarchies, covert or overt competition, forms of exclusion and power-brokering, and disunited intentions.

Nevertheless, the evidence in this case is that group production lives up to its ideals. Students choose production roles in negotiation with the teacher:

Decimus - editing/SFX
Prof - story
Faz - explosives/props
Achilles - recording
Martin - casting/storyboards
Hapno - Directing/animation
??? - Music/sound effects, costumes

(the '???' indicates that we still need someone to do those)

In the case of Britta's class, the Schome students make some of their own assets. Her evaluation of the project's outcomes referred to these processes: 'Skills included character design and realisation of objects and sets using second life interface building and scripting tools'.

The content of the film shows clearly the kinds of transformation of genre, semiotic resource and given information to which Vygotsky's notion of creativity can apply. It is a hybrid of documentary elements—the historical narrative of the Hindenburg's destruction – and fantasy elements suggesting murder and thriller genres, which produce a mysterious saboteur who kills a guard and plants the explosive which destroys the ship. The process of negotiation which accepts the various ideas here, as well as the joyful exploitation of big disaster scenes which machinima allows amateur film-makers to do (Kelland et al., 2005), and fuses all this into a coherent narrative, is a distinctive feature of this project.

On the other hand, where constraints and structures are clearly apparent is in the the pedagogy Britta describes here, which recalls, as in her earlier work in schools, the synthesis of art education and media education. There is a strong emphasis on the 'language' of the moving image, as well as the metalanguage of the digital medium:

We have a specific media discussion forum where we set up topics, such as the machinima workshops. We post ideas, scripts, and I also manage to include terminology about film language. We discuss a lot of technology too, how things work such as streaming media, what codec to use.

The teaching combines old and new—the grammar of shot types developed in the early days of cinema and still fundamental to the art of machinima, and the social processes of film-making, along with the specific filming tools provided in SL:

> We are very 'hands-on' and the students learn a variety of skills. It's not just about technology. I help the team to be a complete film crew, from script writing, prop making, clothes design, filming, to editing. This means that the participants learn how to use the alt-zoom camera, the SL interface camera, how to set up shots, including wide, medium, close as well as over shoulder shots, etc.

The pedagogy recalls the emphasis of media education and art education on the craft of creative production work. On the one hand, this is rooted in what Metz (1974) called the cinematic language: filming and editing. In some respects, this seems to resemble closely the production processes typical of media education:

> We get organised via the forum, and in world everybody makes what is needed, or I train and teach camera skills and recording techniques. That can be very demanding once we get to film. The *Hindenburg* took 3 months to make … I was filming alongside Achilles (16 years), so we had two sets of files. … Editing was tricky as the teens haven't got very good editing software. Most use movie maker and that really is not very good, so that is what I like to develop with them further.

However, there are specific differences. A screenshot used by Britta to teach different roles shows the student camera operator floating in mid-air to film the ship from the outside. Machinima makes possible, then, shots which would normally be quite beyond the technical possibilities of a school production: shots which are only possible in professional production with cranes, planes, or, indeed, CGI.

If the teaching focuses on Metz's cinematic language on the one hand, however, it also recognises what he saw as the wider filmic language: the multimodal nature of film, and the other signifying systems it incorporates, such as costume, words, dramatic movement:

> Acting—he he, tat was hard as I had to probe the teens and the camera man, all by typing. But we had a script, and the teens followed their basic idea … e.g., the guard shooting and the bomb. They negotiate via chat of how to film and what to do … I only took over when it got tooo complicated or I wanted to focus them back to their ideas.

The dramatic element is, because of the nature of machinima, a much stronger component than in traditional animation work, where it is really limited to speech characterisation. Here, the process is much more like live action moving image production work in education, in which students act roles as well as filming, editing and directing. Performance is perhaps the feature of machinima which most obviously distinguishes it from conventional animation. Avatars perform

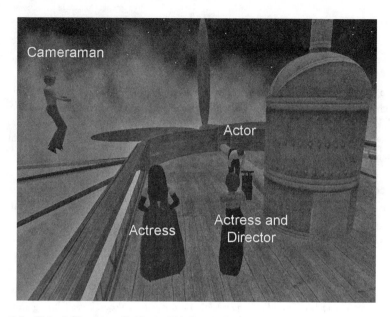

Figure 8.2 Britta's Teaching Guide for Filming in Second Life.

roles in real time, filmed by themselves or others, replacing the atomised production process of cel or stop-frame animation with the performative continuity of virtual bodies and running cameras.

The dramatic element in the multimodal ensemble of moving image production is under-recognised in media education: at its worst, the acting roles can be given to students perceived to be less competent with filming and editing. More generally, however, it is simply a failure of dialogue between the pedagogic traditions of media and drama education: the one has equipped itself with a language of representation, mediation, screens and distributed exhibition; the other with a language of dramatic presence, phenomenological embodiment, and local, immediate display. The truth is that the two need each other.

In the case of the *Hindenburg* project, it is not immediately clear what the nature of the dramatic work might be. It is clearly a form of roleplay, as Carroll and Cameron argue:

> Both process drama and machinima possess the kind of agency that Murray wants to build into the form she calls Cyberdrama [20]. Both of these forms lead to a type of dramatic creative work that is intermediate between dramatically 'linear narrative' and functional 'game' play. Role distance allows the required 'psychologically present entity', which is somewhere between 'me' and 'other' to operate within the framed context. (2005: 8)

Role distance offers here the possibility of critical distance, in effect a descendant of Brechtian alienation, which process drama in education has at its core. The point is not so much to be emotionally immersed in a role as to be able to move in and out of role to reflect on the development of the drama and its meaning for the various participants and spectators. A different metaphor is offered by Henry Lowood:

> This was a first step towards what Paul Marino, one of the founding members of the Ill Clan, would call the virtual puppetry of machinima, that is, the careful synchronization of avatar actions (moving, speaking) to voice actors/game players via keyboard bindings. (2005: 20)

The avatar as puppet resembles in some ways Augusto Boal's notion of the *spectactor*—the member of the theatre audience who crosses the threshold and becomes part of the drama (Boal, 1992). Most importantly, both offer critical distance. But there are differences of emphasis. The spectactor implies a serious political project. The puppet, by contrast, suggests play, carnival, street theatre, childhood. Of course, the future of machinima, whether as art form or as educational process, can embrace both.

In general terms, the question here is about the pragmatic diversity of creative work in education. This kind of work moves beyond the traditional practices of the media classroom or the art classroom. We can no longer be certain of whether the work of art belongs to the world of popular culture or the avant-garde, or both; whether students are fledgling filmmakers, visual designers or actors; whether their work belongs to literacy, visual culture, popular cinema, digital drama, or all of these. Whatever the case, it is clear that the teaching intelligence at work here is quietly refusing to throw out pedagogic babies with the bathwater. The old order may be giving way to something more pluralistic, more fluid, more easily characterised by postmodernist modes of thought than modernist, but the process of creative making still needs to retrieve the detailed procedures of older media, their grammars and their cultural echoes. This is as true for the Schome students as it is for the adult machinima community.

CONCLUSION

One possible conclusion of this study is that new media raise old questions, albeit in new forms. Britta's work with the Schome students suggests that students need a stake in the content of their work, that approaches to creative production which somehow balance play and work are successful, that a detailed attention to the semiotic specificity of the moving image pays dividends. It raises the question of the differences between the aesthetic practices of art education and media

education but also suggests that this kind of project can be situated within changing practices in both disciplines, the one moving towards a more pluralistic, critical approach, the other towards a closer engagement with the arts in education. It raises the issue of the advantages enjoyed by informal education and its freedom from the constraints of statutory mechanisms of curriculum and assessment. It demonstrates the advantages in both art and media education of a teaching approach rooted in and informed by professional artistic practice. It shows the complexity and the benefits of collaborative production work.

This much is a reinforcement of older lessons about media education, though ones which need repeating and refreshing, especially in the context of new media.

But what can be said that is distinctive and different about machinima—its culture and its technology?

Machinima is both enabled and constrained, defined and confined, let loose and tied down by its dependence on game worlds and the resources they offer. It can never start from scratch, but must always adapt, transform, re-purpose. This is its strength and its weakness. Maybe not too much of a weakness—the art of collage, synthesis, and the transformation of found materials has an honourable history in the modernist period (Braque's newspaper collages, Picasso's bike saddle bull's head), while practices of bricolage are well-established markers of postmodernist culture, in the sampling practices of contemporary popular music; or in the material and semiotic transformation of codes in fashion and design, in which military uniforms become garments of dissent, or the severe lines of Shaker domestic style become markers of bourgeois wealth.

More specifically, an aesthetic practice based in the adaptation of existing resources is conducive to the cultural work of schools and education. Chapter 3 of this book describes a popular media education activity—the making of film trailers by editing found footage from popular movies. The forms of cultural raiding represented by mash-ups, fan art, fan fiction, modding, reverse engineering: these are all grist to the mill of the educational project. In this sense, school students and their teachers resemble always the textual poachers of Jenkins and de Certeau's metaphor (1992): they create in rented space, with borrowed tools, in genres and forms invented by other people.

Furthermore, these practices enact the central processes of creativity envisaged in Vygotsky's essay on the subject, as noted above. His emphasis on the transformation of semiotic and cultural resources serves as a vindication of the use of machinima in education. To provide resources which are already heavily culturally shaped, and shaped within contemporary gaming cultures, is to offer a starting-point full of possibilities for young animators to play with. While social semiotics has always regarded language and other systems of signification as being

systems of meaning potential, to regard games and game-like environments in the same way is a productive way forward. Lowood cites Manovich's notion of the 'cultural economy' of games in this respect, seeing them as toolkits for creative work, rather than fixed textual entities (Lowood, 2005).

It must be acknowledged, though, that metaphors of border raiding and trespass run the risk of romanticising educational creative production work. There are counter-arguments: schools *are* in many ways authentic and distinctive cultural spaces owned by teachers and students, with no need to trespass; their creative work is more like professional apprenticeship than amateur production: it is their day job, not a transgressive leisure activity. In particular, if the teacher's identity derives as much from professional artistic practice as from a pedagogic role, as Britta's does, then apprenticeship becomes an even more appropriate idea. In addition, there is an important question about the ontology of the artistic work, which is in many ways made from scratch by the Schome students, who script and shape their own assets for their animated films rather than adapting them from found objects within Second Life. This looks much more like a digital equivalent of the plasticine modelling of stop-frame animation than like the bricolage of culturalist rhetoric.

Nevertheless, if they are a professionalised production team, as Britta's machinimators in many ways are, they work with restricted tools, budgets, time. They beg, borrow and steal, as well as design, invent and transform; and, while its future may hold something quite different, this is the dominant aesthetic practice of machinima in its early years and what makes it so suitable for educational animation work. What is clear already is that it is a mistake to over-generalise. As Kelland et al. emphasise (2005), there are already many different genres of machinima, some of which depend on gaming culture, some of which derive from established film genres, others which occupy a new kind of indie space. Plenty of room and time, then, for art and media educators to find the creative spaces and resources for their young machinimators to play, work and learn with.

Notes

1 MAKING NEW MEDIA: CULTURE, SEMIOTICS, DIGITAL LIT/ORACY

1. The exhibition of historic computer games, artwork and consoles, *Game On*, was held first at London's Barbican Centre in 2002 and returned, after an international tour, to the Science Museum in 2006.
2. Or older: Julian McDougall criticises media teachers who routinely fall back on reductive versions of the narrative theories of Propp and Todorov (McDougall, 2006).
3. a rare exception is Julian Sefton-Green, who explores the implications of Manovich for students' understandings of digital compositional practices, transferred across different media (2005).

2 GRABBING THE WEREWOLF: DIGITAL FREEZEFRAMES, THE CINEMATIC STILL AND TECHNOLOGIES OF THE SOCIAL

1. The film posters of Vladimir and Georgii Stenberg were the subject of an exhibition at the New York Museum of Modern Art in September 1997. I have drawn on the account of their lives and work in the catalogue article by Christopher Mount: 'Stenberg Brothers: Constructing a Revolution in Soviet Design' (Museum of Modern Art: New York, 1997).
2. AIP, American International Pictures, offered a new kind of independence from the Hollywood studios and produced important sci fi and horror B movies as well as many of Roger Corman's films. For an extended discussion of this, see Jancovich, 1996.

3. For a detailed account of this mediaeval version, see Zipes, 1983. Also, Angela Carter paraphrases Zipes' account in her notes to *The Virago Book of Fairytales*.
4. Clover's argument about the masochistic, female-structured viewing position of horror audiences operates a complete reversal of Laura Mulvey's well-known argument that film narrative positions all audiences as male and sadistic/scopophilic (Mulvey, 1975).
5. The catchphrase can be seen as the verbal equivalent of a still: a powerful quotation, condensing particular meanings and film-spectator relations, particularly suited to publicity use (in fact, it was at the head of the page on *The Fly* in the Internet Movie Database at the time of writing).
6. In many ways, of course, these early experiences of video 'mash-ups' of film anticipate, as does Williams' essay, the advent of participatory internet culture and online exhibition of the kind that YouTube exemplifies. At the time of this book's publication, tribute videos to *Company of Wolves* can, indeed, be found on YouTube.

3 DIGI-TEENS: MEDIA LITERACIES AND DIGITAL TECHNOLOGIES IN THE SECONDARY CLASSROOM

1. Philip Brophy (1986), for instance, argues that the 'Hitchcock debt' represents a restrained aesthetic which is to be preferred to that of more recent 'body-horror', such as the films of David Cronenberg or John Carpenter. Our argument is that, while films may present themselves as operating strategies of implicit or explicit revelation of the terrifying image, they all depend on a dialectic between revelation and concealment. My image for this is borrowed from Kant's treatise on the sublime and the beautiful (1763/1960), in which he imagines the sublime image of awesome limitlessness as a vast desert which we people with imaginary monsters: the fear/pleasure is caused by both the emptiness and the monsters. The romantic concept of the sublime has been used by a number of commentators to describe the history of narratives of horror over the last two hundred years.
2. This kind of image is what Kress and van Leeuwen (1996) call a *demand* image act, in which the character (the 'represented participant') is directly demanding some kind of response or engagement from the spectator. This supports Barthes' argument for the catalyser's role in maintaining the contact between narrator and addressee: the function that Kress and van Leeuwen call 'interactive'.

5 'TWO TONGUES OCCUPY MY MOUTH'—POETRY, PERFORMANCE AND THE MOVING IMAGE

1. This work took place in 2000, with a Year 11 (16-year-old) GCSE English group.
2. The films were later incorporated into an Open University resource for teachers and students, edited by Jenny Leach. They could still be viewed there as this book went to publication, at http://www.open.ac.uk/crete/movingwords/pages/gallery.html

6 POTTERLITERACY: FROM BOOK TO GAME AND BACK AGAIN—LITERATURE, FILM, GAME AND CROSS-MEDIA LITERACY

1. Pseudonyms have been used for the children referred to in this chapter.

7 'WRITING' COMPUTER GAMES: GAME-LITERACY AND NEW-OLD NARRATIVES

1. A level editor is a form of authoring software made available within a commercial game. It enables players to design their own section of the game, using the games own assets and then to play this section.
2. Frasca (ibid.) makes two points in relation to the settings of games. Firstly, he suggests that settings (and characters) are among the more obvious common features of games and narratives. Secondly, he argues that in the settings of games, the potential for unstructured play (paidea) is greater: activities like exploring, for example, are playful and rule governed but not necessarily oriented towards obligatory completion and a win-lose state.
3. The final iteration of the software, field-researched in 2006 and published as a commercial product under the name of Missionmaker, does have a library of animated characters.
4. See Burn and Schott, 2004, for a fuller explanation of walkthroughs and mood.

8 MACHINIMA, SECOND LIFE AND THE PEDAGOGY OF ANIMATION

1. The chapter draws on two funded research projects: Learning from Online Worlds; Teaching in Second Life, funded by the Eduserv Foundation; and the Digital Video Pilot project, funded by BECTa. It also draws on the work of the Schome project at the Open University.
2. BECTa (the British Education and Communication Technology Agency) is the UK agency supporting the development of ICT use in schools. THE DV pilot project involved giving an i-mac and a digital video camera to 50 schools and monitoring and evaluating their use of this equipment. The uses ranged across different subject areas and different ages from early primary to post-16.
3. Learning from Online Worlds; Teaching in Second Life, Eduserv Foundation, 2007–8.
4. There are distinctions to be made between Schome, the Schome Initiative and the Schome Park Programme:

 * Schome will be the education system for the information age.
 * The Schome Initiative is developing schome.
 * The Schome Park Programme (which Britta was involved with) is a subset of the Schome Initiative which was set up specifically to help us to give people 'lived expe-

riences' of radically different models of education. More details can be found on the project website at www.schome.ac.uk.

5. With Diane Carr, Principal Investigator of Teaching and Learning in Virtual Worlds. The interviews cited in this chapter were all conducted in Second Life via in-world chat.
6. The Learning from Online Worlds; Teaching In *Second Life* project held a series of Masters seminars in Second Life, which included two sessions addressed by visiting lecturers. The report of the study, Learning to Teach in Second Life, can be found at http://learningfromsocialworlds.wordpress.com/learning-to-teach-in-second-life/

References

Adorno, T. (1941). 'On Popular Music', in Frith, S. & Goodwin, A. (eds.) (1990). *On The Record*. London: Routledge.

Addison, A. & Burgess, L. (eds). (2003). *Issues in Art and Design Teaching*, London: Routledge Falmer.

Andrews, R. (1994). 'Towards a New Model: A Rhetorical Perspective', in Watson, K. (ed.), *English Teaching in Perspective*. Sydney: St. Clair.

Appelbaum, P. (2003). 'Harry Potter's World: Magic, Technoculture and Becoming Human', in Heilman, E. (ed.) *Harry Potter's World*. New York: Routledge Falmer.

Bakhtin, M. (1952–3). 'The Problem of Speech Genres', reprinted in Morris, P. (ed.) *The Bakhtin Reader*. London: Arnold, 1994.

Bakhtin, M. (1981). *The Dialogic Imagination*, edited by Michael Holquist. Austin, Texas: University of Texas Press, 1981.

Banaji, S. & Burn, A. (2007). *Rhetorics of Creativity*, commissioned by Creative Partnerships, at www.creative-partnerships.com/literaturereviews.

Barthes, R. (1978).'The Third Meaning', in *Image-Music-Text*, translated by Stephen Heath. New York: Hill and Wang.

Barthes, R. (1978). 'Introduction to the Structural Analysis of Narrative', in *Image-Music-Text*, translated by Stephen Heath. New York: Hill and Wang.

Bazalgette, C. & Buckingham, D. (1995). 'The Invisible Audience', in Bazalgette, C.& Buckingham, D. (eds.) *In Front of the Children*. London: British Film Institute.

Beavis, C. (2001). 'Digital Culture, Digital literacies: Expanding the Notions of Text', in Beavis, C. & Durrant, C. (eds.) *P(ICT)ures of English: Teachers, Learners and Technology*. Adelaide: Wakefield.

Benjamin, W. (1938). 'The Work of Art in the Age of Mechnical Reproduction', in Benjamin, W. (eds.) *Illuminations*. Trans. Harry Zohn. Edited by Hannah Arendt. New York: Schocken, 1968.

Benjamin, W. (1999). *The Arcades Project*, edited by Roy Tiedemann. Boston: Harvard University Press.

Bennett, A. (2000). *Popular Music and Youth Culture*. Basingstoke: Palgrave Macmillan.

Bigum, C., Durrant, C., Green, B., Honan, E., Lankshear, C., Morgan, W., Murray, J., Snyder, I. & Wild, M. (1998). *Digital Rhetorics: Literacies and Technologies in Education— Current Practices and Future Directions*. Canberra: DEETYA.

Black, S. (2003). 'The Magic of Harry Potter: Symbols and Heroes of Fantasy', *Children's Literature in Education*, Vol. 34, No.3, September 2003, 237–247.

Boal, A. (1992). *Games for Actors and Non Actors*. London: Routledge.

Boden, M. (1990). *The Creative Mind: Myths and Mechanisms*. London: Weidenfeld and Nicolson.

Borah, R. (2003). 'Apprentice Wizards Welcome: Fan Communities and the Culture of Harry Potter', in Whited, L. (ed.) *The Ivory Tower and Harry Potter: Perspectives on a Literary Phenomenon*. Columbia, MO: University of Missouri Press.

Bordwell, D., Staiger, J. & Thompson, K. (1985). *The Classical Hollywood Cinema*. London: Routledge & Kegan Paul.

Bourdieu, P. (1984). *Distinction: A Social Critique of the Judgement of Taste*. London: Routledge.

Brophy, P. (1986). 'Horrality', *Screen*, Vol. 27, No. 1, February 1986, 2–13.

Bruner, J. (1996). *The Culture of Education*. Cambridge, MA: Harvard University Press.

Buckingham, D. (1993). *Children Talking Television: The Making of Television Literacy*. London: Falmer.

Buckingham, D. (1996). *Moving Images: Understanding Children's Emotional Responses to Television*. Manchester: Manchester University Press.

Buckingham, D. (2001). 'New Media Literacies: Informal learning, digital technologies and education'. London: Institute for Public Policy Research.

Buckingham, D. (2003). *Media Education: Literacy, Learning and Contemporary Culture*. Cambridge: Polity.

Buckingham, D. (2007): *Beyond Technology: Children's Learning in the Age of Digital Culture*. Cambridge: Polity.

Buckingham, D. & Burn, A. (2007). 'Game-Literacy in Theory and Practice', *Journal of Educational Multimedia and Hypermedia*, Vol. 16. L,NO. 3, October 2007, 323–349.

Buckingham, D. & Domaille, K. (2003). 'Where Have We Been and Where Are We Going? Results of the UNESCO Global Survey of Media Education', (pp. 41–52) in Von Feilitzen, C. and Carlsson, U. (eds.) *Promote or Protect UNESCO Children, Youth and Media Yearbook* Goteborg, Sweden: Nordicom.

Buckingham, D. & Sefton-Green, J. (2003). 'Gotta Catch 'Em All: Structure, Agency or Pedagogy in Children's Media Culture.' *Media, Culture & Society*, Vol. 25, 379–399.

Buckingham, D. & Sefton-Green, J. (1994). *Cultural Studies Goes to School*. London: Taylor and Francis.

Buckingham, D., Grahame, J. & Sefton-Green, J. (1995). *Making Media—Practical Production in Media Education*. London: English & Media Centre.

Buckingham, D., Harvey, I. & Sefton-Green, J. (1999). 'The Difference Is Digital? Digital Technology and Student Media Production', *Convergence*, Vol. 5, No. 4, Winter 1999, 10–20.

Burn, A. (1997). 'Spiders, Werewolves and Bad Girls', *Changing English*, Vol. 3, No. 2, 163–176.

Burn, A. (2005). 'Potter-Literacy—From Book to Game and Back Again; Literature, Film, Game and Cross-Media Literacy', in *Papers: Explorations into Children's Literature*, Vol. 14, No. 3, 5–17.

Burn, A. & Durran, J. (1999). 'Tigerwoman and the Grammar of Comics', Open University e-lecture, Open University PGCE virtual conference.

Burn, A. & Durran, J. (2007). *Media Literacy in Schools: Practice, Production and Progression*. London: Paul Chapman.

Burn, A. & Leach, J. (2004). 'ICT and the Moving Image', in Andrews, R. (ed.) *The Impact of ICT on Literacy Education*. London: Routledge Falmer.

Burn, A. & Parker, D. (2005). *Analysing Media Texts*. London: Continuum.

Burn, A. & Parker, D. (2003). 'Tiger's Big Plan: Multimodality and the Moving Image', in C. Jewitt and G. Kress (eds.) *Multimodal Literacy*. New York: Peter Lang, 56–72.

Burn, A. & Schott, G. (2004). 'Heavy Hero or Digital Dummy: Multimodal Player-avatar Relations in Final Fantasy 7', *Visual Communication*, Vol. 3, No. 2, Summer 2004, 213–233.

Caillois, R. (2001). *Man, Play and Games*, translated by Meyer Barash. Chicago: University of Illinois Press.

Carr, D., Buckingham, D., Burn, A. & Schott, G. (2006). *Computer Games: Text, Narrative, Play*, Cambridge: Polity.

Carroll, J. (2002). 'Digital Drama: a Snapshot of Evolving Forms', *Melbourne Studies in Education*, Vol. 43, No. 2, November 2002, 130–141.

Carroll, J. & Cameron, D. (2005). 'Machinima: Digital Performance and Emergent Authorship', *Proceedings of DiGRA 2005 Conference: Changing Views—Worlds in Play*. University of Vancouver, June 2005. At www.digra.org

Carter, A. (1981). 'The Company of Wolves', in *The Bloody Chamber*. Harmondsworth: Penguin.

Carter, A. (1991). *The Virago Book of Fairytales*. London: Virago.

Channel 4 (2000). *On The Edge of Bladerunner* (TV documentary).

Clover, C. (1993). *Men, Women and Chainsaws*. London: BFI.

Connor, S. (1992). *Theory and Cultural Value.*, Oxford: Blackwell.

Cope, B. & Kalantzis, M. (eds). (2000). *Multiliteracies: Literacy Learning and the Design of Social Futures*. Melbourne: Macmillan.

du Gay, P., Hall, S., Janes, L., Mackay, H. & Negus, K. (1997). *Doing Cultural Studies, The Story of the Sony Walkman*. The Open University and Sage Publications.

Duncum, P. (2001). 'Visual Culture: Developments, Definitions and Directions for Art Education', *Studies in Art Education*, Vol. 42.2 No. 101–112.

Durrant, C. & Green, B. (2000). 'Literacy and the New Technologies in School Education:

Meeting the L(IT)eracy Challenge', *Australian Journal of Language and Literacy Education*, Vol. 23, No. 2, 88–109.

Eisenstein, S. (1968). *The Film Sense*, translated by J. Layda. London: Faber and Faber.

FEWG (Film Education Working Group) (1999). *Making Movies Matter*. London: BFI.

Fiske, J. (1989). *Reading the Popular*. London: Unwin Hyman.

Frasca, G. (1999). 'Ludology Meets Narratology: Similitude and differences Between (Video) games and Narrative': http://www.ludology.org/

Fraser, P. & Oram, B. (2003). *Teaching Digital Video*. London: BFI.

Freud, S. (1915). 'The Unconscious', in the *Penguin Freud Library*, Vol. 11. Penguin: Harmondsworth.

Gauntlett, D. (2007). 'Media Studies 2.0', unpublished article, at http://www.theory.org.uk/mediastudies2.htm

Gee, J. (2003). *What Video Games Have to Teach Us about Learning and Literacy*. London: Palgrave.

Genette, G. (1980). *Narrative Discourse*. Oxford: Blackwell.

Goffman, E. (1959). *The Presentation of Self in Everyday Life*. New York: Anchor.

Grahame, J. & Simons, M. (2004). *Media Studies in the UK*. London: Qualifications and Curriculum Authority.

Green, B. (1995). 'Post-Curriculum Possibilities: English Teaching, Cultural Politics and the Postmodern Turn', *Journal of Curriculum Studies*, Vol. 27, No. 4, 391–409.

Halliday, M.A.K. (1985). *An Introduction to Functional Grammar*. London: Arnold.

Halliday, M.A.K. (1978). *Language as Social Semiotic*. London: Edward Arnold.

Halliday, M.A.K. (1989). *Spoken and Written Language*. Oxford: Oxford University Press.

Heath, S. (1980). 'Technology as Historical and Cultural Form', in de Lauretis and Heath (eds.) *The Cinematic Apparatus*. London: Macmillan.

Heath, S. (1976). 'Narrative Space', *Screen*, Vol. 17, No. 3, reprinted in Easthope, A. (ed.) (1993), *Contemporary Film Theory*. London: Longman.

Hebdige, D. (1979). *Subculture: the Meaning of Style*. London: Methuen.

Hodge, R. & Kress, G. (1988). *Social Semiotics*. Cambridge: Polity.

Hodge, R. & Tripp, D. (1986). *Children and Television*. Cambridge: Polity.

Homer. (1946). *The Odyssey*, translated by E. V. Rieu. London: Penguin Classics.

Jancovich, M. (1992). *Horror*. London: Batsford.

Jancovich, J. (1996). *Rational Fears—American Horror in the 1950s*. Manchester: Manchester University Press.

Jenkins, H. (1992). *Textual Poachers: Television Fans and Participatory Culture*. New York: Routledge.

Jenkins, H. (2002). 'Interactive Audiences?: The "Collective Intelligence" of Media Fans' in Dan Harries (ed.) *The New Media Book*. London: British Film Institute.

Jenkins, H. (2006). *Convergence Culture: Where Old and New Media Collide*. New York: NYU Press.

Jenkins, H. (2007). 'Confronting the Challenges of Participatory Culture: Media Education for the 21st Century', at http://digitallearning.macfound.org/atf/cf/%7B7E45C7E0-A3E0-4B89-AC9C-E807E1B0AE4E%7D/JENKINS_WHITE_PAPER.PDF

Jewitt, C. & Kress, G. (eds.) (2003). *Multimodal Literacy*. New York: Peter Lang.

Kant, I. (1763/1960). *Observations on the Feeling of the Beautiful and the Sublime*, translated by John T. Goldthwait. Oxford: University of California Press.

Kelland, M., Morris, M., & Lloyd, D. (2005). *Machinima*. London: Course Technology PTR.

King, S. (1982). *Danse Macabre*. London: Futura.

Kress, G. (2003). *Literacy in the New Media Age*. London: Routledge.

Kress, G. and van Leeuwen, T. (1992). 'Trampling All over Our Unspoiled Spot: Barthes' "Punctum" and the Politics of the Extra-semiotic', *Southern Review* Vol. 25, No. 1, 27–8.

Kress, G. & van Leeuwen, T. (1996). *Reading Images: the Grammar of Visual Design*. London: Routledge.

Kress, G. & van Leeuwen, T. (2000). *Multimodal Discourse: The Modes and Media of Contemporary Communication*. London: Arnold.

Lanham, R. (1993). *The Electronic Word: Democracy, Technology, and the Arts*. Chicago: University of Chicago Press.

Lankshear, C. & Knobel, M. (2003). *New Literacies, Changing Knowledge and Classroom Learning*. Buckingham: Open University Press.

Lankshear, C., Snyder, S. & Green, B. (2000). *Teachers and TechnoLiteracy: Managing Literacy, Technology and Learning in Schools*. St. Leonards: Allen & Unwin.

Leadbeater, C. (2000). *Living on Thin Air: The New Economy with a Blueprint for the 21st Century*. London, Penguin.

Leander, K & Frank, A. (2006). 'The Aesthetic Production and Distribution of Image/Subjects among Online Youth', *E-Learning*, Vol. 3, No. 2, 185–286.

Leavis, F. & Thompson, D. (1933). *Culture and Environment*. London: Chatto and Windus.

Lemke, J. (2002). 'Travels in Hypermodality', *Visual Communication*, Vol. 1, No. 3, 299–325.

Loveless, A. (2002). *Literature Review in Creativity, New Technologies and Learning*. Bristol: Futurelab.

Lowood, H. (2005). 'High-Performance Play: The Making of Machinima', in Clarke, A. & Mitchell, G. (eds.) *Videogames and Art: Intersections and Interactions*. London: Intellect.

Mackereth, M. & Anderson, J. (2000). 'Computers, Video Games, and Literacy: What Do Girls Think?' *The Australian Journal of Language and Literacy* Vol. 23, No. 3, 184–195.

Mackey, M. (2001). 'The Survival of Engaged Reading in the Internet Age: New Media, Old Media, and the Book', *Children's Literature in Education*, Vol. 23, No. 3, September 2001, 167–189.

Mackey, M. (2002). *Literacies Across Media: Playing the Text*. London: Routledge Falmer.

Manovich, L. (1998). *The Language of New Media*. Cambridge, MA: MIT Press.

Marsh, J. & Millard, E. (2000). *Literacy and Popular Culture: Using Children's Culture in the Classroom*. London: Paul Chapman.

McClay, J. (2002). 'Hidden "Treasure": New Genres, New Media and the Teaching of Writing', *English in Education*, Vol. 36, No. 1, 46–55.

McDougall, J. (2006). *The Media Teacher's Book*. London: Hodder Education.

McLuhan, M. (1962). *The Gutenberg Galaxy: The Making of Typographic Man*. Toronto: University of Toronto Press.

McRobbie, A. (1991). *Feminism and Youth Culture: From Jackie to Just 17*. London: Macmillan.

Metz, C. (1974). *Film Language*. Chicago: Chicago University Press.

Morgan, W. (1997). *Critical Literacy in the Classroom: The Art of the Possible*. London: Routledge.

Moseley, D., Higgins, S., Bramald, R., Hardman, F., Miller, J., Mroz, M., Tse, H., Newton, D., Thompson, I., Williamson, J., Halligan, J., Bramald, S., Newton, L., Tymms, P., Henderson, B. & Stout, J. (1999). *Ways Forward with ICT: Effective Pedagogy Using Information and Communications Technology for Literacy and Numeracy in Primary Schools*. Newcastle: University of Newcastle.

Mulvey, L. (Autumn 1975). 'Visual Pleasure and the Narrative Cinema', in *Screen*, Vol. 16, No. 3.

Murray, J. (1998). *Hamlet on the Holodeck*. Cambridge, MA: MIT Press.

NACCCE (1999). *All Our Futures: Creativity, Culture and Education*. Sudbury, National Advisory Committee on Creative and Cultural Education: DfEE and DCMS.

Oliver, M. (2008). 'Exclusion and Community in Second Life', online paper at http://learningfromsocialworlds.wordpress.com/exclusion-community-in-second-life/

Ong, W. (1982). *Orality and Literacy: the Technologizing of the Word*. London: Methuen.

Pelletier, C. (2005). 'How Meaning Is Produced in Game-Authoring' (unpublished research paper, Institute of Education, University of London: Centre for the Study of Children, Youth and Media).

Perrault, C. (1991). 'Little Red Riding Hood', in Carter, A. (ed.) *The Virago Book of Fairytales*. London: Virago.

Potter, J. (2005). '"This Brings Back a Lot of Memories"—A Case Study in the Analysis of Digital Video Production by Young Learners', *Education, Communication & Information*, Vol. 5, No. 1, March 2005, 5–24.

Propp, V. (1970). *Morphology of the Folktale*. Austin: University of Texas Press.

Raney, K. (1998). 'A Matter of Survival: On Being Visually Literate', *The English & Media Magazine*, No. 39, Autumn 1998, 37–42.

Reid, M., Burn, A., & Parker, D. (2002). Evaluation Report of the BECTa Digital Video Pilot Project, BECTa, http://www.becta.org.uk/research/reports/digitalvideo/index.html

Rowling, J.K. (1998). *Harry Potter and the Chamber of Secrets*. London: Bloomsbury.

Ryan, M.L. (2001). 'Beyond Myth and Metaphor—The Case of Narrative in Digital Media', *Game Studies*, Vol. 1, No. 1 (www.gamestudies.org)

Scruton, R. (1987). 'Expressionist Education'. *Oxford Review of Education* Vol. 13, No. 1, 39–44.

Sefton-Green, J. (2005). 'Timelines, Timeframes and Special Effects: Software and Creative Media Production', *Education, Communication & Information*, Vol. 5, No. 1, March 2005, 99–103.

Sefton-Green, J. (1995). 'New Models for Old? English Goes Multimedia', in Buckingham, D., Grahame, G. & Sefton-Green, J. (1995) *Making Media—Practical Production in Media Education*. London: English & Media Centre.

Sefton-Green, J. (1999). 'Media Education, but Not as We Know It: Digital Technology and the End of Media Studies', *The English & Media Magazine*, No. 40, 28–34.

Sefton-Green, J. & Parker, D. (2000). *Edit-Play*. London: BFI.

Selwyn, N. (2008). 'Developing the Technological Imagination: Theorising the Social Shaping and Consequences of New Technologies', in *Theorising the Benefits of New Technology for Youth: Controversies of Learning and Development*, ESRC seminar series, University of Oxford and London School of Economics and Political Science.

Sharples, M. (1999). *How We Write: Writing as Creative Design*. London: Routledge.

Sinker, R. (2000). 'Making Multimedia', in Sefton-Green, J. & Sinker, R. (eds.) *Evaluating Creativity*. London: Routledge.

Street, B. (1997). 'The Implications of the "New Literacy Studies for Literacy Education", *English in Education*, Vol. 31, No. 3, 45–59.

Sutton-Smith, B. (2001). *The Ambiguity of Play*, Cambridge: Harvard University Press.

Taylor, T.L. (2006). *Play Between Worlds: Exploring Online Game Culture*. Cambridge, MA: MIT Press.

Tucker, N. (1999). 'The Rise and Rise of Harry Potter', *Children's Literature in Education*, Vol. 30 No. 4, 221–234.

van Leeuwen, T. (1985). 'Rhythmic Structure of the Film Text', in van Dijk (ed.) *Discourse and Communication*. Berlin: de Gruyter.

van Leeuwen, T. (1999). *Speech, Music, Sound*. London: Macmillan.

Vygotsky, L.S. (1931/1998). 'Imagination and Creativity in the Adolescent', *The Collected Works of L.S. Vygotsky*, Vol. 5, 151–166.

Vygotsky, L.S. (1962). *Thought and Language*. Cambridge, MA: MIT Press.

Willett, R. (2006). 'Constructing the Digital Tween: Market Discourse and Girls' Interests', In Mitchell, C. & Reid Walsh, J. (Eds.) *Seven Going on Seventeen: Tween Culture in Girlhood Studies*. (pp. 278–293). New York: Peter Lang.

Williams, R. (1961). *The Long Revolution*. London: Chatto and Windus.

Williams, R. (1981). 'Communications, Technologies and Social Institutions', republished in Williams, R. (1988) *What I Came to Say*. London: Hutchinson.

Williams, R. (1974/1983). 'Drama in a Dramatized Society', in *Writing in Society*. London: Verso.

Willis, P. (1977). *Learning to Labour*. Aldershot: Ashgate.

Willis, P. (1990). *Common Culture*. Buckingham: Open University Press.

Zipes, J. (1983). *Fairy Tales and the Art of Subversion*. New York: Routledge.

TV AND FILM

Aliens, James Cameron, US, 1986
An American Werewolf in London, John Landis, UK, 1981
Carrie, Brian de Palma, US, 1976
Dr. Jekyll and Mr. Hyde, Rouben Mamoulian, US, 1931
Dr. Who, series 1 (2005), DVD, London: BBC

Halloween, John Carpenter, US, 1978
Harry Potter and the Chamber of Secrets, Chris Columbus, UK, 2002
It, Tommy Lee Wallace, US, 1990
A Nightmare on Elm Street, Wes Craven, US, 1984
Poltergeist, Tobe Hooper, US, 1982
Psycho, Alfred Hitchcock, US, 1960
Scream, Wes Craven, US, 1996
The Company of Wolves, Neil Jordan, UK, 1984
The Exorcist, William Friedkin, US, 1976
The Fly, David Cronenberg, US, 1986
The Shining, Stanley Kubrick, US, 1980: Warner
The Silence of the Lambs, Jonathan Demme, US, 1991
The Tommyknockers, John Power, US, 1993

GAMES

Final Fantasy VII (1998) Developer: Square; Publisher: Eidos

Harry Potter and the Chamber of Secrets (2002) Developer: KnowWonder; Publisher: EA Games

Planescape Torment (1999) Developer: Black Isle Studios; Publisher: Interplay Productions, Inc.

Skid the Squirrel (2005) London: BBC, at http://www.bbc.co.uk/cbbc/wild/games/ (last accessed, 5.6.06)

Timesplitters 2 (2002) Developer: Free Radical Design; Publisher: Eidos Interactive

Tomb Raider 4: The Last Revelation (1999) Developer: Core Design; Publisher: Eidos

Index

Colin Lankshear, Michele Knobel,
& Michael Peters
*General Editor*s

New literacies and new knowledges are being invented "in
the streets" as people from all walks of life wrestle with
new technologies, shifting values, changing institutions,
and new structures of personality and temperament emerging
in a global informational age. These new literacies and
ways of knowing remain absent from classrooms. Many educa-
tion administrators, teachers, teacher educators, and aca-
demics seem largely unaware of them. Others actively
oppose them. Yet, they increasingly shape the engagements
and worlds of young people in societies like our own. The
New Literacies and Digital Epistemologies series will ex-
plore this terrain with a view to informing educational
theory and practice in constructively critical ways.

For further information about the series and submitting
manuscripts, please contact:

> Michele Knobel & Colin Lankshear
> Montclair State University
> Dept. of Education and Human Services
> 3173 University Hall
> Montclair, NJ 07043
> michele@coatepec.net

To order other books in this series, please contact our
Customer Service Department at:

> (800) 770-LANG (within the U.S.)
> (212) 647-7706 (outside the U.S.)
> (212) 647-7707 FAX

Or browse online by series at:

> www.peterlang.com